THE LOST WORLD OF
POMPEII

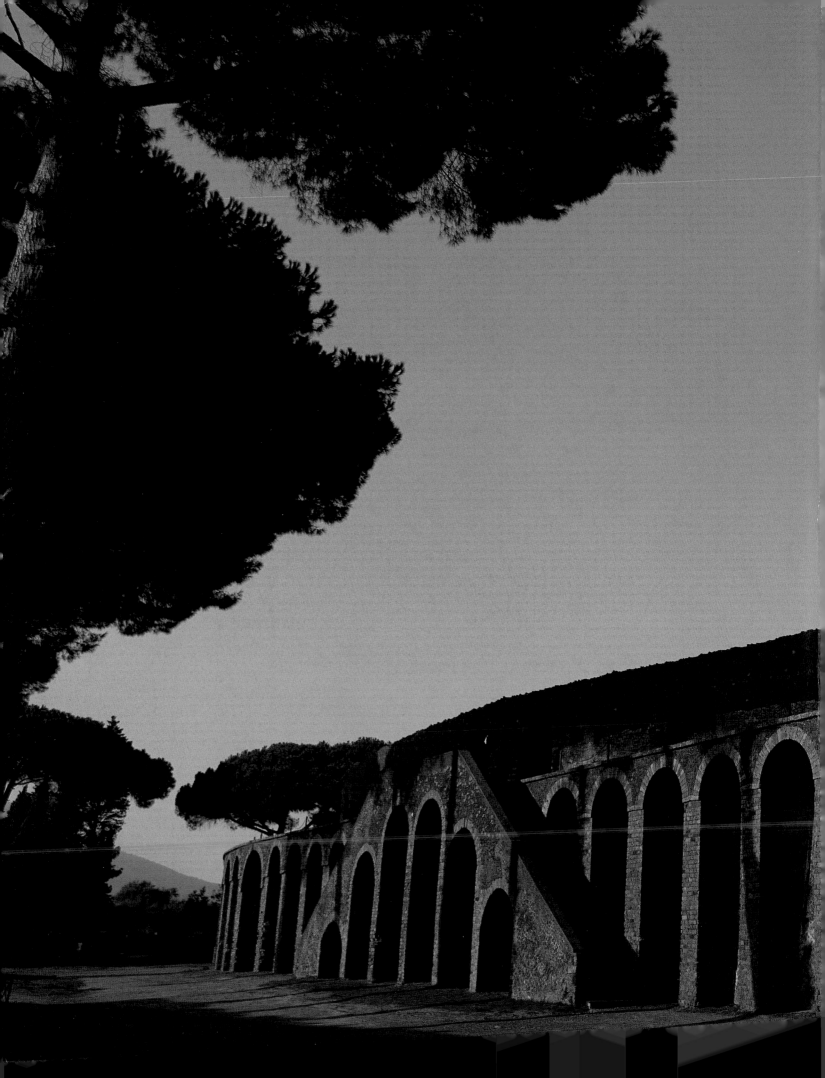

THE LOST WORLD OF
POMPEII

COLIN AMERY
BRIAN CURRAN JR

FRANCES LINCOLN
IN ASSOCIATION WITH THE WORLD MONUMENTS FUND

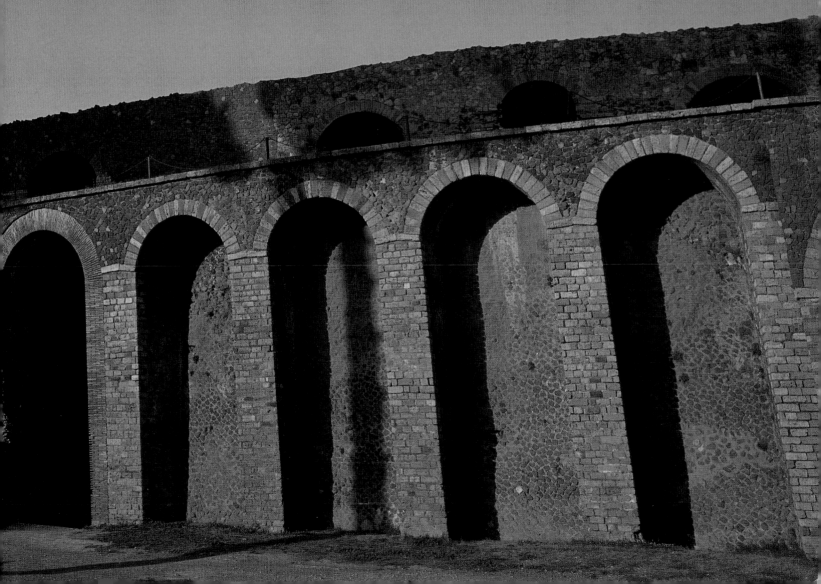

OF ALL THE CITIES OF ANTIQUITY, Pompeii is undoubtedly the best known. It is famous for its art, architecture, and objects of daily life, preserved in volcanic ash when Vesuvius erupted just after daybreak on 24 August, AD 79. Considered the world's oldest archaeological dig, Pompeii has been under almost continuous excavation since 1748. Today, more than two thirds of the site have been cleared of ash, providing a window on Roman cultural and intellectual life nearly two millennia ago. For all its fame, however, Pompeii is a site at risk. Its buildings and streets, laid bare at a time when preservation did not go hand in hand with excavation, have suffered from exposure to the elements, poor site management, and uncontrolled tourism: its ruins are trampelled by more than two million visitors each year. Fresoes, perfectly preserved until the day of their excavation, now lie crumbling, strewn among the weeds.

In recognition of Pompeii's imperilled state, the World Monuments Fund (WMF), the foremost private, non-profitmaking institution devoted to preserving cultural heritage worldwide, included the site on its 1996, 1998, and 2000 lists of the 100 Most Endangered Sites. Issued every two years, this list sheds light on sites at risk in the hope that they will be accorded the financial support and technical assistance they so desperately need. Since Pompeii's inclusion on the list, joint funding from the American Express Company and the Samuel H. Kress Foundation has underwritten the creation of a digitized map of the site. The WMF has also been instrumental in drafting *Un Piano per Pompei* ('A Plan for Pompeii'), an assessment of the condition of the archaeological remains for use in conservation planning, which has been published in conjunction with the Ministero per i Beni Culturali e Ambientali and the Soprintendenza Archeologica di Pompei.

As you pore through the pages of this book, it is our hope that you will come to appreciate the splendour of Pompeii and, in your own way, work to ensure that it is preserved for future generations.

Angela M. H. Schuster, Director of Publications
World Monuments Fund, New York City

Frances Lincoln Ltd
4 Torriano Mews, Torriano Avenue
London NW5 2RZ
www.franceslincoln.com

The Lost World of Pompeii
Copyright © Frances Lincoln Ltd 2002
Text copyright © Colin Amery and Brian Curran Jr 2002
Introduction by Andrew Wallace-Hadrill © Frances Lincoln Ltd 2002
Illustrations copyright as listed on page 192
Artwork by Alex Matheson © Frances Lincoln Ltd 2002

First Frances Lincoln edition 2002
First paperback edition 2011

Hardback ISBN: 978-0-7112-1966-3
Paperback ISBN: 978-0-7112-3262-4

Printed and bound in China

9 8 7 6 5 4 3 2 1

HALF TITLE At the heart of the city is the solemn dignity of the Basilica in the Forum. It was here that by the end of the second century BC the citizens of Pompeii used to meet to settle and discuss all their municipal business.

TITLE Not for nothing was the giant amphitheatre known as the *spectacula*. The huge elliptical structure was capable of seating twenty thousand people to watch gladiatorial contests. Men and animals fought to the death in this vast arena – a place of beauty today, but once stained with blood.

RIGHT A Medusa's face looks out from a Fourth Style fresco in the House of the Vettii.

CONTENTS

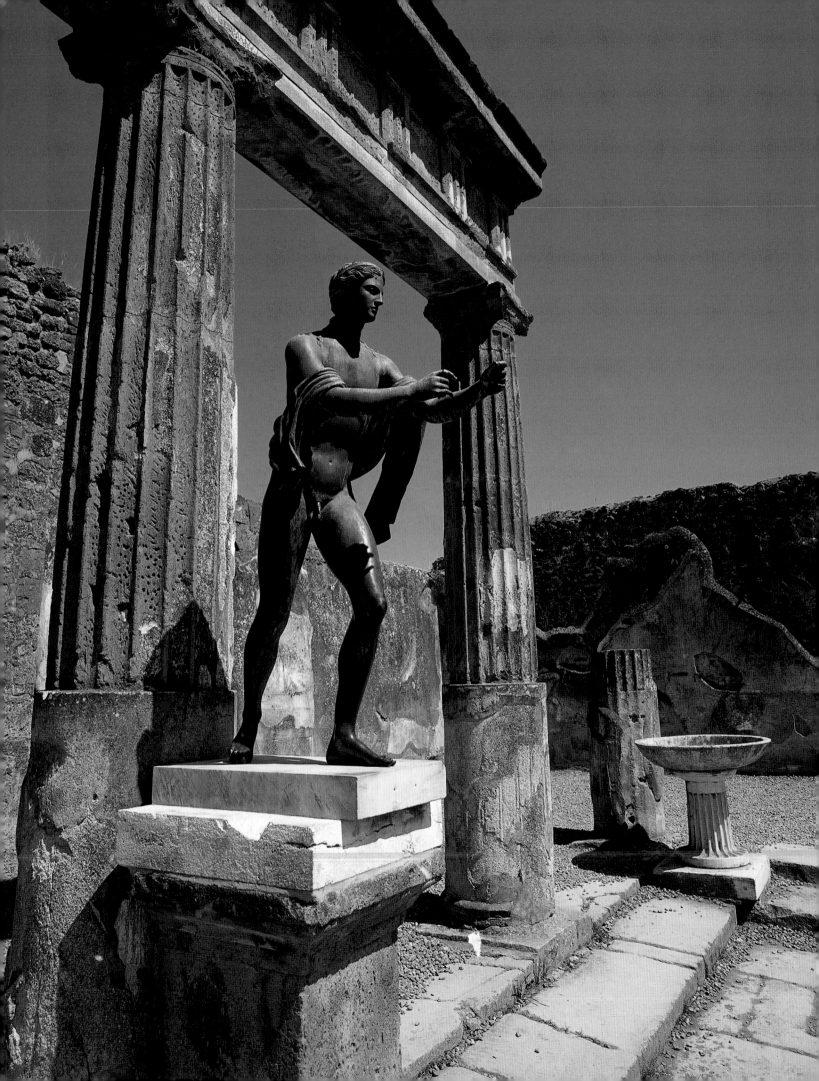

INTRODUCTION

LOST, AND FOUND. Destroyed, and preserved. Pompeii encapsulates, more than any other site, a paradox of the survival of the past: catastrophic destruction is the means by which the traces of the past survive to speak to us now. The cast of a human body in death agonies, legible in feature and in gesture, smothered by dust, choked by fumes, frozen rigid by the thermal shock of a pyroclastic flow: in preserving the gruesome fact of death so vividly, the cast also evokes human life most vividly. Pompeii has consequently an exceptional place in the history of archaeology. From the first days of the Grand Tour in the eighteenth century, it has been an experimental laboratory in which we have searched for the secret formula that will enable us to bring the dead to life, to leap in time from the present to the past. Over and above any gain to our knowledge of the ancient world, Pompeii is important for its continuous impact on the modern imagination.

One way of measuring that impact is to look at the passion for classical decoration in the 'neoclassical' country houses of the late eighteenth century. Figures like Robert Adam and John Soane drew direct and specific inspiration from Pompeii – Soane even brought back fragments of Pompeian plaster as colour matches for the 'Pompeian red' of his home in London, now the Soane Museum. 'Pompeian' became synonymous in the eighteenth-century mind with Roman interior decoration. Thus, when Penrose and Crace designed a room at Ickworth House in Suffolk that precisely reproduced the published drawings of the decoration of a house excavated in Rome in 1777 at the Villa Negroni, it did not seem unnatural to call it the 'Pompeian' room. Pompeii could even eclipse the capital in the public's imagination.

But the impact did not stop short with the aristocrats who made their Grand Tour and brought back mementoes to their country houses. Already the nineteenth century brought an expansion in the social range of travellers, and the 'Mediterranean passion' established its tenacious hold on the northern European mind. Even those who could not travel experienced Pompeii vicariously through publications. Sir William Gell (supported by the artist John P. Gandy) reached a wide public with his enormously successful *Pompeiana*, not one but two publications that vividly described in word and image the latest excavations (those up to 1819, and those from 1819 to 1827). His beautiful engravings, matched only by those of his French contemporary, François Mazois, not only recorded the current state of the monuments, but sought to reconstruct their original state. The reader could look into a 'real' image of an ancient house. Among those whose imagination was fired was Edward Bulwer-Lytton (Lord Lytton), a popular novelist.

The portico of the Temple of Apollo, where the bronze statue of the god reaches towards the Forum, bringing a sense of enlightenment to the city.

His book *The Last Days of Pompeii* (1834) rose to the challenge of imaginatively reconstructing the human and social foreground to the reconstructed antiquity. Lytton's novel was a runaway success, proliferating ever more popular forms of recreation of antiquity: theatrical performances ('Vesuvius erupts every night'), and novelty shows with fireworks, in which scenes from Lytton's novel were enacted before a pyrotechnic recreation of Vesuvius.

Gell and Mazois saw their role as primarily one of documentation; the element of reconstruction was only a matter of filling out an already visible image. But they in turn stimulated the imaginations of other artists. The most conspicuous proponent of this late-nineteenth-century fashion in England was Sir Lawrence Alma-Tadema. From his first visit to Pompeii in 1863, he built up a repertoire of images of the intimate detail of Roman material culture – textures, furnishings and decorations. His scenes from Roman baths and houses are exceptionally learned in their references to archaeological evidence, but strain to bring 'alive' a lost world in its sensuous detail. The line of inspiration leads directly from Gell, Lytton and Alma-Tadema to the new medium of the twentieth century: film. Here too, Pompeii was irresistible for its challenge to bring the lost world alive with the new sense of realism offered by the moving image. By the end of the twentieth century, new computer technologies of virtual reality had only further fuelled the desire to make a world of two millennia ago seem present and accessible to our imaginations. The frozen image of death seems to inspire an irresistible desire to lean out and touch the past: it makes Pygmalions of artists of every medium, so in love with the fleshy texture of their recreation as to believe it will reanimate and reciprocate their affection.

The visitor today is in a real sense the heir of the Grand Tourist. The Bourbon kings built their palace at Portici as part of a deliberate strategy to attract the tourist southwards. Sir William Hamilton is the 'patron saint' of all tour operators: by his incessant cultivation of ties with the local authorities, his collection of antiquities, explorations of Vesuvius and of vulcanology, publications, entertainment of visitors, patronage of artists and re-enactments of Antiquity through the 'attitudes' of his striking second wife, Emma, he vastly promoted the interest of his fellow countrymen in southern Italy, and laid the basis of British study of antiquities in the British Museum. The archaeology of Pompeii and Herculaneum grew and prospered in the context of a nexus of political and economic interests. Each new regime grasped and exploited the potential gains of the excavations in their ability to dazzle the world: the French, under Murat (who prudently expropriated for the state all the fields that covered the ancient townscape of Pompeii), the new national government of Garibaldi (who found in the superintendent of Pompeii, Giuseppe Fiorelli, a staunch supporter) and, in unbroken continuity, the fascist regime of Mussolini.

The fascists invested unparalleled sums in the excavations, exposing most of the south-eastern quarter of Pompeii, and launching in earnest for the first time the 'open' excavation of Herculaneum, until then explored only by subterranean tunnels. The investment was proved by events to be a good calculation economically: the postwar boom of tourism to the Bay of Naples, stimulated by the possibilities of air travel and package holidays, brought visitors in unprecedented numbers. Today the annual count of visitors to Pompeii (or at least those who come on site furnished with a ticket) exceeds two million. The importance for the local economy, above all for the hotel trade of Sorrento and the Amalfi coast, is massive. But the very phenomenon that brings a boom elsewhere has brought a fundamental crisis for the ancient remains themselves.

Mass tourism, unlike its princely forebear, brings tens of thousands of feet every day to trample delicate pavements and mosaics, a constantly fluctuating atmosphere as each batch of visitors brings warm, damp breath into cool dark rooms, a bombardment of camera flashes and, only too often, less subtle assaults: fingers touch the fragile surfaces and knives seek to scratch records of a fleeting and unthinking presence. It is easy to lament the damage, far less easy to know how to manage the problem. Again, Vesuvius has trapped us in a paradox: the growth of international interest in Pompeii has caused it to be excavated, yet the same wave of `attention threatens to overwhelm it. But even if the public were denied their right to see, the problems of conservation would remain awesome. Of the 165 acres enclosed by the town walls, 110 have been excavated, uncovering a dense texture of streets, public buildings, houses, shops and workshops. The majority of these structures were preserved up to a height of 10–12 feet by the blanket of ash and pumice pellets that fell within the first twelve hours of the eruption. We are looking at thousands of units of habitation and other activity, with tens of thousands of rooms and hundreds of thousands of wall and floor surfaces, a surprisingly high percentage of which were originally decorated in some form or other. How can any organization or authority preserve such a vast quantity of material? How can a city live and repair itself without the presence of the citizens themselves?

Choices have to be made, and the history of the excavation of the city is also the history of experimentation in how to present the findings appropriately to the public. The Bourbon kings had the finest frescoes and mosaics hacked off and carried back to their palace/museum, along with statuary and other precious objects. They guarded them jealously – so jealously that at first they had all 'doubles' destroyed for fear that any other collector should lay hands on material as fine as their own. Only from the end of the nineteenth century, after over a hundred years of 'open-cast mining' at Pompeii, did the idea take hold that it was better to reconstruct the lost roofs of the houses and to make them a 'museum in the open'.

For most of the twentieth century, it was assumed that the Bourbon approach was an act of vandalism, and the new style an act of responsible conservation. But the site has proved very far from safe. It has been exposed to incidents of catastrophic damage, including a sustained aerial bombardment by the Allies in 1943 and ongoing seismic activity of the volcano, especially in 1980. On top of that is a daily damage that takes place through the inevitable agency of the elements: sunlight bleaching frescoes, rain penetrating roofs and running down surfaces, damp rising from floors, and the continually corrosive action of a fierce climate that fluctuates between extreme heat in the summer to extreme cold in the winter (when Vesuvius is often capped with snow). This has been compounded by unsuccessful experiments in conservation. In the mid-twentieth century, the new technology of reinforced concrete seemed to offer a sound way of rendering crumbling ancient structures more robust. But iron

Bacchus and Ariadne (left) and Perseus and Andromeda (right) against a 'Pompeian red' background, in a Fourth Style fresco in the House of the Vettii.

armatures have rusted, splitting open the concrete beams and causing the collapse not just of the modern restorations, but of the ancient structures themselves. Application of modern mortars to ancient frescoes has precipitated damage by salts and the smearing of painted surfaces with paraffin wax or, even more recently, paraloids has prevented the plaster from breathing and destroyed what should have been protected.

In consequence, the story of Pompeii is not just of the instantaneous death of a city, but of a second, ongoing, destruction. Walk through the site from the northwest (where excavation started in 1748) to the southeast (where the postwar excavations finished), and you can read in the degree of degradation the history of our failure to keep Antiquity alive. The frescoes in the museum at Naples turn out, in the end, to be the lucky ones.

What is the proper response to this ongoing crisis? One answer, indeed the traditional one, is to say that we need to continue digging to keep fresh evidence before our eyes. Many visitors marvel to hear that one third of the site is still to be uncovered. The press, like the visitor, craves novelty: why not hasten on with new discoveries? Indeed, archaeological technique has been revolutionized since most of the excavation was done. We can now read an intimate history of daily life from analysis of bones and pollen spores. We can tell the exact composition of the grasses in the hay a donkey ate from the remains left in its bowel. We have learnt not simply to shovel the volcanic material away to expose underlying structures, but to peel it off gradually, with a minute attention that can expose the exact dynamics of the moments of destruction and collapse. In this sense, archaeological science strives more effectively for the 'reality effect' that Pompeii also provokes in the imaginative arts. Surely we have it in our power now as never before to 'bring Pompeii back to life'.

We do, but the power to give life is also the power to destroy. We know that whatever we expose must join the queue, built up over two and a half centuries, of remains that fade, crumble and disappear. The supply is not infinite, but limited like any other resource on the planet. We must consume our ancient ruins, like all else, in a way we can sustain. The problem is not limited to Pompeii. All over the world, awareness grows that the heroic days of archaeology, which unearthed whole cities and civilizations, have left a legacy of conservation problems that no government can afford (or at least is willing) to finance. Again, we must make choices. We cannot preserve everything as if in aspic. We cannot even intervene to protect the ancient remains without in some ways compromising them. The best we can do is to seek a balance that acknowledges competing interests: not only the tourists, the local economy, scholarly research, the press and television, but also the obligation to hand down a unique cultural legacy to future generations that may prove more skilled than ourselves in reading and interpreting it.

Perhaps the most urgent need is to stem the loss of knowledge. Houses collapse before they have even been studied, photographed and documented adequately. Since the number of experts is limited, they must prioritize study of older excavations against newer ones. Nor should we assume the interests of scholar and tourist are in conflict. The tourist's appetite for understanding is excited by the visit; but little information is on offer. Not only should the visitors be better informed about the ancient Romans, and what the remains say about their lives, they should also learn just how fragile are the ancient traces at which they are looking, and that they have the power either to conspire to destroy or help to preserve. We need to explore means of disseminating better information, including the power of the Internet.

The present publication is sponsored by the World Monuments Fund. The conservation of a precious past is at the heart of its agenda. In reading this book we can acquire a clearer vision of how precious that past is; its sales will contribute to preserving the past as an enduring legacy for the future.

Andrew Wallace-Hadrill
The British School in Rome

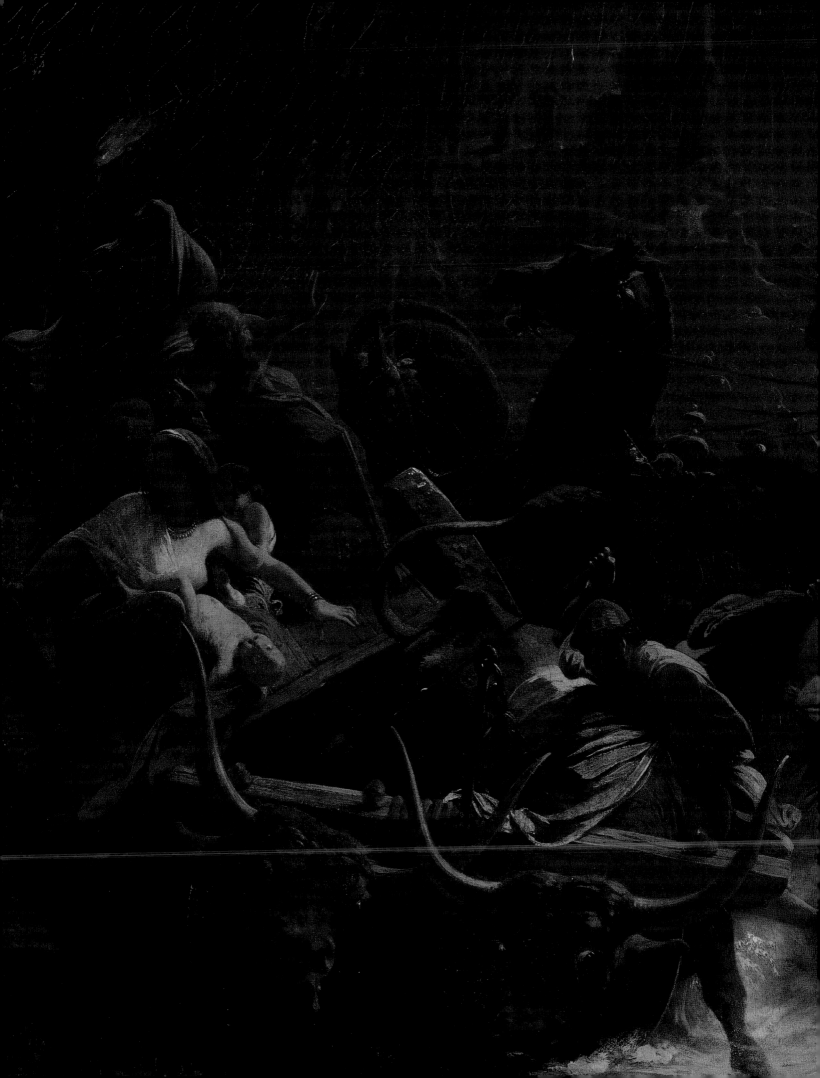

THE CITY VANISHES

IT IS A STORY THAT COULD HAVE BEEN TAKEN from the pages of today's newspapers, a disaster of epic proportions: trails of refugees fleeing the destruction, failed attempts to rescue those trapped amid the devastation and the obliteration of untold lives and property. The eruption of Vesuvius and the consequent destruction of Pompeii and the nearby town of Herculaneum on 24–25 August AD 79 sent shockwaves across the ancient world. Prestigious writers and commentators penned eyewitness reports and poets lamented the tragedy and its victims:

> We had scarcely sat down when a darkness came that was not like a moonless or cloudy night, but more like the black of closed and unlighted rooms. You could hear women lamenting, children crying, men shouting. Some were calling for parents, others for children or spouses; they could only recognize them by their voices. Some bemoaned their own lot, others that of their near and dear. There were some so afraid of death that they prayed for death. Many raised their hands to the gods, and even more believed that there were no gods any longer and that this was one last unending night for the world.[1]

> Here is Vesuvius, only yesterday covered still with greenery and shaded by vineyards from which the most savoury wines once flowed like rivers. Here is the mountain that Bacchus preferred even to the hills of Nyza, where satyrs were wont to dance. Such was Pompeii, the city sacred to Venus, dearer to her heart than Sparta itself. And here was the proud town of Herculaneum, named in homage to the great hero. Yet all lies wretchedly engulfed in flames and ashes. The gods themselves wish today that such a thing might have been beyond their power to perpetrate.[2]

PREVIOUS PAGES Henri-Frederic Schopin's (1804–80) painting *The Last Days of Pompeii* gives a nineteenth-century view of the disaster, relishing the drama with a real sense of theatre.

BELOW Vesuvius overshadows the panorama of the Forum. At the heart of the city is a long narrow space framed by a two-storey Doric colonnade which brings an architectural order to the area between the Temple of Apollo and the Triangular Forum.

While Pliny the Younger's harrowing account of the eruption described the plight of those caught up in the confusion and terror of the events, the poet Martial's words expressed the shock and sorrow of the Roman empire as it tried to grasp the sheer enormity of the catastrophe. The fallout swiftly covered neighbouring villages, towns and resorts, and even reached the capital, Rome. Dio Cassius described in his *Roman History* that residents could see and smell the acrid clouds of ash emanating from the smouldering epicentre to the south in Campania.[3] As the sky darkened above the imperial city, many believed that the end had come. The darkness lasted for several days, terrifying the populace. Reports came through that the ash was being carried as far as Egypt and Syria and news of the tragic events filtered into the provinces of every corner of the empire. Soon the whole world seemed spellbound in the story's morbid thrall.

In the days and weeks following the eruption of Vesuvius many of the survivors of Pompeii returned to be confronted by an eerie and unfamiliar landscape, a smouldering ground zero where their homes and lives had once been. Columns of temples and broken walls of houses jutted out of the ground, creating the appearance of a vast graveyard marking a world that had vanished beneath the ash. Even after the volcano had fallen silent and the fires burnt themselves out, the site remained a treacherous one for those seeking the remains of their homes and possessions.

The mourning residents of Pompeii were joined by teams of relief workers led by ex-consuls sent from Rome, on the direct instructions of the emperor Titus, to assess the damage and to recover anything of substantial value. Titus even went so far as to appropriate the property of those known to have perished to use as funds toward the relief efforts.[4] At first this was seen as a preliminary stage of a future rebuilding of Pompeii. This idea was later abandoned, however, once the extent of the destruction was fully understood.

The people fled: some from the houses into the streets, others from outside into the houses, some from the sea to the land and some from the land to the sea; for in their panic they regarded any place where they were not as safer than where they were.

DIO CASSIUS,
ROMAN HISTORY LXIV.22

ASHES TO ASHES

Gangs of salvage workers set to work immediately, beginning with the public buildings and temples, removing statuary and marble veneers. They were so efficient that the triumphal arches of the Forum were laid bare and the entire stone backdrops (*scaenae frons*) of the two theatres were stripped down to their brick structure. The job was made easier in the vaults of some of the larger public buildings that had held, such as the markets and courts of the Forum and the Stabian Baths, allowing property to be removed. Also, many of the fine statues of the Forum had been stored together in a warehouse, making their recovery simple. Since the area had been undergoing restoration at the time of the eruption, all the workers had to do was locate the warehouse to recover all of the statuary for shipment back to Rome or other locations in the region.[5]

Alongside the government-supported relief efforts, private citizens who had located their homes also began excavations to recover jewellery or gold left behind during the evacuation. Looters, skilled at seeking out and digging for buried treasure, also joined in the general scrabble for the recovery of buried wealth. Evidence of their labours was discovered by later archaeologists at the House of the Dioscuri, the Villa of the Mysteries and the House of the Lovers. They found tunnels that had been dug through the volcanic ash, running the lengths of houses and cut through walls; occasionally they came across the body of a hapless treasure hunter, crushed when a building or tunnel collapsed on top of him.

Eventually, the recovery missions ceased. Government teams finished their work and survivors built new lives in other cities and towns. Pompeii was virtually abandoned. A few die-hard residents lived on among the ruins briefly, still searching for lost possessions and lost lives, unable to break with the past. Pompeii lay plundered and buried; her ancient families had been dispersed and her purpose had been decimated. Time and rain hardened the layers of pumice and ash, making continued excavations increasingly difficult. Soon vegetation began to cover the site and neighbouring fields once again began to be farmed. Within a century the ruined city no longer appeared on regional maps and was simply a ghostly crossroads marked 'Civitas' – meaning little more than 'settlement' – on the way to Nocera or Sorrento. Pompeii had vanished into history.

Pompeii, a city of 20,000 inhabitants at the time of the eruption in AD 79, had been developing for over a thousand years. It began its long history as a large mound used as a necropolis for the adjoining Bronze Age settlement now referred to as Sant'Abbondio. The region in which this and other settlements grew was ideal. The Nola flood plain through which the River Sarno flows is rich and fertile: ideal for farming and also for trade, as at that time the river was navigable with access to the sea.

Strangely enough, Pompeii's earliest phase also ended with a devastating eruption of Vesuvius, in about 1360 BC. The eruption apparently wiped out the settlement in the area, although the site shows evidence of reoccupation after 1000 BC. The site of the future city of Pompeii continued to be an attractive place for settlement; it was the largest plateau in the region, commanding a superb position above the mouth of the River Sarno. This afforded control over river traffic throughout the valley and access to the Bay of Naples.

Urbanization of the area did not begin until the sixth century BC. At this time, Pompeii stood at the border between two powerful cultures: the Greeks and the Etruscans. While the coastal towns of the entire Bay of Naples had been imbued with Greek culture, the inland towns had fallen under the influence of the native Etruscans. It is difficult to say who actually controlled the settlement at Pompeii at this time, but there are suggestions that it had a mixed population, with Greeks, Etruscans, Oscans and possibly other groups residing alongside each other. While the major architectural achievements of this period – the Temple of Apollo and the Doric Temple, most likely dedicated to Heracles and Athena, in the Triangular Forum – are decidedly Greek in appearance, a large number of Etruscan *bucchero* ceramics and materials were found, giving further evidence to the theory of a cultural amalgamation.

The great sweep of the Bay of Naples looking towards Vesuvius still has all the aquamarine beauty that perpetually inspires artists.

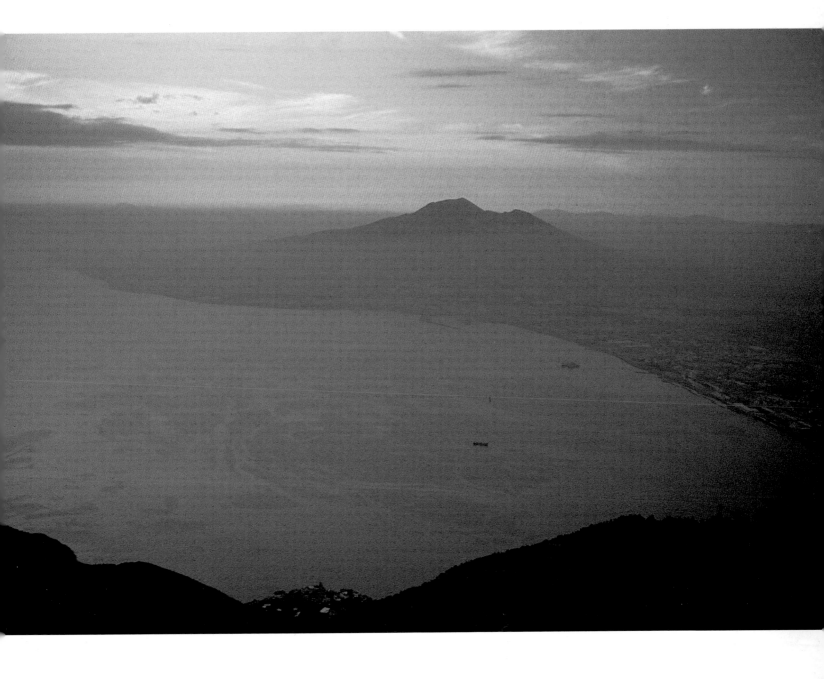

This unusual situation is also believed to have influenced Pompeii's name. There is speculation that Pompeii derives from an Oscan word meaning 'five', referring to five ethnic populations living on the site or in the region;[6] others, however, argue that it comes from the common Roman name Pompeius.[7]

The cultural mix of the sixth and early fifth centuries BC was shattered at the Second Battle of Cumae, which effectively gave the Greeks hegemony over the coast of the Bay of Naples. But as the Greeks concentrated solely on seafaring, they left a power vacuum further inland which was quickly filled in the late fifth century by the Samnites, who swept down into Campania from their Apennine fortresses. During this turbulent period, Pompeii continued to expand and be

Now in the National Archaeological Museum in Naples, this wall painting from the first century AD depicts ships in an architectural fantasy that could be an idealized view of the harbour at Stabiae or Puteoli.

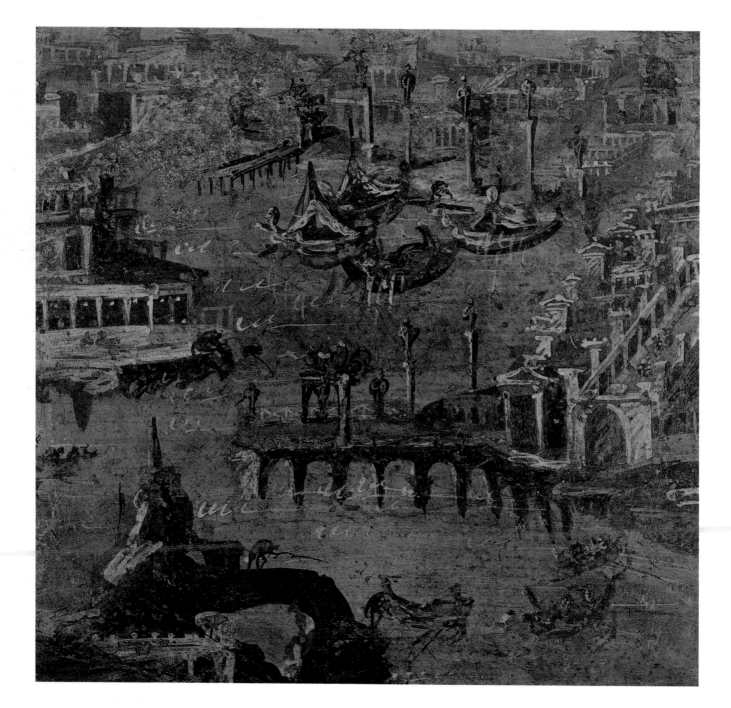

reinforced through the construction of a defensive wall of *lava tenera* – solid lava – faced with limestone. The placement of the gates of the city inside suburban areas during this period indicates that Pompeii had become an Oscan city in a larger Samnite confederation which would grow to include Herculaneum, Surrentum (Sorrento), Stabiae (Stabia) and Nuceria (Nocera).

Throughout this Samnite period Pompeii experienced further stabilization of its urban fabric with the establishment, by Samnite communities, of blocks of buildings. Pompeii also makes its historic début into written history at this time. The city is mentioned by the historian Livy as the landing point of a Roman fleet in 310 BC during the Second Samnite War.[8] Following the Samnite Wars a strategic alliance was established between Nuceria, Pompeii's ally, and Rome.

During the First Punic War (264–241 BC), the Bay of Naples became the centre of a huge war effort to build fleets for the Roman navy. Pompeii, being a navigable port, is assumed to have profited by this upsurge in business, and the town expanded accordingly to greet the influx of tradespeople and ship builders. The city escaped the devastation of Hannibal, which befell Nuceria and Nola in the Second Punic War (218–202 BC), and remained loyal to Rome. After this conflict, Pompeii flourished. During the second century BC Pompeii matured sufficiently to become a force in itself, allied to, yet not so much dependent upon its neighbours.

By the end of the second century BC the city boasted a colonnaded forum with a monumental Temple of Jupiter. These impressive structures were followed by the building of the Macellum – a meat and fish market – and the Basilica, where all municipal business was decided and carried out. City fathers also began a substantial redevelopment of the Theatre District, including the conversion of the oldest part of the city, the Triangular Forum, into a city park. This brought an element of culture that hitherto had not existed. The city's wealthy families began to construct magnificent mansions in the northwest corner of the city, among them the House of Sallust, the House of the Faun, the House of the Large Fountain and the House of Pansa.

With the success of the regional cities of Campania resentment grew over the rights of the inhabitants to become Roman citizens. Rome had consistently refused such requests and continued to deny non-citizens certain legal and economic privileges. Pompeii was among the cities who felt that her loyalty to Rome during the Punic Wars was underappreciated by the Romans. Resentment turned to anger and anger to action – a revolt, referred to as the Social War of 91–88 BC. Pompeii took a leading role in this rebellion, encouraging the Samnite general Gaius Papius Mutilus to seize the Campanian heartland, which he did by conquering Nola, Surrentum and Stabiae. Pompeii suddenly became a regional power. This, however, did not last.

The Romans recovered from their early losses and marched into Campania to retake what had been lost and crush the rebellion where it had begun. The Roman general Aulus Postumius Albinus began to lay siege to Pompeii in 89 BC. However, his men mutinied and hanged him, after which Sulla took charge of the operation, setting about the reduction of Pompeii through starvation and bombardment. Evidence of this siege can be seen today at Pompeii in inscriptions in Oscan giving directions to local militiamen of where to assemble in case of an assault. It seems that Pompeii held with the assistance of Lucius Cluentis, whose attempted raising of the siege was repulsed. Sulla decided that he could make further

The Tower of Mercury surveys the street near the city gate leading to the road to Herculaneum. The Tower still carries the damage done by Sulla when he besieged the city in 89–88 BC.

BELOW A constant supply of fresh water from the aqueducts fed tanks, fountains and swimming baths throughout the city.

BOTTOM The two-storey Forum colonnade brought imperial marble grandeur to the city centre.

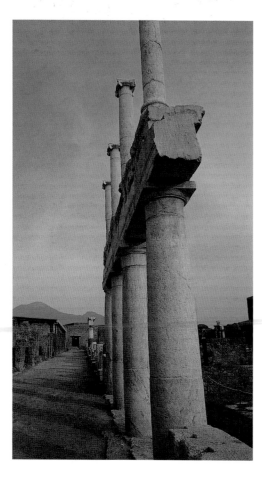

advances elsewhere and abandoned the siege to move on to Hirpini. The historian Appian, writing in the second century AD, mentions these episodes of the siege and Sulla's campaign. Pompeii remained defiant and relatively unscathed until the close of the war, which ended after the fall of Asculum to Pompeius Strabo.

Although the rebellion did achieve Roman citizenship for all Samnites, Pompeii paid dearly for her involvement. The city was forced to endure the humiliation of colonization by Roman veterans of the war. Pompeii's oldest families were disenfranchised and portions of their property holdings were seized as compensation. Latin was made the official language and a new Roman municipal organization made up mostly of colonists was imposed to govern the city. The colonization of Pompeii after the Social War essentially became its Romanization, sweeping away its old government and ruling families and introducing the traditions of Rome which would remain in place until the city's destruction.

As time passed the new colonists settled in and began to intermarry with the older families and embellish the city with the new wealth that they produced. Lavish houses such as the House of Marcus Obellius Firmus and the House of the Silver Wedding appeared during this period of colonial ascendancy. Large civic projects were also undertaken with the restoration of the Stabian Baths and construction of the Forum Baths as well as the completion of the Theatre District and the jewel in the crown: a 20,000-seat Amphitheatre. The new rulers also brought with them new deities, building a temple to Venus and renaming the city *Colonia Cornelia Veneria Pompeianorum*, 'Pompeii, City of Venus and Cornelia'. The hills around Pompeii soon became dotted with grand villas built by Pompeians and Romans alike. Among the Romans who had a holiday home at Pompeii was the famous orator Cicero.

The dawn of the Roman empire began to heal many of the old wounds left by the Social War. Julius Ceasar's pardon of 49 BC initiated the process of reintegrating Pompeii's old families into the political life of the city. At the same time new arrivals loyal to the imperial order also filtered into the city and mixed with the rehabilitated Pompeian aristocracy. The Augustan age that followed ushered in an era of social mobility where freedmen – slaves who had bought their freedom – began to assume a larger role in the public affairs of Pompeii and participate in a growing middle class.[9] High offices and administrative posts became open to freedmen, and their children began to marry into the more established families of the city. This mixture of old and new blood produced a dynamic class that set out to enhance further the city and bring it in line with the new imperial age.

Buildings were enlarged and refaced with marble and travertine, and new statuary adorned public buildings and meeting places. Buildings such as the Temple of Augustus, the Temple of Fortuna Augusta and the Eumachia were all built to celebrate the imperial cult of Caesar Augustus, emperor of Rome. Luxurious new athletic facilities were also introduced near the great Amphitheatre with a massive gymnasium and swimming pool, which attested to the growing interest in public spectacles and games. Perhaps the greatest achievement of the early imperial era was the construction of an aqueduct, which brought running water to Pompeii. Soon fountains proliferated throughout the city, adorning the finest of homes and the public squares and baths.

At the height of its glory and grandeur during the reign of Nero, Pompeii was one of the largest cities in the empire with a population totalling 20,000, double

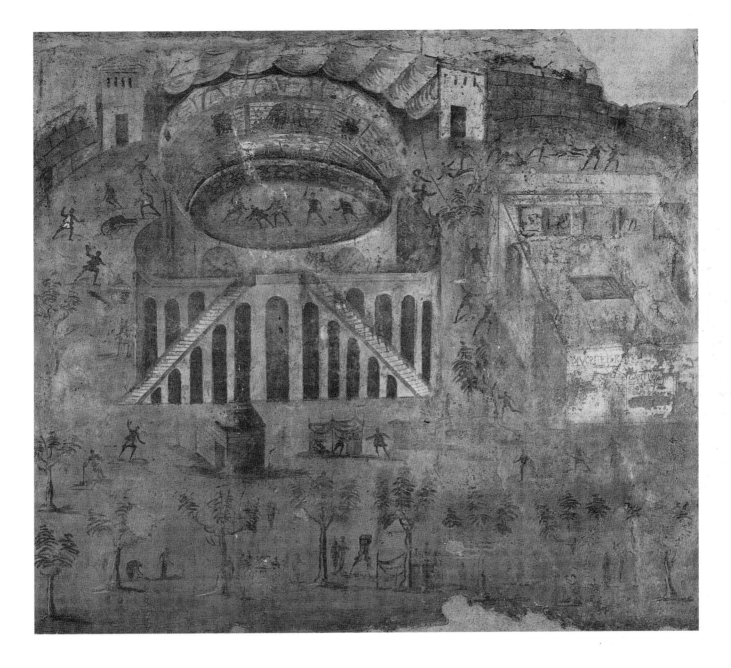

the population of most provincial Roman cities. With this growth came rivalry with its neighbours. Pompeii's rivalry with Nuceria – its traditional protector and ally – flared up in an episode that would reach the marbled halls of the Senate in Rome. In AD 59 Pompeii hosted games in its Amphitheatre at which a large group of Nucerians were present. During the games a brawl broke out which quickly turned into a riot. Weapons were drawn and many people were killed or wounded. The riot had to be put down by the local militia before the crowds dispersed. The Nucerians, seething because they had been attacked, appealed to Rome for justice against the perpetrators and the city. The Roman Senate handed down a judgment forbidding the holding of such games for ten years, and some of the games' organizers were exiled.[10]

Pompeii's disgrace in this sordid episode has been overshadowed in history by another event: a disaster from which the city was still recovering when

This first-century AD Roman fresco, now in the National Archaeological Museum in Naples, gives a vivid account of the famous riot of AD 59, in which violence spilled out into the surrounding streets.

An everyday streetscape with a bustling concentration of houses and shop fronts on the Via di Nola.

AUGUST AD 79

Vesuvius erupted seventeen years later. On 5 February AD 62 Pompeii was at the epicentre of an earthquake whose catastrophic effects nearly levelled the city. Seneca, in his *Questions on Natural History*, described the horror of the earthquake which devastated the region including the cities of Herculaneum, Nuceria and Naples:

> What hiding place will creatures find, where will they flee in their anxiety, if fear arises from below and is drawn from the depths of the earth? There is panic on the part of all when buildings creak and give signs of falling. Then everybody hurls himself headlong outside, abandons his household possessions, and trusts to his luck in the outdoors.[11]

Pompeii suffered immensely in the days that followed. The majority of the houses had been made uninhabitable and the city's proud Forum lay in ruins. This seismic activity was well documented in Pompeii: damage caused by the earthquake to some of the town's monuments was recorded on a bas-relief found in the House of Lucius Caecilius Iucundus. However, Pompeii was not defeated. The citizens' horror at seeing all that they had built and accomplished destroyed soon gave way to a stronger civic pride and a determination to rebuild the city. Pompeii began a rebuilding effort unparalleled in the region. Demolition teams cleared away the rubble and engineers drew up a master plan and programme for rebuilding which assigned priority to public buildings and services. Even the emperor Nero contributed to the effort, although after the great fire in Rome of AD 64 fewer resources could be spared.

Pompeii became a massive building site with houses, temples and public buildings all under construction or restoration. Shortages of workers and craftsmen meant that many residents had to wait for long periods, even years, before help was forthcoming. This led to some crude repair jobs which were still unresolved at the time of the eruption. The rebuilding of Pompeii was a slow process and the city also underwent profound changes; once grand houses were vacated by their owners for villas in the countryside and converted into workshops and commercial ventures or broken up into smaller flats. The Via dell'Abbondanza saw an increase in small shops and industries. Pompeii had been humbled, but not broken, and was back in business soon after.

Seventeen years after the great earthquake life had returned to normal for the citizens of Pompeii. The reconstruction efforts still continued, but the new building projects had been completed and, by all appearances, the city was prospering. Pompeians went about their daily routines, buying and selling, building and restoring, governing and performing. Sacrifices were being made and bread was being baked as the long hot Campanian summer settled in. The month of August, however, began with a small earthquake.

This earthquake did little damage and most took no notice. Campania was a seismic region and the people were used to small tremors from time to time. A few people noticed that some wells had dried up and that certain springs were no longer flowing. The more suspicious claimed that these were omens, signs that the gods were displeased. Yet these were minority opinions and most scoffed at such a suggestion.

On 20 August the tremors began once again. This time the sea became restless, with larger waves than was normal for the Mediterranean. People noticed that animals were becoming agitated, and yet nothing seemed odd or out of order. The sun still beat down on the streets of Pompeii. Pompeians took refuge on the shady sides of the streets or in the cool atria of their homes while being soothed by the sound of trickling water from the fountains.

Four days later Vesuvius awoke. On the bright morning of 24 August, just before noon, a small explosion rocked the countryside below the mountain. Although it is likely that this initial flare-up alarmed the local farming communities, there is no evidence that the population of Pompeii viewed it as anything other than a natural curiosity. There is no evidence either that any organized evacuation of the countryside or the city had begun at this point.

Suddenly, in the early afternoon, Vesuvius blew open, shooting a column of tephra – dust, smoke and pumice – nearly 17 miles into the air. It was soon afterwards that Pliny the Younger with his uncle Pliny the Elder first viewed the great cloud, from across the Bay of Naples in Misenum:

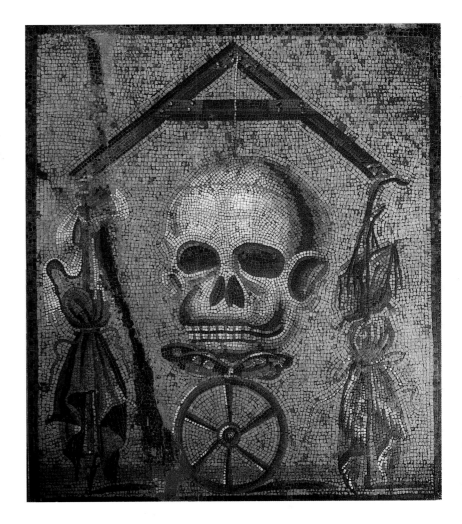

'Death equalizes all': a complex symbolic mosaic, now in the National Archaeological Museum in Naples, from a workshop in Pompeii. Beneath the skull are a butterfly, symbolizing fragility and a wheel, symbolizing fortune, while a builder's spirit level balances, on either side, a royal sceptre and purple robe and a beggar's stick and rags.

> He was at Misenum in his capacity as commander of the fleet on 24 August, when between two and three in the afternoon my mother drew his attention to a cloud of unusual size and appearance. He had had a sunbath, then a cold bath, and was reclining after dinner with his books. He called for his shoes and climbed up to where he could get the best view of the phenomenon. The cloud was rising from a mountain – at such a distance we couldn't tell which, but afterwards learned that it was Vesuvius. I can best describe its shape by likening it to a pine tree. It rose into the sky on a very long 'trunk' from which spread some 'branches'. I imagine it had been raised by a sudden blast, which then weakened, leaving the cloud unsupported so that its own weight caused it to spread sideways. Some of the cloud was white, in other parts there were dark patches of dirt and ash. The sight of it made the scientist in my uncle determined to see it from closer at hand.

The account of Pliny the Younger remains the most significant description of the events of the destruction of Pompeii handed down from antiquity. Pliny is the source to which historians, archaeologists and vulcanologists have repeatedly turned to shed light not only on the progression of the eruption but also on the reaction of those caught amid the chaos. It is a unique version of events in the form of two letters written to the historian Tacitus, who had requested the

recounting of the tale for possible use in his histories. In the first letter he told the story of the death of his uncle, which he had gleaned from eyewitness reports from slaves and members of his entourage. In the second he recounted his own personal experiences during the events. Pliny thought his own experiences were without interest and his reactions to the eruption unimportant. However, it is they which provide the only first-hand account of the eruption and its effects on other areas of the Bay of Naples.

The huge 'pine tree'-shaped cloud, as described in Pliny's account, is typical of what happens during a volcanic eruption. The plug of dirt and rock blocking the mouth of the volcano is suddenly destabilized under intense heat and pressure from the magma underneath and is rocketed upwards into the sky, after which the material loses its momentum and begins to fall, exactly as Pliny describes. In reference to his account of the eruption of AD 79 vulcanologists call this first phase of an eruption the Plinian phase.

The massive tephra column soon began to shift towards the southeast, directly over Pompeii. This ominous cloud darkened the skies over the city and began to rain small pumice stones, while the continuous rumble of the eruption echoed through the streets. The pumice rain fell hard and fast, creating a layer of rubble all over the city which increased by 5–6 inches per hour. Total darkness engulfed the city and panic ensued. Many took refuge in their homes to escape the constant pelting by the solid rain while others made straight for the roads out of the city, beginning what would later be a mass exodus. Across the bay, Pliny the Elder began making preparations for the navy to assist with the evacuation of the far shore of the bay. His plan was to join up with Pomponianus, one of his friends:

> He ordered a boat made ready. He offered me the opportunity of going along, but I preferred to study – he himself happened to have set me a writing exercise. As he was leaving the house he was brought a letter from Tascius' wife Rectina, who was terrified by the looming danger. Her villa lay at the foot of Vesuvius, and there was no way out except by boat. She begged him to get her away. He changed his plans. The expedition that started out as a quest for knowledge now called for courage. He launched the quadriremes [galley ships with four banks of oars] and embarked himself, a source of aid for more people than just Rectina, for that delightful shore was a populous one. He hurried to a place from which others were fleeing, and held his course directly into danger. Was he afraid? It seems not, as he kept up a continuous observation of the various movements and shapes of that evil cloud, dictating what he saw.
>
> Ash was now falling on to the ships, darker and denser the closer they went, together with pieces of pumice and rocks that were blackened, burned and shattered by the fire. The sea was becoming clogged with stone and debris from the mountain was blocking the shore. He paused for a moment, wondering whether to turn back as the helmsman urged him. 'Fortune helps the brave,' he said. 'Head for Pomponianus.'

While Pliny the Elder was making his way to Pompeii, the pumice continued to fall. When the layer of pumice reached 16 inches, roofs all over the city began to collapse under the weight of the accumulation, driving more residents out on to

the streets to join those already on their way out. Within hours there were few buildings in all of Pompeii which could have been considered habitable. The majority of the population of the city was on the move, fleeing in terror into the darkness, assaulted by projectiles as Vesuvius continued to belch its pent-up rage into the heavens. By this time the column had risen to a height of 20 miles above the city. Meanwhile, Pliny had landed in Stabiae, the closest port to Pompeii. There, he met Pomponianus, who was himself preparing to flee:

At Stabiae, on the other side of the bay formed by the gradually curving shore, Pomponianus had loaded up his ships even before the danger arrived, though it was visible and indeed extremely close, once it intensified. He planned to put out as soon as the contrary wind let up. That very wind carried my uncle right in, and he embraced the frightened man and gave him comfort and courage. In order to lessen the other's fear by showing his own unconcern he asked to be taken to the baths. He bathed and dined, carefree or at least appearing so (which is equally impressive). Meanwhile, broad sheets of flame were lighting up many parts of Vesuvius; their light and brightness were the more vivid for the darkness of the night. To alleviate people's fears my uncle claimed that the flames came from the deserted homes of farmers who had left in a panic with the hearth fires still alight. Then he rested, and gave every indication of actually sleeping; people who passed by his door heard his snores, which were rather resonant since he was a heavy man. The ground outside his room rose so high with the mixture of ash and stones that if he had spent any more time there escape would have been impossible. He got up and came out, restoring himself to Pomponianus and the others who had been unable to sleep. They discussed what to do, whether to remain under cover or to try the open air. The buildings were being rocked by a series of strong tremors, and appeared to have come loose from their foundations and to be sliding this way and that. Outside, however, there was danger from the rocks that were coming down, light and fire-consumed as these bits of pumice were. Weighing the relative dangers they chose the outdoors; in my uncle's case it was a rational decision; others just chose the alternative that frightened them the least.

By midnight on 24 August Pompeii was covered by a layer of pumice over 5 feet thick. Still there were people moving about or trapped within their homes, unable to move through the drifts of fallen debris and pumice. Streams of people were still struggling through the darkness along the roads out of the city. Some made for nearby towns such as Nuceria, Stabiae and Herculaneum, while others headed towards the water, waiting for Pliny's fleet, which would never arrive.

Over twelve hours had passed since the beginning of the eruption, during which Vesuvius had sent vast amounts of ash and debris sailing into the sky in a massive column which had grown enormous and bloated. The region was shaken

The silhouette of Mount Vesuvius looms at the end of the Via di Mercurio. Residents of this street would have fled southwards through the supposed Arch of Caligula, named after the remnants of a bronze statue found at the site.

I sing these words to you, Marcellus, on the Cumaean shore where Vesuvius sends up a broken anger, upwhirling fires emulous of Etna. In a future generation, when crops spring up again, when this wasteland regains its green, will men believe that cities and peoples lie beneath? That in days of old their lands lay closer to the sea? Nor has that fatal summit ceased to threaten. May such a fate avoid your Teate, may madness like this never rouse the Marrucinian hills.

STATIUS, *SILVAE* 4.4.78–86

by earthquakes and electrical storms lit up the night sky, adding to the symphony of terror. Around 1 a.m. the eruption began its second phase, the repercussions of which would seal the fate of Pompeii. After hours of continuous volcanic activity the tight eruptive vent of Vesuvius began to widen, decreasing its support of the column. Vesuvius was also slowly growing weaker and its levels of volatile magma which had built up were now decreasing. The giant column floating over the volcano and Pompeii like some dark Icarus began to collapse under its own weight and descend to the earth. This phase is also known as the Pelean Phase, after Mont Pelée on the Caribbean island of Martinique whose eruption in 1902 followed a similar progress and culminated in a similar result, the obliteration of the island's capital, St Pierre.

The column hovering over Vesuvius and Pompeii did not fall as easily as it did on Martinique. It collapsed in a series of six phases over seven hours. In each phase a portion of the column fell, creating what are known as pyroclastic flows and surges. The first two phases created a pyroclastic surge of volcanic ash and scorching gases travelling at speeds in excess of 60 miles per hour which overwhelmed Herculaneum in a matter of minutes, wreaking havoc and destruction while creating a swathe of death from the town to the shore, where hundreds had sought shelter. This surge was followed by a further flow or avalanche of pumice, ash and volcanic gases, which streamed around the city and down to the shore. At 6:30 a.m. the third phase began with a final surge which crashed down on Herculaneum, completely submerging the town underneath a mass of volcanic debris and mud, sealing it for over a thousand years.

Pompeii at this stage was largely evacuated and unaware of the fate of its neighbours. The city was by now blanketed under 8 feet of pumice, making any movement slow and arduous. At 7:30 a.m. the fourth phase of the collapse suddenly began. Nearly two thousand people were still in Pompeii at that fateful moment, climbing over the mounds of pumice searching for lost loved ones, or carrying loot stolen or recovered from abandoned houses and temples. A pyroclastic surge poured over the city and the intense volcanic gases annihilated the remaining inhabitants. The twisted corpses of these pathetic souls, which would be uncovered during the excavations, were all found along the same narrow stratum of pumice (the lower 8 feet), allowing archaeologists and vulcanologists to study their fate.

Two more phases of pyroclastic surges and flows were to follow, burying Pompeii under layers of pumice and ash. The final phase took place around 8 a.m. on the morning of 25 August, creating a huge radial surge which emanated from the crater flowing out over the Bay of Naples. This spread over a vast area reaching as far away as Stabiae, which received 6½ feet of pumice. Pliny writes of the fate of his uncle during this last phase:

They tied pillows on top of their heads as protection against the shower of rock. It was daylight now elsewhere in the world, but there the darkness was darker and thicker than any night. But they had torches and other lights. They decided to go down to the shore, to see from close up if anything was possible by sea. But it remained as rough and uncooperative as before. Resting in the shade of a sail he drank once or twice from the cold water he had asked for. Then came a smell of sulphur, announcing the flames, and the flames themselves, sending others into flight but reviving

him. Supported by two small slaves he stood up, and immediately collapsed. As I understand it, his breathing was obstructed by the dust-laden air, and his innards, which were never strong and often blocked or upset, simply shut down. When daylight came again two days after he died, his body was found untouched, unharmed, in the clothing that he had had on. He looked more asleep than dead.

The fallout from the eruption covered 25 miles from Vesuvius outwards. Almost every city and town in the region experienced the clouds of ash and the hail of pumice. The darkness that fell spread panic and chaos. Fires started in some places, burning villas and portions of towns. As Pliny explained, it was as if the end of the world had arrived. Of the 18,000 people who escaped Pompeii before the collapse of the volcanic column which dealt the death blow to the town, most are believed to have perished. Recent theories suggest that most of the population of Pompeii were killed during the last pyroclastic surge, as few could have got very far in total darkness, trudging through a hail of pumice on roads crowded with refugees.

In his second letter to Tacitus, Pliny described his own ordeal on 25 August as the fallout from the eruption reached across the Bay of Naples to Misenum where

Terror strikes and the sea boils in this painting depicting the death of Pliny the Elder by Pierre-Henri de Valenciennes (1750–1819).

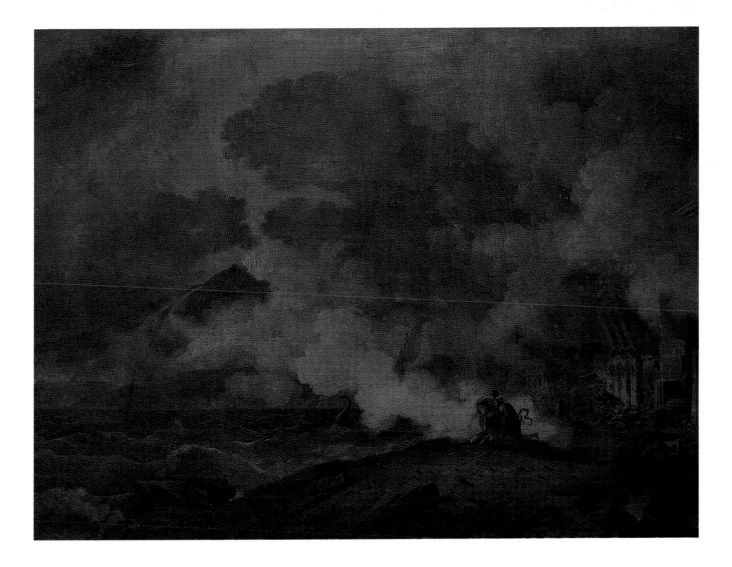

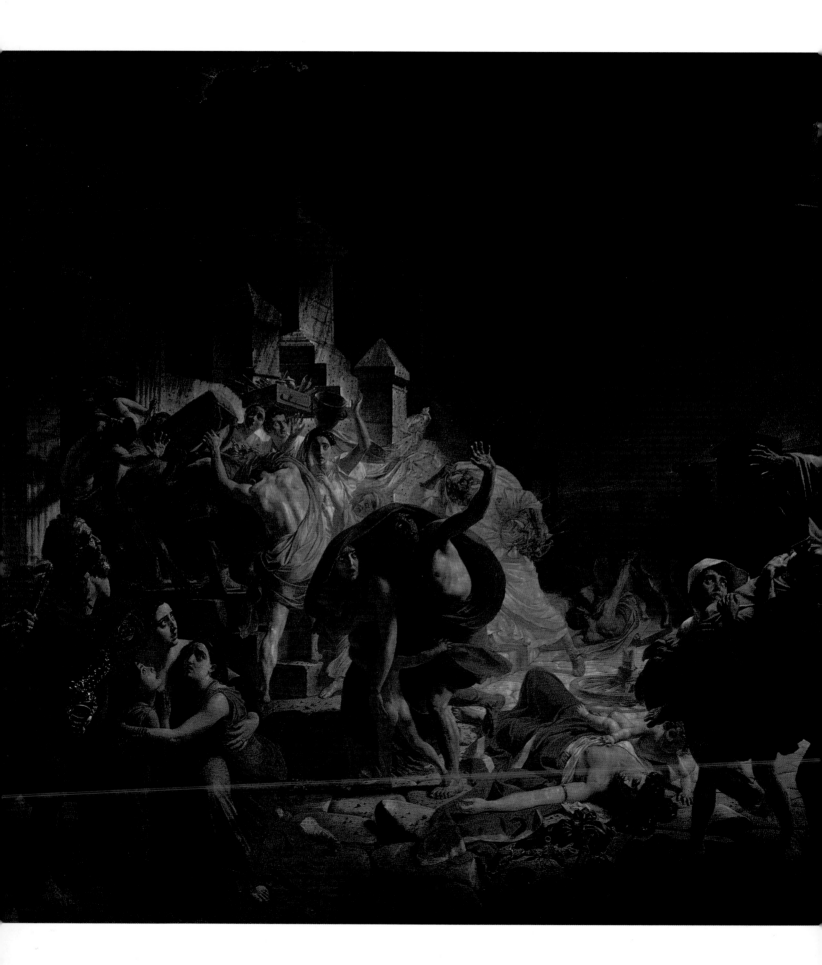

he was staying. Earthquakes shook the town, forcing everyone out into the open, where the terrified crowds witnessed the awesome cloud creeping across the water. Soon the darkness fell and the rain of pumice pelted the fleeing people as they scrambled northwards. Eventually they reached the edge of the cloud of ash which had enveloped them:

> At last the cloud thinned out and dwindled to no more than smoke or fog. Soon there was real daylight. The sun was even shining, though with the lurid glow it has after an eclipse. The sight that met our still terrified eyes was a changed world, buried in ash like snow. We returned to Misenum and took care of our bodily needs, but spent the night dangling between hope and fear. Fear was the stronger, for the earth was still quaking and a number of people who had gone mad were mocking the evils that had happened to them and others with terrifying prognostications. We still refused to go until we heard news of my uncle, although we had felt danger and expected more.

Slowly the darkness gave way to light as the winds dispersed the clouds of ash or blew them northwards and out over the Mediterranean. Like Pliny, many would wait for news that their friends and family were safe, only to learn of their untimely deaths or not hear anything at all. As the reports of the disaster spread, many came from Rome and other cities of the empire to view the extent of the grey wasteland where lush fields, rolling hills and prosperous cities once stood. Herculaneum had disappeared beneath the depths of volcanic mud, which hardened, preserving the city in an amber-like state at the moment of destruction.

Those who could return to Pompeii had little to return to. Everything lay buried: houses, possessions and people. There was little hope in trying to uncover the city and no interest in building a new community over it. After two natural disasters in one century the message seemed clear. So, after all that could be removed easily from the ruins was carted up and hauled away, Pompeii's once crowded streets went silent: a haven only for ghosts and stories.

Doomsday in Pompeii painted with elaborate detail and drama by Bruelow Karl Pawlowitsh (1799–1853). The hellish obliteration that came from above was depicted as divine vengeance upon a pagan city seemingly devoted solely to pleasure.

REDISCOVERY AND EXCAVATION

I stood within the city disinterred;
And heard the autumn leaves like light footfalls
Of spirits passing through the streets; and heard
The mountain's slumberous voice at intervals
Thrill through those roofless halls.

PERCY BYSSHE SHELLEY, *ODE TO NAPLES*

IT IS ONE OF THE GREAT IRONIES OF HISTORY that a small seaside town, which did little to influence its time, would, through its death and rediscovery, become one of the main keys for unlocking the mysteries of the classical world. Wolfgang von Goethe was correct in saying: 'Many disasters have befallen the world but few have brought posterity so much joy.' The story of Pompeii's rediscovery and excavation was as dramatic as that of its destruction. What began as a great treasure hunt ended with Pompeii being considered the principal resource of information about its time, influencing the science of archaeology as well as design and architecture throughout the world. The story is told through the experiences of a cast of colourful characters: princes and rogues, queens and scholars, whose ambition and diligence raised a world out of the ashes.

STOPS AND STARTS

(FOURTH CENTURY TO 1716)

PREVIOUS PAGES The nineteenth century romanticized the joy of archaeology. In *The Excavations at Pompeii* (1865), by Edouard Alexandre, girls in an almost musical procession happily remove the soil from amazing discoveries.

Within a decade of the eruption and the destruction of the city, Pompeii had become the stuff of legend, a tragic story recounted only by survivors and locals. Pompeii was gradually removed from regional maps, appearing for the last time on the *Tabula Peutingeriana* in the fourth century AD. As the centuries passed, farmers would begin to encounter walls, the tops of buildings and occasionally statuary hidden in the earth. The area became known as the Civitas, a vague toponym referring to the ancient obstacles which impeded their work. Pompeii's vast presence beneath the layers of soil and ash was unknown. Local builders sometimes used stones and bricks found at the site, or dug in the vicinity of the ruins in search of precious materials such as marble or gold coins. However, no concentrated effort to excavate the site took place during the early centuries following Pompeii's demise.

Pompeii could not remain hidden for ever. The ash that had covered the city and surrounding countryside had, over time, become a rich black soil perfect for the cultivation of olive groves and vineyards. Campania's agricultural base continued to be productive in spite of the fall of the Roman empire, wars and various occupations. The province was still under intense cultivation in 1504, when the Spanish viceroyalty of Naples was established; it was during the viceregal period at the end of the sixteenth century that Pompeii began to re-emerge from the ashes.

Domenico Fontana, an architect to the court, was carrying out a civil engineering project to divert the waters of the River Foce, a tributary of the Sarno, through the new Sarno Canal, to supply an armaments factory at Torre Annunziata. As part of the canal's construction, Fontana planned to build a subterranean stretch, which was to pass under the Civitas hill *en route* to the

Sarno. Soon the workmen began to encounter slabs of marble and frescoed walls. Further digging produced statues and inscriptions in the strange vernacular Latin of ordinary Romans. Although these were significant finds, Fontana had encountered buried Roman villas elsewhere during his work and did not identify them with any larger urban fabric. Little did he know, however, that his crews had been painfully close to Pompeii's largest structure, the Amphitheatre. Nevertheless for the first time in over fifteen hundred years a noteworthy portion of Pompeii had been uncovered and would not be forgotten.

Nearly a century later, Pompeii made its presence known once more. In 1689, during the sinking of a well, a number of walls with inscriptions were discovered. The find was curious enough to attract the attention of Neapolitan architect Francesco Pichetti, who quickly attributed the inscription *decurio Pompeiis* ('Councillor of Pompeii') to the villa of Gaius Pompeius Magnus.[1] Pichetti's assumptions were questioned by others. Francesco Bianchini from Verona declared that the inscription referred not to the name of a councillor but to the name of the city in which the councillor held office. Giuseppe Macrini, a scholar who was making a study of Vesuvius, carried out some exploratory excavations in 1693. After seeing for himself the ancient walls and

A copy of the fourth-century *Tabula Peutingeriana*, dated 1264, showing Pompeii, Oplontis and Herculaneum.

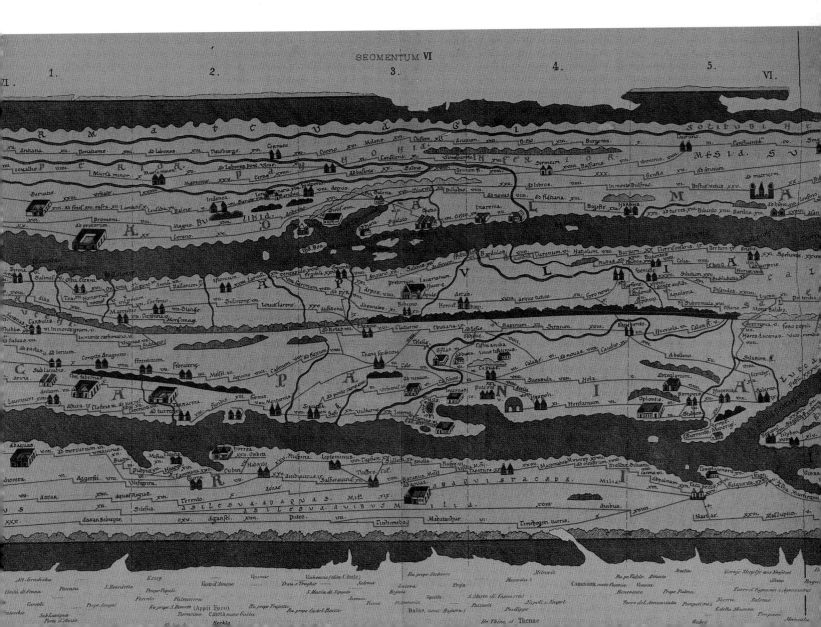

frescoes that had been revealed during an enlargement of the original well, he confirmed Bianchini's hypothesis that the ancient city of Pompeii lay beneath the Civitas. He published his conclusions in his work *De Vesuvio* in 1699. Still, Bianchini's and Macrini's judgments were treated with scepticism by other scholars, who scoffed at the thought of buried cities. No further excavation was undertaken.

A decade later the mocking of Macrini's theories stopped. In 1709, during the sinking of another well at the monastery of Resina to the north of the area where Pompeii lay buried, a workman made a most remarkable discovery. He had struck the upper tier of seats of the theatre in Herculaneum, Pompeii's tragic sister city. Word of the polished marble they extracted from the well quickly reached a local nobleman, Maurice de Lorraine, Prince d'Elbeuf, an officer in the Austrian army now in control of the Kingdom of Naples. He quickly ordered the excavation to be extended. Prince d'Elbeuf was building a villa in the vicinity of the royal palace at Portici and was looking for a cheap source of marble with which to decorate his new home. Thus began the rapacious looting of the only intact theatre remaining from Roman antiquity. For seven years workmen assiduously created a murky and dank labyrinth of tunnels in the solid volcanic mud which wrapped around the structure of the theatre. For years they literally mined the theatre for its marble facing and statuary. On the completion of the prince's villa in 1716 the entrance to the tunnels was sealed and all work ceased at Herculaneum. Pompeii and Herculaneum would have to wait two more decades before their true re-emergence would begin.

THE EXCAVATIONS BEGIN

(1734–63)

In 1734, the Kingdom of Naples was in a state of great transition. Charles III of the Bourbon dynasty assumed the throne of Naples, having driven out the Austrian Habsburgs. Once firmly ensconced on the throne Charles III began exploring his new kingdom and became fascinated by the stories and finds of the tunnels below Resina. Wishing to be seen as an enlightened and cultured monarch, Charles agreed to finance a programme of digging and exploration to search for more classical treasures. To carry out this work he hastily chose a Spanish colonel of the engineering corps, Roque Joachim de Alcubierre. He was chosen for his skills as a military engineer, able to overcome large logistical problems and obstacles such as the digging of tunnels and the commanding of large teams of sappers. However, Alcubierre was not a scholar or an antiquarian and used methods that were crude and destructive, with little attention paid to recording artefacts and discoveries.

Alcubierre set about his work by widening the original well at Herculaneum. Soon, an enormous gaping hole had been formed, plunging 60 feet into the earth. An army of men descended. The original tunnels surrounding the theatre were also made broader and the assault began. Alcubierre next ordered the construction of new tunnels sprouting outwards from the theatre, deep beneath the existing town and into the lost streets of Herculaneum. Workers emerged from the shafts telling stories of the horribly cramped conditions. Water and slime poured from the walls as they hacked at the hardened pyroclastic deposits that encased everything. The only available lights were meagre oil lamps or smoky torches. The feeble light created a world of shadow, which gave ancient statues emerging from the rock the appearance of demons released from Hell by the hapless excavators.

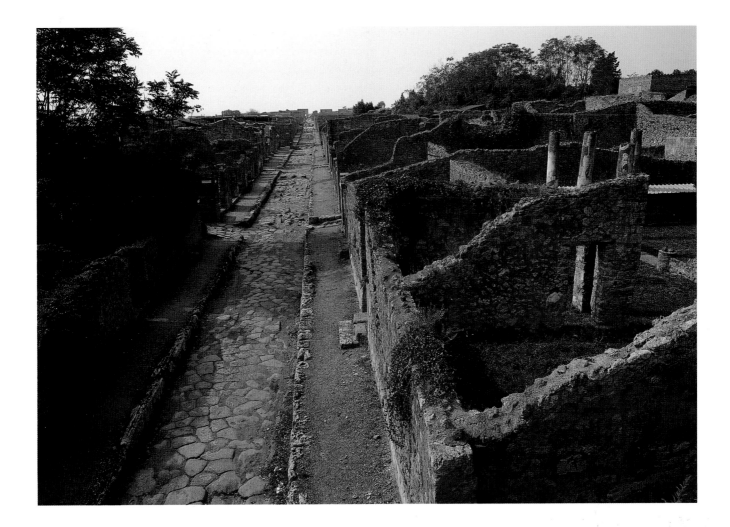

Both the oil lamps and torches were constantly being extinguished, plunging the men into claustrophobic blackness or threatening them with suffocation.

By 1738, an inscription was unearthed confirming that the town beneath Resina was indeed Herculaneum. The treasure hunt continued with even greater enthusiasm. Soon objects and statuary of great value and beauty began to be pulled out of Alcubierre's mine. They were then crated and sent off to the royal palace at Portici. The Portici collections would later serve as the nucleus of the modern-day collections at the National Archaeological Museum in Naples.

It is inconceivable today to try to comprehend the amount of damage that Alcubierre caused to the near-pristine site of Herculaneum. Mercilessly, he smashed through fresco-covered walls, tunnelled through houses, removed brass lettering from walls and statues without first recording the inscriptions. A decade later, however, the finds at the site were becoming increasingly scarce. Alcubierre turned his avaricious gaze southwards towards the Civitas hill, where frescoes, objects and even bodies had been discovered near what is now known as the intersection of Via di Nola and Via Vesuvius.[2] He first examined the channel dug by Fontana over a century before and assessed that this site, previously ignored, might hold great promise and renew the flow of treasure to Charles III. In 1748, Alcubierre enlisted twenty-four men, twelve of whom were convicts, and began digging in the vicinity of the town of Torre Annunziata.

During the initial excavations sponsored by the Bourbon King Charles III entire streetscapes were uncovered, revealing the once bustling urban corridors of Pompeii. It was here on the Via di Nola that the first human remains were discovered.

The initial work at Pompeii was much easier than at Herculaneum. The layers of accumulated volcanic pumice were removed with little difficulty in contrast to the concrete-like pyroclastic flow deposits encasing Herculaneum. Unknown to Alcubierre, Pompeii had its own perils, often more terrifying than those in the caves beneath Herculaneum. Workmen were constantly injured by falling into trenches or being swallowed up in pools of loose stones. The greatest danger at Pompeii, however, was the presence of *mofeta*. These were pockets of lethal carbon monoxide, decayed organic material and traces of hydrogen sulphide trapped in the strata. The *mofeta* would be released, giving off the smell of rotten eggs, sending the workers scurrying for their lives.[3] The *mofeta* could delay work for days, even months.

Alcubierre's efforts soon seemed to be stymied at Pompeii. Although he recovered a few frescoes, he did not feel that his continued efforts were justified, especially with the continuing delays due to the *mofeta*. In his opinion, the finds were not as substantial as those he had plucked from the mines at Herculaneum, so he returned to the subterranean city the following year, leaving only a skeleton crew of workers at Pompeii. Pompeii's largest structure, the Amphitheatre, was uncovered during these early excavations but, being of little interest or value to Alcubierre, its discovery was ignored.

In 1750, recovery efforts at Herculaneum and Pompeii underwent a profound change, with the introduction of a young Swiss engineer, Karl Weber, to the king's excavation team. Weber is credited with beginning the first documentation of the archaeological sites of Pompeii and Herculaneum. He drew up plans of buildings,

Outside the Gate of Herculaneum, a view published in 1817 by Sir William Gell and John P. Gandy in *Pompeiana: The Topography, Edifices and Ornaments of Pompeii.*

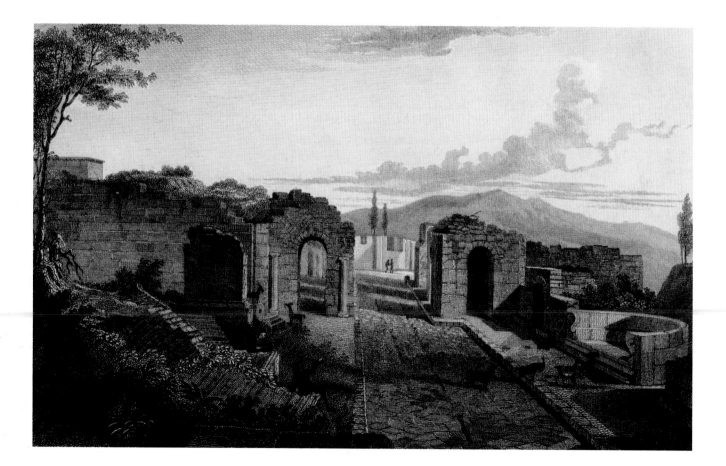

maps of streets and recorded frescoes and objects discovered. His approach was routinely ridiculed by Alcubierre, who felt that the primary purpose of their job was to provide treasures for the king's museum at Portici, not to study the lost world of a dead civilization. He often caused wanton destruction of buildings simply to prevent Weber from recording them. Although Alcubierre despised the young architect, Weber's methods of systematic tunnelling and digging were far more productive and lucrative than the 'mining' carried out previously. Weber's methods paid off almost immediately. Within a year of his arrival on site, he discovered the Villa of the Papyri in Herculaneum. It was to be described by the famous archaeologist and future curator of Herculaneum, Amedeo Maiuri, as 'the most valuable and richest villa of the ancient world'.[4]

The excavations at Pompeii moved slowly as Alcubierre's and Weber's work and bickering focused attention elsewhere. Extensive digging at Pompeii did occur periodically during the 1750s, but it tended to follow the same destructive pattern as the previous excavations. As rooms or buildings were uncovered, objects and statues were set aside. Light documentation would take place for tax purposes and then Camillo Paderni, curator of the king's museum in Portici, would arrive, and the selection process would begin. Paderni was charged with the task of choosing only the finest objects for the king's collections and, since there was no repository for more common objects, the rest were destroyed by hammer and discarded. He also engaged the sculptor Canart to detach the most beautiful frescoes from the walls of the uncovered houses for transportation to Portici.[5] Later, if the frescoes were considered to be too damaged or unsuitable, they were destroyed as well. On completion of each excavation, individual sites were picked clean of anything of value, then customarily backfilled before the group moved on to the next.

For fifteen years the two engineers worked together at Pompeii, digging excavation trenches, Alcubierre extracting finds and Weber recording what he could. Their collaboration and mutual dedication to their work – for whatever reasons – led to the discovery, in 1755, of the Praedia of Julia Felix, a large town house occupying an entire city block. This was Weber's first significant discovery at Pompeii and the items found there were of suitable quality to convince the court to continue the excavations.[6] This substantial find was followed in 1763 by the discovery of the Herculaneum Gate and the Via delle Tombe, and news of the work and the treasures emerging from Pompeii and Herculaneum began to reach the outside world. Charles III, anxious to show off his collections, invited foreign dignitaries and visitors to view them and the excavation sites. The Royal Herculaneum Academy was founded in 1759 to begin recording some of the more important and dramatic discoveries.

All of this international attention exposed the methods and work at Pompeii and Herculaneum to the harsh light of public scrutiny. Very soon the castigation of Alcubierre began as many witnessed his reckless destruction of artefacts. The German classicist Johann Joachim Winckelmann fired the opening salvo in 1762 in an open letter to Count Erico di Bruhl, lamenting the slow pace of the work at Pompeii and a bitter disgust with Alcubierre. He declared: 'This man, who has absolutely no experience working with antiques, is to blame for the many disasters and the loss of many beautiful things.'[7] He went on to attack Alcubierre's efforts, saying that his ignorance slowed his work because he did not know where the ancients would have kept their treasure.[8]

The excavation of the Herculaneum Gate led to the discovery of the Via delle Tombe. Burying bodies within the city walls was forbidden, so this road was lined with funerary monuments to the great families of Pompeii, such as the tholos Tomb of the Istacidii family.

POMPEII ASCENDANT

(1763–99)

The excavation of the Temple of Isis – an engraving after a drawing by Pietro Fabris for *Campi Phlegraei*, funded and published by Sir William Hamilton in 1776.

In 1763, an inscription was found during the digging at the Civitas. It read: *respublica Pompeianorium* or 'the commonwealth of the Pompeians'.[9] Pompeii had now been positively identified. On the death of Karl Weber in 1764, a new Spanish engineer by the name of Francesco La Vega was appointed to assist Alcubierre in the continuing efforts at Herculaneum and Pompeii. La Vega, building on the precedent of Weber, was ready to take a new, more scientific and systematic approach to the excavations. He believed strongly in uncovering each building in its entirety to allow not only for a complete search of the premises for artefacts but also for the documentation of important interiors. But he did not stop there. Conservation became an issue. With the growing chorus of concerned notables at the Neapolitan Court and foreign luminaries visiting the site, La Vega understood the need to protect what he was uncovering. He made provision for the structural repair and maintenance of buildings exposed after their long sleep beneath the stone and made sure the excess earth and volcanic material were completely removed from the site to allow better access for those who had come to marvel at the re-emergence of the ancient city.

When La Vega joined Alcubierre's team, work was still largely concentrated on the excavations in the murky tunnels at Herculaneum and at Karl Weber's greatest discovery, the Villa of the Papyri, which were still believed to be more profitable from the point of view of the royal collections. Pompeii, however, fascinated La Vega. Gazing at the rolling landscape of the Civitas hill, he saw a city beneath the fields waiting to be uncovered. At that time work was proceeding in two locations. The first location, to the north of the city, concentrated on the area around the Herculaneum Gate and the Via delle Tombe, while simultaneously, to the south of the site, excavations focused on the Theatre District.

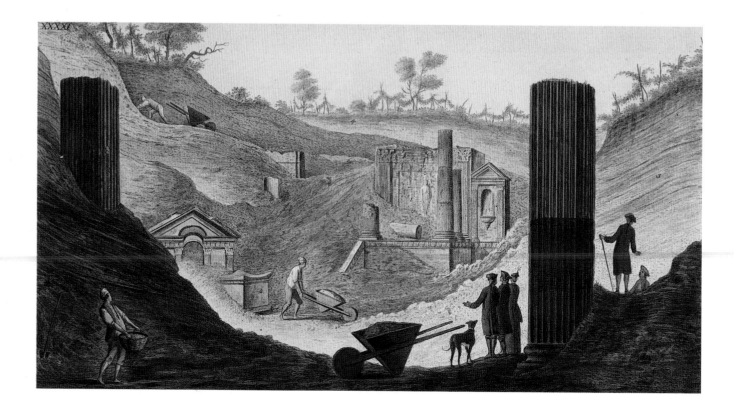

On 15 December 1764, while attempting to measure the circumference of Pompeii's Large Theatre, La Vega made a discovery which would guarantee his position at the court and make Pompeii known throughout the world. At first he did not know what he had found: a few small antechambers with mysterious objects, then a magnificent frieze with painted spirals. Finally, an inscription was found identifying the site as the Temple of Isis restored to its former glory following the earthquake of AD 62. La Vega personally undertook a survey of the temple and imported the best draughtsmen in Italy to copy the frescoes.[10] The discovery caused an incredible sensation. Never before had a complete Roman temple been found so intact with its furnishings, decorative schemes and even the tortured corpses of its priests, too laden with booty to escape Vesuvius' wrath.

Sir William Hamilton, then British ambassador to the court of Naples, marvelled at its pristine state, commenting that even 'the very bones of the victims were upon the altars'. However, recognizing that souvenir hunters would loot the temple before long, Hamilton conceded that the removal of the great temple murals was necessary. 'I could have wished that before they were removed, an exact drawing of the temple had been taken and the position of the paintings expressed therein, as they all related to the cult of Isis, and would have been more interesting published together than at random, which I fear will be their fate.'[11]

The discovery of the Temple of Isis caused a sea change in the way Pompeii was viewed around the world. By the late 1760s Pompeii had become one of the primary sites on the Grand Tour. Visitors poured into Naples to see the sensational discovery. Previously, when Herculaneum had been the principal attraction of the region, the site lacked appeal to a wider audience. At Pompeii, visitors could enjoy watching the excavations in an idyllic landscape under the southern Italian sky rather than soiling their finery in the dark and filthy caves beneath Resina. They could examine and walk through entire structures rather than just view fragments of buildings or rooms encased in rock.

The official position towards the excavations at Pompeii also changed. In 1765, La Vega was elevated to the post of director of the excavations in Pompeii. Athough he still reported to Alcubierre, La Vega's methodology was officially sanctioned. In the same year it was ordered that the excavations at Herculaneum halt and the tunnels be sealed. The focus of the attention was now to be on Pompeii solely, and work began in earnest. The excavations were expanded, opening up larger areas and enabling a street pattern to emerge. In 1771, yet another important discovery was made with the uncovering of the Villa of Diomedes near the Via delle Tombe. The villa, at first recognized for its great size and wealth of furniture and decoration, became a place of morbid pilgrimage for tourists. The bodies of eighteen women and children had been found huddled in a porch in the middle of the villa.

By 1780, La Vega was finally put in full charge of the excavations. Alcubierre died that year, and his forty-six-year reign of destruction at the Vesuvian sites was over. With his death one of the greatest hindrances to the development and execution of proper archaeological practice at Pompeii was removed. With his brother Pietro and his

The Villa of Diomededes caused a sensation in 1771, when eighteen bodies of women and children trapped by the eruption were discovered in the cryptoporticus.

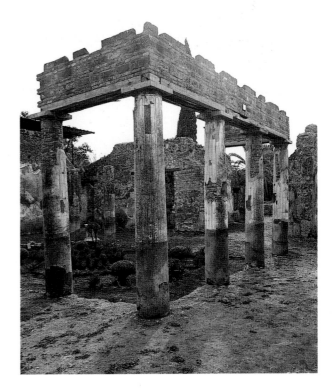

assistant Antonio Bonucci, La Vega began to change all of this and developed a vision to connect the two main areas of excavation to create one unified archaeological site. He drove Via delle Tombe excavations southwards through the Herculaneum Gate, uncovering the House of the Surgeon and the House of Sallust. To the south the excavations were widened and many great public buildings, such as the Large Theatre and the Odeon, the Gladiators' Barracks, the Temple of Jupiter Meilichius and the Triangular Forum, were unearthed.

THE NAPOLEONIC RENAISSANCE

(1799–1815)

The city walls remain as picturesque today as they were when they were first revealed.

At the outbreak of the French Revolution in 1789 all of Europe erupted into war and revolt. The Kingdom of Naples, at first far removed from the centre of conflict, was shaken into action in 1797 with the creation of the Cisalpine Republic in northern Italy. The following year, Naples joined the Second Coalition to defeat Napoleon. In response, the French army swept down upon Naples, forcing the royal family of Ferdinand IV to flee to Sicily.

The following year, France established the short-lived Parthenopean Republic, which briefly sought the creation of a liberal democratic state. The man charged with this task was General Jean Étienne Championnet, commander of the army of Rome. Championnet, in his attempt to be an informed and enlightened ruler, began to explore the Bay of Naples, including Pompeii. Because of the complexities of the political situation the excavations at Pompeii had slowed during the closing decade of the eighteenth century, nearly grinding to a halt. The general ordered the immediate resumption of the excavations and closely monitored them himself. He even participated in the excavation of two houses, which were then named after him.[12]

The Parthenopean Republic fell within a year. Its collapse gave way to an awful period of bloody reprisals and the re-establishment of the Bourbon dynasty in Naples. On his return from Sicily, Ferdinand IV appointed Francesco La Vega's brother Pietro chief director of the excavations. His tenure as sole director was to be a brief one as historical events once again overtook the work at Pompeii. The Second Italian Campaign began with the victory of the French over Coalition forces at Marengo on 14 June 1800 and ended with the Peace of Luneville on 9 February 1801, effectively giving Napoleon control over Italy. Ferdinand, only just back on the throne, bided his time before leading Naples into the Third Coalition against Napoleon. This

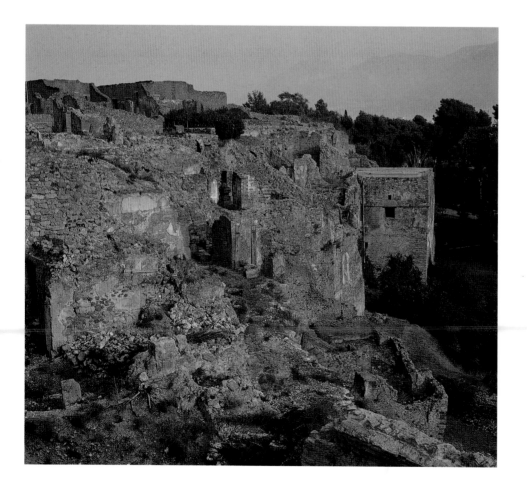

disastrous decision led in 1806 to the flight of the Bourbons to Sicily, where, under British protection, they waited for another chance to return.

Meanwhile, the emperor Napoleon gave the throne of Naples to his brother Joseph Bonaparte. Joseph had not been on the throne two weeks when he appeared at Pompeii. The vast archaeological site held the new king spellbound. He quickly understood the significance of the work going on there and was determined that it should continue. He sought the advice of the director of the royal museums, Michele Arditi, and commissioned him to draw up plans to expand and accelerate the project. Arditi's plans recommended the acquisition of all land holdings within the perimeter of the ancient city, which had only recently been surveyed. He also advocated a more aggressive execution of La Vega's dream of creating one unified archaeological site. Arditi believed he could achieve this not only by increasing the size of the sites currently in excavation but also by uncovering the entire system of the city walls. From this position each of the main gates could be identified, as well as the major roads leading into the heart of the city. Arditi then planned to remove all the earth and volcanic debris systematically, block by block.[13]

The implementation of Arditi's plan was temporarily interrupted when Joseph was recalled by Napoleon to assume the throne of Spain. For the Kingdom of Naples Napoleon chose another sibling, his sister Caroline and her husband Joachim Murat. Their ascension to the throne brought in a new era of activity at Pompeii. The work was elevated to a state priority, personally overseen by the

This view of the Nocera Gate and the hills beyond gives an idea of the extent of the planned city that is still to be excavated.

Although their better preservation was the end consulted in thus transferring these monuments to form a part of a distant collection, still it is much to be regretted that means could not be devised for their preservation on the precise spot at which they were originally found.

SIR WILLIAM GELL,
POMPEIANA

Les Fouilles de Pompeii, an 1814 engraving by François Mazois depicting the excavation of a street in progress. Here women carry the removed *lapilli* from the site in baskets balanced on their heads. The use of women labourers at the site continued throughout the nineteenth century.

sovereigns. Queen Caroline's support and enthusiasm for the project was so strong that she personally financed some of the work when money was short.

A beautiful and cultured woman, Caroline was also responsible for the continued dissemination of information about Pompeii. She frequently wrote letters to scholars and influential figures throughout Europe, reporting on the ongoing excavations and the newest discoveries. One of her most important contributions to the documentation of Pompeii occurred through her support of the artist and recorder of Pompeii, François Mazois. From 1809 to 1811, Mazois drew measured plans, sections and views of many of the buildings and sites of Pompeii. His works were engraved in Rome by Ruga, Feoli and Cipriani, and published as a two-volume set, *Les Ruines de Pompeii*, which he dedicated to Caroline. These first two volumes were later followed by two more and was to become the most important and most popular work on Pompeii in the mid-nineteenth century.

At Pompeii the effects of royal patronage were instantly apparent. King Joachim ordered the workforce to be dramatically increased to 688 civilians and over 1,500 sappers. By 1811, Arditi, assisted by La Vega's lieutenant Antonio Bonucci, was able to expropriate all of the land above the site. He also began the first extensive attempt to excavate the city walls. Well financed and well manned, the excavation sites grew and larger areas of the city were unearthed. In 1812, Antonio Bonucci began the labour of uncovering the civic heart of Pompeii, the

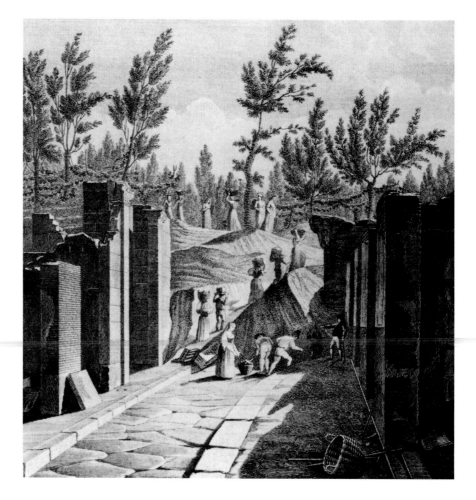

Forum, while simultaneously working on the great Amphitheatre. Slowly the Forum took shape. The Basilica, the Temple of Apollo and the Macellum were explored and documented. By 1813, La Vega's dream had become reality. The northern excavations centred on the Via Consulare and the southern site concentrated at the Theatre District met at the Forum, creating a vast ancient Roman cityscape. Suddenly a lost world appeared to have been recovered from the darkness. Visitors could now imagine sandalled feet walking on polished cobblestones; they could hear Greek tragedies performed at the Odeon, and they could smell the incense burning on pagan altars. The rediscovery of Pompeii had resurrected history in a completely new way.

In 1814, time ran out for the Napoleonic empire and its satellite states. Joachim Murat managed briefly to hold on to his and Caroline's thrones through betraying Napoleon, by signing a treaty with Austria after the Battle of Liepzig. Still fearing a return of the Bourbons, Murat allied the Kingdom of Naples with Napoleon during the Hundred Days, but was defeated by the Austrian army after an ill-fated attempt to unify Italy, allowing Ferdinand IV to return from Sicily. Ignored by Napoleon and without a throne, Murat tried to lead one last attempt from Corsica to retake Naples by force. Ferdinand, firmly back on the throne, immediately ordered his capture. Murat was tried, convicted and sentenced to death. As he was their former commander, it was Murat himself who, on 13 October 1815, gave the order to the death squadron to fire.

The Temple of Jupiter and the Forum, from an engraving published in the mid-nineteenth century by Fausto and Felice Niccolini in *The Houses and Monuments of Pompeii* (1854–90).

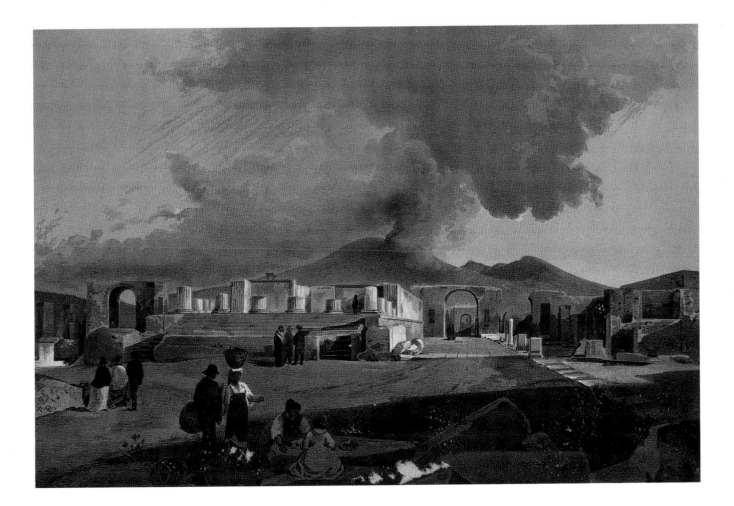

RESTORATION AND UNIFICATION

(1815–PRESENT)

The restoration of Ferdinand IV to his throne in Naples as Ferdinand I, the new King of the Two Sicilies, marked a period of reduced activity at Pompeii. Lack of funds and a sharp reduction in the workforce slowed the excavations, at times bringing them almost to a standstill. Lands acquired for the state within the perimeter of the site were sold to raise money to finance continued work, and Antonio Bonucci, who became director of the excavations during this period, was then forced to lease the land back. In 1825, Antonio was succeeded by his nephew, Carlo Bonucci, who was forced to resign his post in 1831 following accusations of mismanagement.

In spite of the administrative difficulties during these years, important discoveries continued to be made. The Forum Baths were uncovered in 1824, followed by the House of the Tragic Poet on the Via Mercurio. Perhaps the greatest discovery of this time was the House of the Faun in 1830, with its great mosaic depicting the battle of Alexander the Great and Darius of Persia. Following this breakthrough, work was given a strong endorsement from the king and took on a renewed momentum. The direction of the excavation now followed the Via

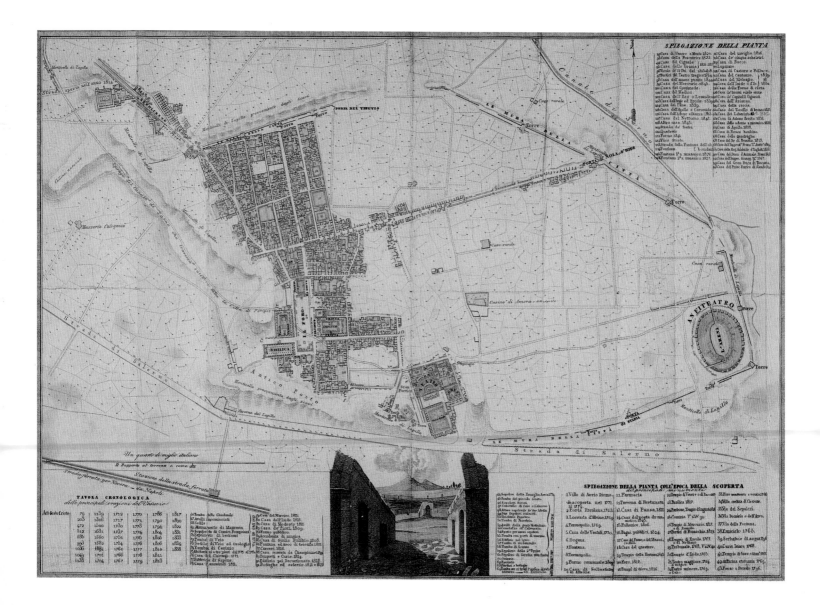

della Fortuna and Via di Nola axis as far as the Via Stabiana. This thoroughfare was then followed south to the intersection with Pompeii's main street, the Via dell'Abbondanza. By now it was not just streets and public gathering places that were being uncovered, but whole city blocks (*insulae*) as well.

As the western half of Pompeii slowly started to take shape, its great avenues being opened once again to the traffic of tourists and workers, more significant buildings began to appear. In 1847, the House of Marcus Lucretius Fronto was excavated. Its elegant frescoes and spectacular gardens lined with marble statuary were considered to be so important that Ferdinand II came to watch the unveiling as it occurred. Following this the Stabian Baths and the House of the Lyre Player were discovered in quick succession.

By 1860 the excavation work at Pompeii had regained its impetus, yet the winds of change were blowing through Italy. A new Italian nation was developing, one that would have a deep impact on the work at Pompeii, once again altering tradition and methodology while introducing new revolutionary ideas in the scientific and archaeological fields. On 7 September Giuseppe Garibaldi and his famous Redshirts captured Naples after their lightning conquest of Sicily. The following month he put an end to nearly a century and a half of Bourbon rule in his campaign to unify Italy. During his brief tenure as dictator of Naples and Sicily, the new leader appointed his friend Alexandre Dumas, the French author of *The Three Musketeers*, director of the museum and excavations at Pompeii. His choice was viewed with great suspicion and protest by the Neapolitans. During this patriotic time, Dumas's French nationality made him a target of derision and led to stories about public money being wasted on lascivious activities at his residence. Strangely enough, Dumas made a valuable contribution to the work at Pompeii and the museum. He is credited with organizing and cataloguing the Raccolta Pornografica – the museum's pornographic collection – which was the largest collection of Roman erotic art. Made up principally of objects and frescoes from Pompeii, the collection contained 206 pieces of erotica in the museum's 'secret cabinet'.[14] During his tenure Dumas kept no fewer than 512 men working at Pompeii.

In 1863, after the resignation of Alexandre Dumas, Giuseppe Fiorelli was appointed as superintendent of excavations and director of the National Archaeological Museum in Naples. Fiorelli had an outstanding scientific background and was a brilliant antiquarian. He had previously worked as an inspector at Pompeii, but was removed due to his activities during the political uprisings in 1848. Fiorelli had not only served as secretary to a revolutionary commission which oversaw the work at Pompeii but also raised a small company of soldiers from the guards and sappers at Pompeii and offered their services to the revolution. He was later imprisoned by the Bourbons, and during this time he wrote a book on Pompeii. He was acquitted and released in 1850. Through his position as secretary to Prince Leopold, the king's brother and a revolutionary sympathizer, Fiorelli managed to regain his reputation.

Fiorelli introduced a new method of excavation, which would better help them to understand each building as it emerged. Previously, buildings were uncovered down to the ancient ground level by shovelling out the layers of lapilli, earth and building debris. During this process objects of interest were extracted and set aside with little reference to their original location in the building being documented. Fiorelli realized that a great deal of information was being lost, especially about the upper storeys of buildings, which had collapsed, and about

OPPOSITE A map of the city made in 1825 shows the theatres and amphitheatre, and the extent of the excavations.

BELOW As archaeological philosophies changed in the late nineteenth century, calling for better documentation and interpretation of Pompeii's buildings, architectural finishes, such as this bas relief from the Stabian Baths, were left *in situ* wherever possible.

the bodies found mysteriously floating in the middle of the debris. Fiorelli initiated a new system, according to which each structure was uncovered by removing individual strata from the highest point of the excavation site down to the ancient ground level. This method quickly began to reveal clues as to the evolution of the eruption and the progress of the events of 24–25 August AD 79. It also enabled his crews to learn more about the upper storeys of buildings so as to be able to restore some of them in a manner true to their original form.

This new method was characteristic of Fiorelli's attitude towards Pompeii. He approached the buildings and artefacts with curatorial care, studying and documenting them as well as making provision for their protection and maintenance. He sought to prevent the removal of objects and murals to the museum in Naples, preferring that they be left *in situ* so that they would not lose their historical context. For movable artefacts, however, he established a small antiquarium, where they could be left on display without their leaving the site.[15]

It was in this small museum at Pompeii that a plaster cast of an ancient victim was first put on display. During the implementation of Fiorelli's new excavation methods at the Vicolo di Augustus, the diggers discovered four small cavities in the ash. Fiorelli had seen these cavities during other excavations elsewhere and understood that they were what was left of the victims of the eruption. While they

The House of the Large Fountain. Few houses had roofs or upper storeys when first excavated. Roofs were rebuilt on some of the houses to protect valuable frescoes or to recreate an important interior.

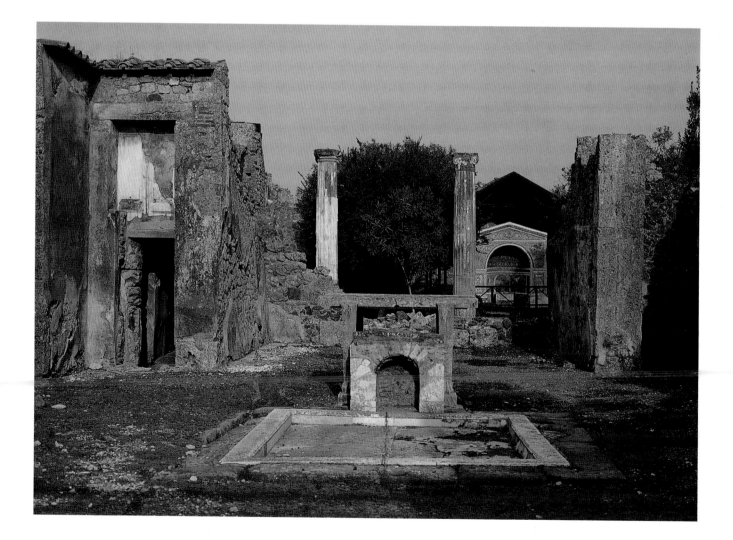

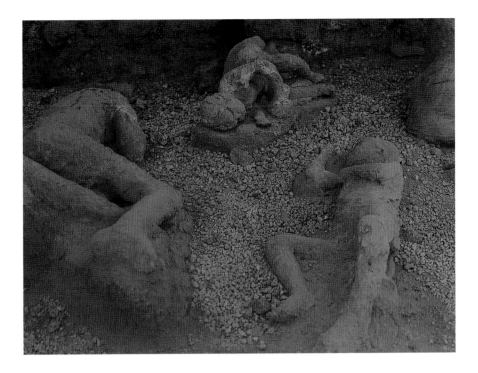

tried to hide or escape from the destruction raining all around them, their bodies were encased in the ash. When they decomposed they left an impression, a cavity within the ash. Fiorelli had plaster poured into the cavities. Once the plaster had hardened and the ash was cleared, casts of four bodies were revealed, locked for ever in their death throes. To this day there is no better way to appreciate fully the true horror of that fateful night than to view the twisted figures of the helpless victims brought back to life through what is now known as Fiorelli's process. This process was later used to reproduce the forms left from the decomposition of other organic materials, such as wooden shutters and tree stumps.

Another goal of Fiorelli's was to bring some order to Pompeii's topography. He instituted a system which divided Pompeii into *regiones* and *insulae* (regions and blocks) and gave each region and block a number by which it could be identified. This made it easier to describe accurately the location of individual structures and their proximity to others as well as providing a basis from which to draw plans and maps. This system was continued by Fiorelli's successors and is in use still today.

In 1875 Giuseppe Fiorelli was promoted to take over as General Director of Antiquities and Fine Arts in Rome, overseeing work throughout the newly unified Italy. His tenure as the superintendent of the excavations had proved more influential than any director or superintendent before him. He brought the revolutionary spirit of the unification to Pompeii, transforming the ancient site from the personal endeavour of the Neapolitan kings to the premier archaeological treasure of the new unified Italy. His contribution was an inspiration to his successors, who would use and expand upon his techniques to further raise the standard of archaeological excavation and discovery at Pompeii.

The unearthing of some of Pompeii's most magnificent structures continued into the next century. The House of the Silver Wedding, the House of the Vettii and the Triangular Forum were all excavated in the late nineteenth century, while

ABOVE LEFT Twisted bodies testify to the horrible toll of Vesuvius's eruption, brought to life by mid-nineteenth-century superintendent Giuseppe Fiorelli's method of filling cavities in the volcanic ash with plaster.

ABOVE RIGHT Marble plaques on street corners and buildings help archaeologists and visitors alike to locate specific sites among Pompeii's many neighbourhoods and city blocks. This system of regions and insulae was also implemented during Fiorelli's directorship.

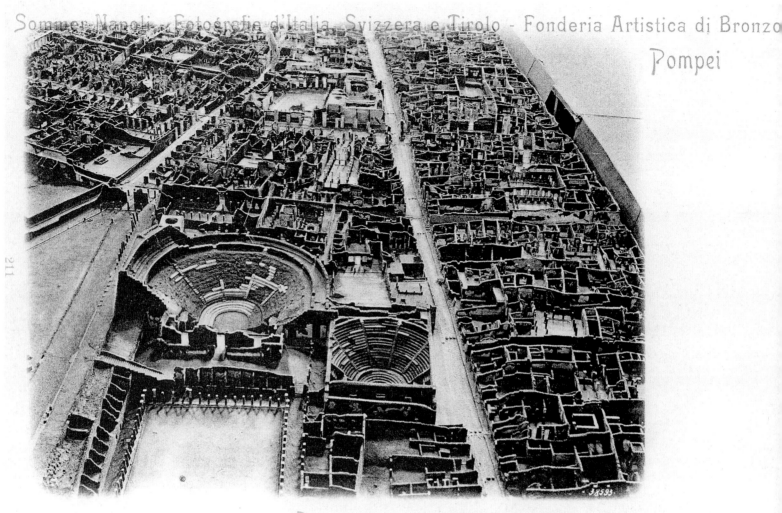

Sommer Napoli - Fotografie d'Italia, Svizzera e Tirolo - Fonderia Artistica di Bronzo

Pompei

Panorama

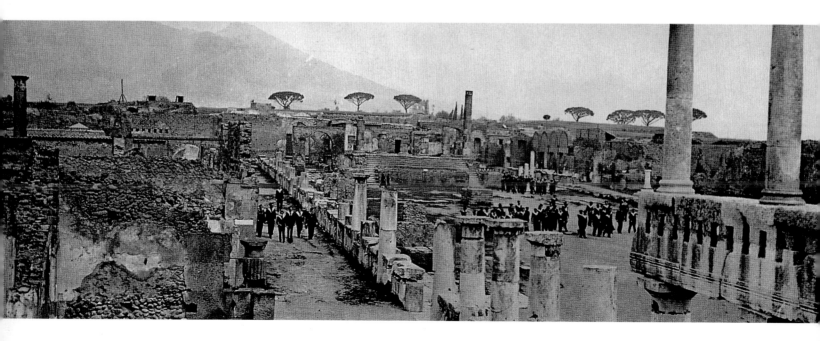

the Villa of the Mysteries, the Via dell'Abbondanza, the Palaestra and the House of Menander were all unearthed in the first half of the twentieth century. These finds were overseen by a host of other excellent superintendents who emerged following Fiorelli. Michele Ruggerio, Antonio Sogliano, Vittorio Spinazzola and Amedeo Maiuri all helped to shepherd the site through periods of bureaucratic reorganization, scandal, dictatorship and even war. Maiuri's tenure at Pompeii is now seen as the most productive and important in the history of the site's excavations. His implementation of archaeological and scientific standards during excavations as well as a substantial clearing of the site provided for the first time a holistic understanding of Pompeii's history and urban fabric.

Large-scale excavation campaigns continued until the 1960s, when it became clear that Pompeii's architectural and archaeological treasures were under attack from a grave new danger. By this time two thirds of the city had been uncovered. The excavation of Pompeii had created a city of mostly roofless structures vulnerable to the elements. Over time, the effects of natural deterioration caused by age and environmental and climatic conditions began to reveal incredible losses of historic fabric. These problems were compounded by an explosion in tourist traffic. Pompeii, as one of Europe's most popular destinations, receives two million visitors annually. This alone has led to a review of the city's tourism management and interpretation of individual sites within the park. Today it has been unanimously agreed to halt all major excavation plans in order to concentrate on the study and conservation of the vast amount of historic structures and fine works of art uncovered during 250 years of excavation. In 1997, Pompeii was awarded World Heritage status by the United Nations Educational, Scientific, and Cultural Organization (Unesco). The conferring of this title on Pompeii recognized the need for the site's protection and conservation. The current relief effort has brought international organizations and institutions together with the current administration to help preserve and understand the vast site of 164 acres, both above and below ground, but has only just begun to address the widespread conservation issues.

OPPOSITE ABOVE An early postcard showing a cork model of Pompeii. Display models such as these provided visitors with a better understanding of the complexity of the site.

OPPOSITE BELOW A group of late-nineteenth-century French sailors on a visit to Pompeii. This view attests to the ever-growing popularity of the site as a tourist destination throughout the nineteenth and twentieth centuries.

LEFT Pompeii is suffering from an epidemic of conservation problems. Temporary awnings and roofs are required in many places to prevent the loss of frescoes and painted inscriptions.

VOICES FROM
A LOST WORLD

Gaius Pumidius Dipilus was here, 3 December.

*We were here, two dear friends, comrades for ever. If you
want to know our names, they are Gaius and Aulus.*

Our daughter was born early in the evening on Saturday 2 August.

Vibius Restitutus slept here all alone and longed for his Urbana.

PREVIOUS PAGES An inscription on a
semi-circular bench or *schola* on the Via
delle Tombe announces the seat as the
tomb of the Priestess Mamia, a prominent
figure and patron of buildings in Pompeii.

RIGHT The Nocera Gate was built in
the fourth century BC. During the
eruption it became an emergency
evacuation point.

LIKE GHOSTLY VOICES, the words of lost Pompeians sound forth from the
darkness. Scrawled on street corners, carved in stone or plastered on walls, the
written word is everywhere in Pompeii. Although it is impossible to gather any
sort of coherent history of Pompeii from the proliferation of graffiti, inscriptions
and political placards, something altogether more important becomes apparent.
These inscriptions, terse and often vulgar, provide a unique glimpse into the
vanished world of Pompeii, a world where, on any given day, a vast array of
activities took place in the residents' lives.

It is difficult for the modern visitor to the ruins of Pompeii to appreciate fully
what daily life was like for the Pompeian citizen in the years leading up to the
city's destruction. Along the ruined streets which, as Mark Twain observed in *The
Innocents Abroad* (1869), were and probably still are 'cleaner a hundred times
than ever Pompeii saw them in her prime', hundreds of empty doorways stand
side by side where once activity bustled. The silence of Pompeii is troubling; the
breadth of the tragedy is compounded by the emptiness of the buildings.

Yet the voices endure. They guide the visitor, telling the story of the people of
Pompeii and giving personality to the avenues and buildings they occupied. There
is not a significant area or edifice in the city which does not contain inscriptions.
The words of the long dead are what most evocatively preserve the memory of
Pompeii's daily life. They help bring back to life the silent streets, the deserted
food counters and the empty Amphitheatre.

THE CITY DEVELOPS

Daily public life in Pompeii, like that in all civilizations, can be divided into the
political, religious, commercial and recreational spheres. As the city developed
and grew in prominence, magnificent structures and public spaces were created
– and then later enhanced – in order to fulfil the corresponding functions of each
of these areas of life.

Even in Roman times Pompeii was a very old city, with its roots in Samnite,
Oscan and Greek cultures. It had grown slowly from a small agrarian community,
which was located along routes across the southwestern quarter of the city.
Pompeii's urban and architectural development passed through five stages: pre-
Roman, colonial Roman, imperial Roman and post-earthquake/pre-eruption.[1] It
has been difficult for architectural historians and archaeologists to gain a clear
picture of what Pompeii may have looked like before the devastating earthquake
of AD 62 because so much of Pompeii was redesigned and rebuilt. However, part
of Pompeii's significance is due to the fact that it was a result of gradual urban
growth. Many of the other large-scale urban areas of the late Roman empire that
remain in the Middle East and North Africa were products of the 'castrum' plan

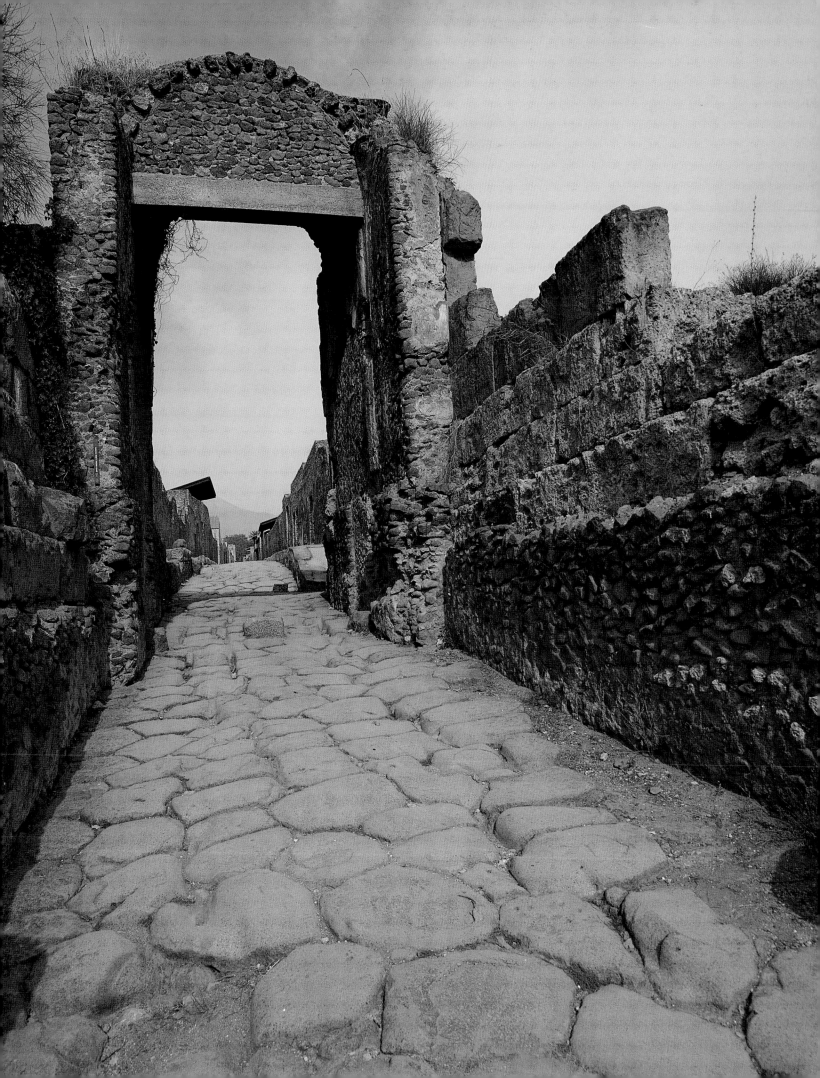

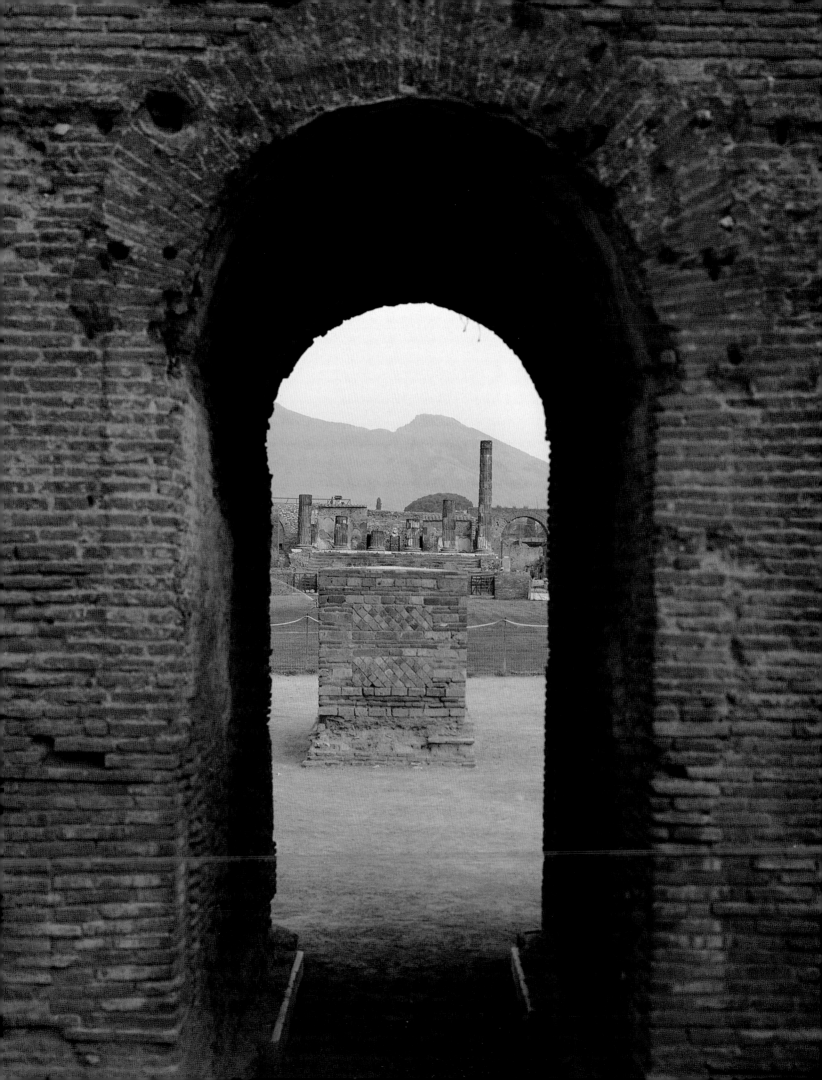

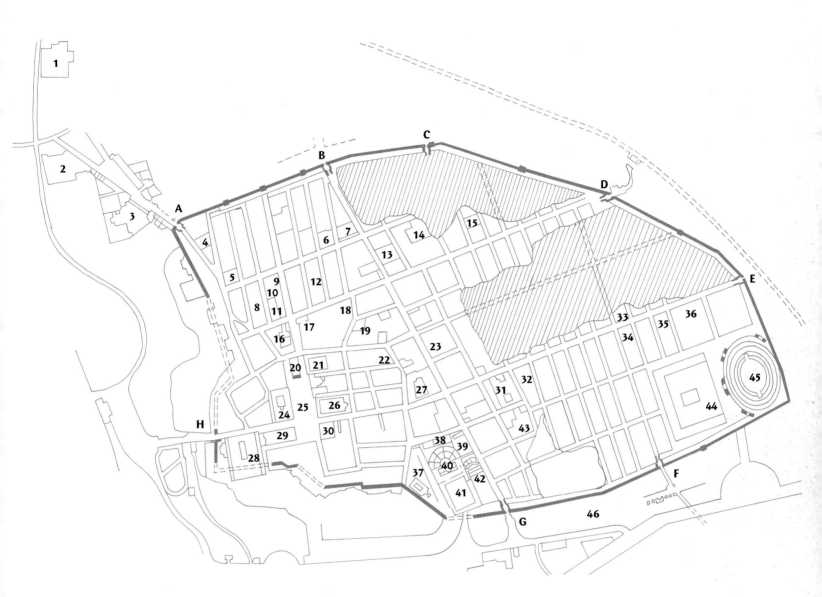

KEY

1 Villa of the Mysteries
2 Villa of Diomedes
3 Villa of Cicero
4 House of the Surgeon
5 House of the Sallust
6 House of the Vettii
7 House of the Gilded Cupids
8 House of Pansa
9 House of the Small Fountain
10 House of the Large Fountain
11 House of the Tragic Poet
12 House of the Faun
13 House of Lucius Caecilius Iucundus
14 House of the Silver Wedding
15 House of Marcus Lucretius Fronto
16 Forum Baths
17 Temple of Fortuna Augusta
18 House of the Ancient Hunt
19 Forum Bakery

20 Temple of Jupiter (Capitolium)
21 Macellum
22 Brothel
23 Asellina's Tavern
24 Temple of Apollo
25 Forum
26 Eumachia
27 Stabian Baths
28 Temple of Venus
29 Basilica
30 Comitium
31 House of the Cryptoporticus
32 House of Paquius Proculus
33 House of the Moralist
34 House of Loreius Tiburtinus
35 House of the Venus
36 Praedia of Julia Felix
37 Triangular Forum
38 Temple of Isis

39 Temple of Jupiter
 Meilichios
40 Large Theatre
41 Gladiators' Barracks
42 Odeon Theatre
43 House of Menander
44 Palaestra
45 Amphitheatre
46 Cemetery

GATES

A Herculaneum Gate
B Vesuvius Gate
C Capua Gate
D Nola Gate
E Sarno Gate
F Nocera Gate
G Stabiae Gate
H Marina Gate

ABOVE A plan of the city of Pompeii. The shaded areas are still unexcavated.

LEFT Bases of statues long removed and brick arches once decorated with polished marble are all that are left of the civic monuments of Pompeii's Forum.

OVERLEAF Pompeii's north–south axis, the great Via Stabiana, divides the city's older western precincts from its more regular and planned eastern half. The street's original name is lost to history; it is today named after the town of Stabiae, located to the south of Pompeii.

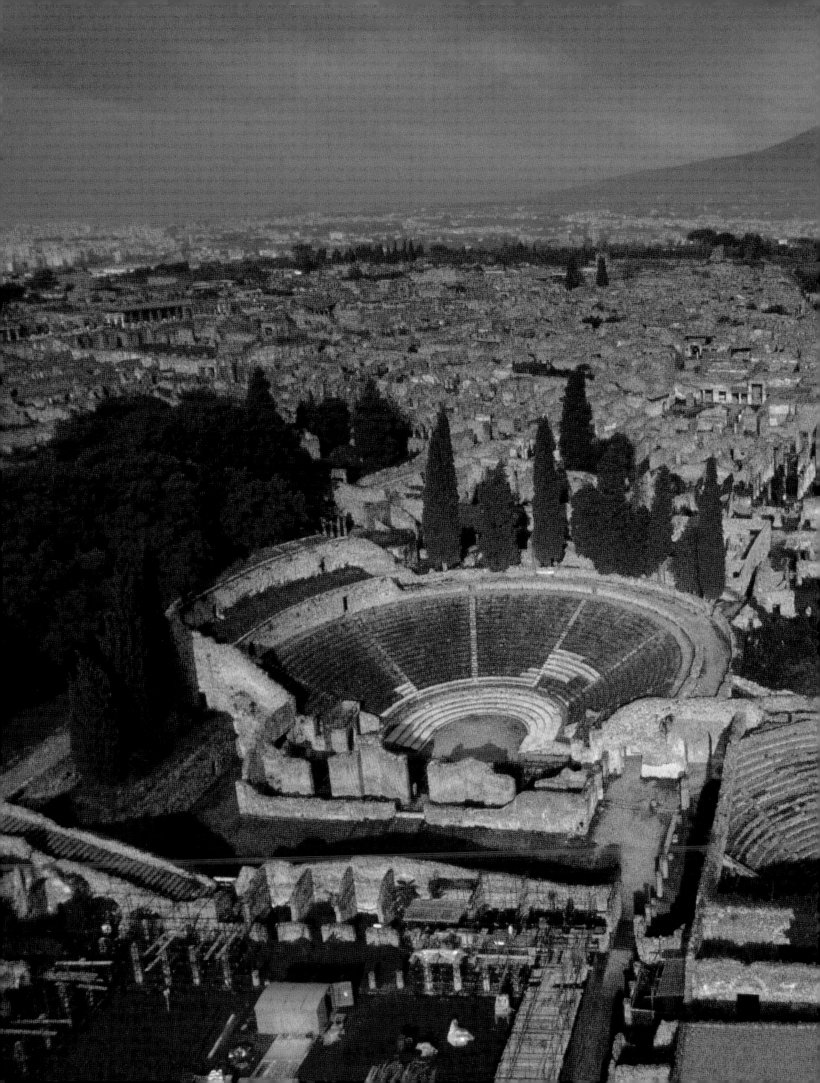

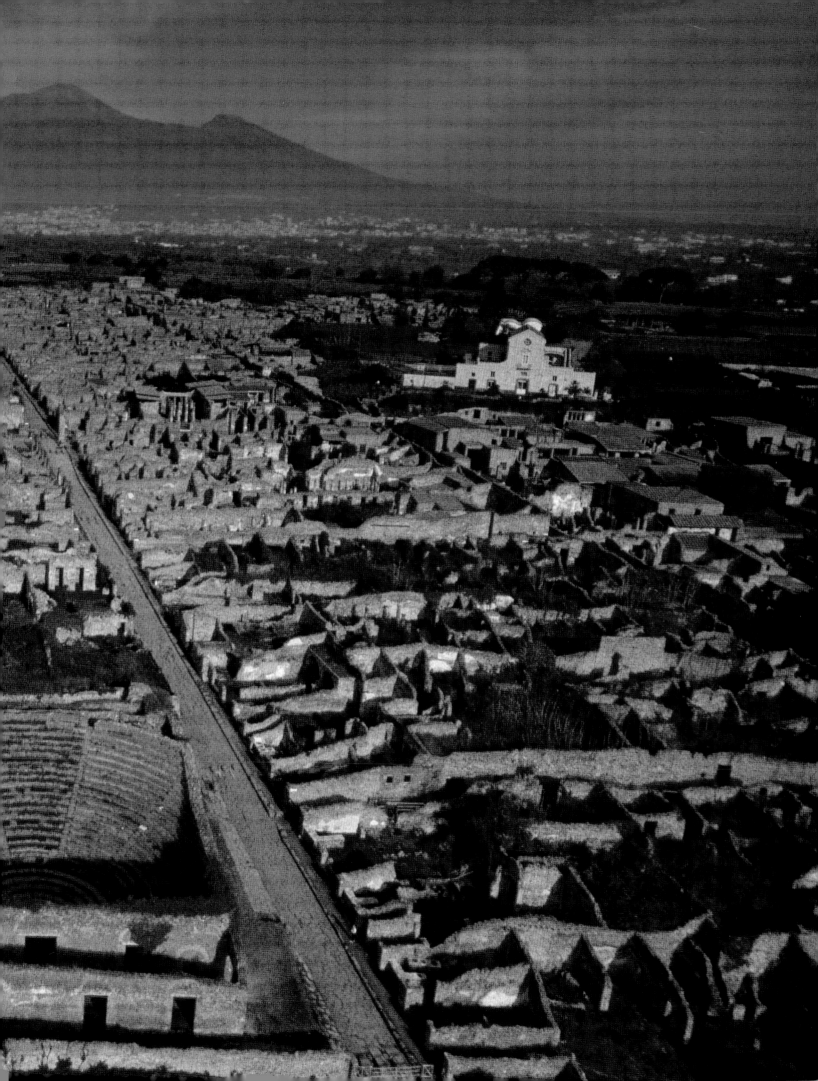

used for the design of military camps and later colonial cities. Pompeii's eventual form reflected the work and ambitions of its people, not primarily the imposition of rules laid down by a town planner.

THE BODY POLITIC

At the time of its destruction, the Forum was still the heart of the city. The main political organizations, religious festivals, civic and legal administrative bodies as well as entertainments and markets were all based in and around the Forum. In the Praedia of Julia Felix there was originally a 100-foot frieze depicting everyday life in the Forum. Only 33 feet of this survives, but it is a crucial archaeological document, showing crowds of shopkeepers under the colonnades, men reading the latest news written on panels, a student being publicly flogged by his teacher and a woman and a little girl giving alms to an old man.

The Forum was the basic urban unit around which the city eventually grew, connecting the two great religious complexes of early Pompeii, the Temple of Apollo, and the Triangular Forum with its Doric Temple. At the time that the Forum was laid out there was probably little city to speak of, yet it was carefully placed parallel to the Temple of Apollo, with a screen wall to separate them. This

OPPOSITE A segment of a fresco from the Praedia of Julia Felix depicting life in the forum. Many monuments were erected to the imperial family and other notables in public spaces. At the time of the eruption the Forum was filled with statues, such as these three equestrian figures.

RIGHT A plan of the Forum and the public buildings surrounding it.

KEY
1 Granary
2 Temple of Jupiter (Capitolium)
3 Macellum
4 Sanctuary of the Public Lares
5 Temple of Vespasian
6 Temple of Apollo
7 Forum
8 Eumachia
9 Basilica
10 Comitium
11 Municipal Buildings

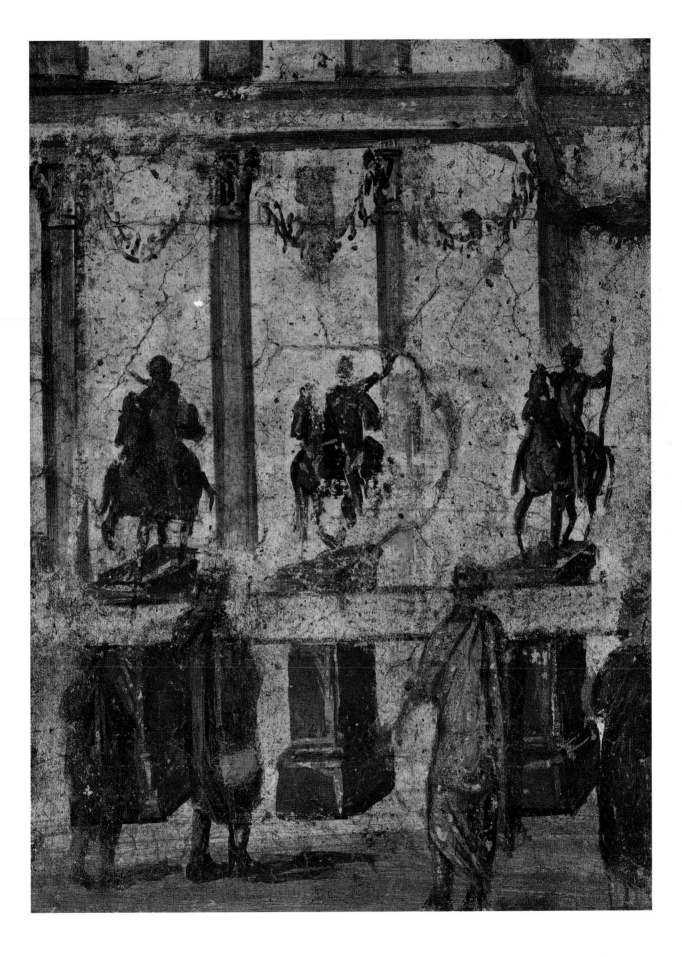

was in accordance with a Greek tradition in which the sacred and secular were kept separate, yet always visible to each other.[2]

The Forum was longer and narrower than prescribed by Vitruvius, the father of Roman architecture and planning. His law was based on the notion that the Forum would be used for games as well as ceremonies. It was flanked on three sides with two-storey Doric colonnades and galleries. At the north end stood a temple dedicated to Jupiter, towering over the open space in classic Roman grandeur. Although there is little evidence to suggest that games were ever held here, we do know that large spectacles and parades, which were part of the political and religious life of Pompeii, did take place in the Forum. An inscription at the Amphitheatre describes such an event:

> Aulus Clodius Flaccus, son of Aulus, of the Menenia voting group in Rome, three times chief magistrate, once in the special fifth year, tribune of soldiers by popular vote, [provided] in his first term during the festival of Apollo in the forum: a procession, bulls, bull-goaders, side-kicks, platform fighters (three pairs), boxing in groups and pairs, shows with all the musicians and all the pantomimes, and [especially] *Pylades*, at the cost of 10,000 sesterces paid to the city in return for his office.

This inscription is significant because it gives insight into the rich and virile political life in Pompeii, which required such acts of beneficence to its citizens. Elections took place annually in March for seats in the city's main political bodies. Pompeii's government consisted of two chief magistrates, the duovirs, who were the supreme representatives of the city, responsible for justice and government, while two lower magistrates, the aediles, were younger men charged with the administration of public and religious structures and services. All four presided over the *ordo decurionum* or municipal council, made up of a hundred magistrates-for-life known as decurions, the wealthiest citizens of the city. Seats in the *decurionum* could only be obtained through the death or disgrace of one of the members or through being elected to one of the four magisterial offices. Cicero commented that because of the intense competition for these offices it was harder to get into the Pompeian city council than it was to get into the Roman Senate.[3]

Every adult male in Pompeii had a vote, and many declared their preferences publically in writing on walls throughout the city. 'Vesonius Primus urges the election of Gnaeus Helvius as aedile, a man worthy of public office.' Political propaganda and placards can be found all over the Forum and throughout Pompeii. Over three thousand have been recorded, more than half of them referring to the last election, in March AD 79. Men also voted in blocks corresponding with their specific trades. One inscription reads: 'The Fruitsellers, together with Helivius Vestalis, unanimously urge the election of Marcus Holonius Priscus.' Although suffrage only extended to men, women openly joined in the political debate and participated in the campaign work for their favourite candidates. While one candidate had his 'little girlfriend' calling for his election,

The Forum today. Mount Vesuvius hovers over the ruins of the Temple of Jupiter as three bare pedestals which once held equestrian statues still stand in front of the remnants of the Forum's marble colonnades.

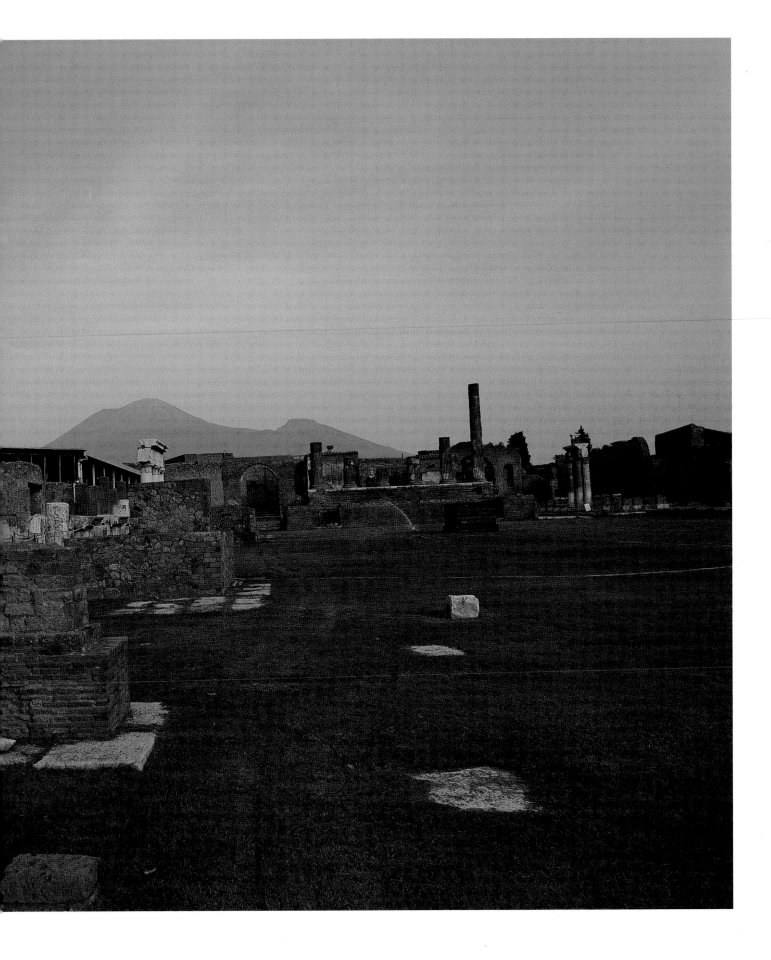

another had his grandmother out canvassing: 'Vote for Lucius Popidius Sabinus; his grandmother worked hard for his last election and is pleased with the results.' Such propaganda could be counter-productive. Caius Julius Polybius demanded the covering over of one such placard, which declared the support of two local prostitutes for his election.[4]

Political activity took place in the various buildings constructed around the Forum for each function of the government. The most important of these was the Basilica, one of the oldest and grandest buildings in Pompeii, located at the southwestern corner of the Forum. Constructed in the second century BC, the Basilica's main hall was two storeys high with a roof held up by 28 fluted Ionic columns, each 36 feet in height. Along the walls ran 24 Ionic pilasters interspersed with brightly decorated painted panels. The Basilica was used for conducting commercial transactions and administering justice.

The walls of the Basilica also carried some of the city's more colourful written declarations, as many Pompeians expressed their affection – 'Auge loves Allotenus' – or displeasure with their fellows – 'Samius to Cornelius: Go hang yourself!' Others became poetic in their venom – 'Chius, I hope your piles are chafed once more, That they may burn worse than they've burnt before.'[5] – which

The tribunal of Pompeii's Basilica. The Basilica served as the primary location for the drawing-up of contracts and other commercial transactions, as well as being the seat of the judiciary.

caused an equally poetic admonition: 'I wonder, Wall, that you do not smash, Who have to bear the weight of all this trash.'[6]

Directly opposite the Basilica, in the southeastern corner of the Forum, was the Comitium. This structure served as the venue for court proceedings. Being roofless, it followed the religious requirement of the time that trials should be held outdoors.[7] The building also functioned as the arena for *contiones* or town hall meetings, at which the public questioned members of government. These could be rowdy affairs, often erupting into violence. Cavities in the entrance pilasters show that the Comitium originally had heavy gates that could be locked in case of public disorder. It is also believed that the Comitium was used as a polling station during the annual elections.

On the southern side of the Forum were a series of smaller buildings used for various governmental functions. Once elected, the magistrates of the *decurionum* met in the Curia chamber, next to the Comitium. In this lavishly decorated interior, with marble floors, the city council debated and voted on issues affecting the government of Pompeii. Next to this building stood the Tabularium, a small building where all the acts and tax records of the municipal government were notarized and filed. Also on the south side of the Forum, the duovirs and aediles had their own special offices.

Pompeii's Basilica was entered from the Forum. Its long nave had twenty-eight massive columns rising two storeys with walls decorated with painted panels. These panels became a favoured place for Pompeians to write graffiti.

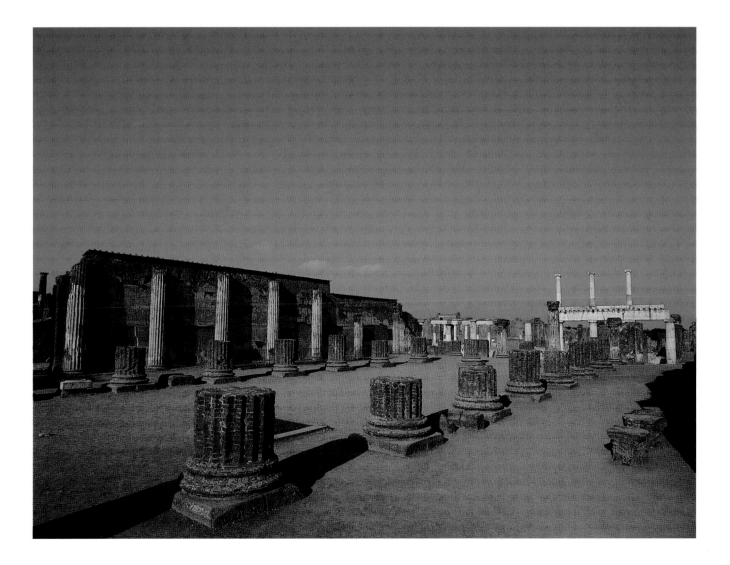

RELIGION

Government of the city was not simply a matter of secular administrative obligations; religious duties were equally important. In Roman times the celestial and the physical worlds were believed to be inextricably linked and mutually dependent. Religious observance pervaded every area of society from politics to domestic life. Religion stood as a pillar of civilization and one that required devotion – through practical observance rather than doctrine – to secure the favour of the gods and, through them, success and fortune. It was believed that failure to conduct the proper rites, whether in the temples of the city's gods or in the shrines of household deities (*lares*), could have devastating consequences.

Nowhere was this more evident than in the political sphere. In Roman society, the law was supreme: it emanated from the gods and was codified by man to carry out their divine will. Consequently, political activities and offices were in effect religious ones as well. In Pompeii, it was the responsibility of the aediles to take care of the temples throughout the city, so that all deities would look with approval upon the activities of the city and guarantee continued prosperity. All magistrates were ordained as members of the priestly caste of the imperial cult so that their decisions would have the weight of religion behind them.

There was no greater paradigm of this union of state and religion than in the divine person of the emperor, who was said to be the direct descendant of the goddess Venus, the lover of Mars and mother of Rome's mythical founder Aeneas.[8] The imperial cult had a special place in the religious life of Pompeii. Its vast hierarchy of priests and priestesses as well as *augustales* and *ministri* took part in the celebration of the divinity of the imperial person and consequently held prominent positions in Pompeian society.

Little remains of the lavish decoration that once covered the Temple of Fortuna Augusta. Built through the patronage of Marcus Tullius on his own land, the temple was originally dedicated to the cult of the emperor Augustus, but later included subsequent emperors as well. Badly damaged in the earthquake of AD 62, it was being restored at the time of the eruption.

Adoration and worship of the imperial cult took place in a number of locations, most of which were in or around the Forum. The most prominent of these was the Temple of Vespasian, the divine emperor at the time of the earthquake in AD 62, on the western side of the Forum. Vespasian had replaced Augustus, who originally held the place of prominence, as described in an inscription found at the site: 'Mamia daughter of Publius public priestess on her own land and at her own expense dedicated a temple to the genius of Augustus.' Augustus was removed from the temple and given a smaller place of veneration in the Augusteum, on the southwest corner of the Forum next to the Basilica. The second most important shrine was the Temple of Fortuna Augusta, built during the first years of the Roman colonization and subsequently dedicated to the emperors Augustus, Tiberius, Caligula and Nero. Other sites of imperial veneration were the entrance chapels of the Macellum and the Eumachia as well as the Sanctuary of the Public Lares.

Alongside and fused with the imperial cult were the cults of the various traditional deities whose worship formed part of the cultural and historical heritage of Pompeii. One of the oldest and most important of these was the cult of Apollo. The Temple of Apollo dates back as far as the sixth century BC and was the principal shrine of the town until 80 BC and the dawn of the Roman colony. Rebuilt several times before its destruction, it continued to occupy an important location on the western side of the Forum. Worship of Apollo was particularly promoted during the reign of Augustus, who identified with Apollo and saw him as representing peace and enlightenment. Due to this patronage the god experienced a renaissance in Pompeii with the inauguration of the Apolline Games every year on 5 July, which were a celebration of all that was new, young and successful.[9]

BELOW Detail of the marble altar in the Temple of Vespasian. The relief shows the sacrifice by the cult of a bull to the divine emperor.

BOTTOM The Sanctuary of the Public Lares. This large public shrine was presumably dedicated to the ancestors of the citizens of Pompeii. Scholars differ on the extent of the use of the building as a site for worship of the imperial cult, while others have suggested that it was used as a library.

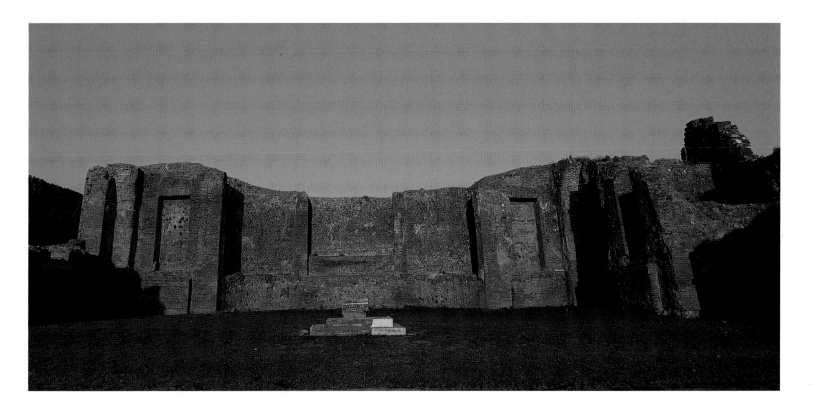

A lone statue of Apollo, originally brandishing his bow, stands guard over the ruins of his temple. One of the oldest religious sites in Pompeii, dating back to the sixth century BC, the Temple sat in the centre of a colonnaded courtyard, which was located on the west side of the Forum. The cult of Apollo was particularly strong because of its associations with the emperor Augustus, who attributed his victory over the army of Antony and Cleopatra in 31 BC to this luminous deity.

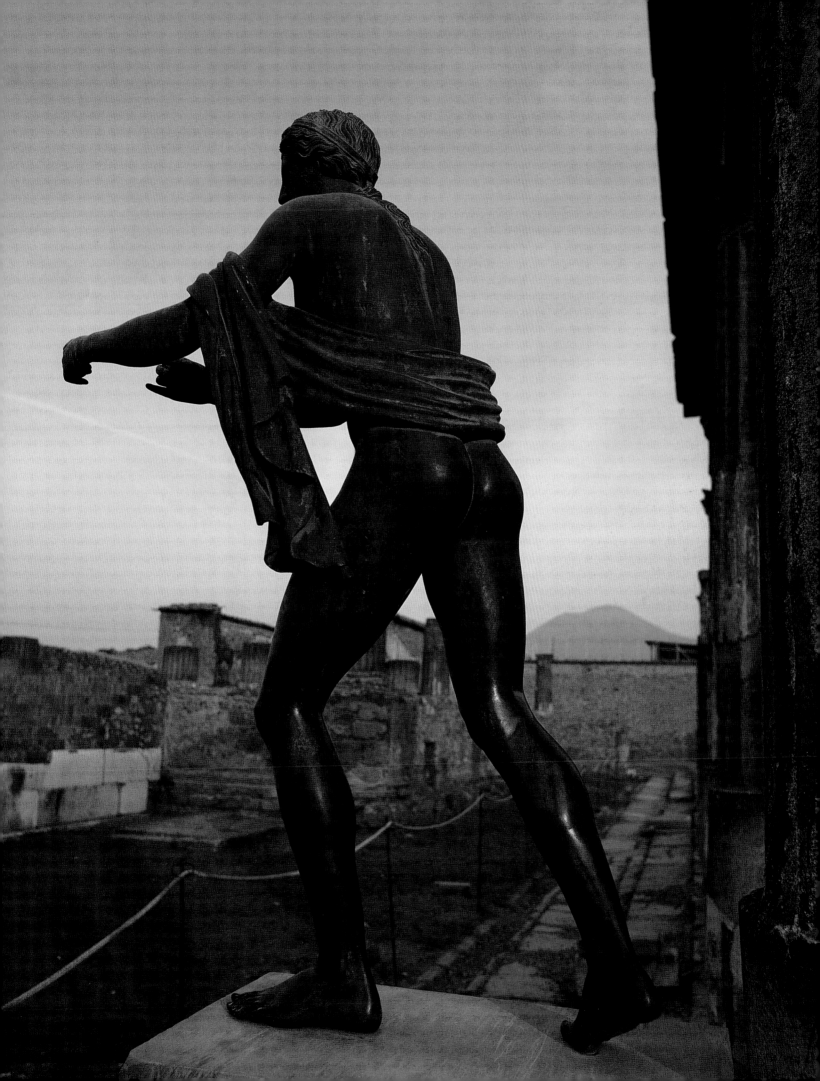

If you were the one suffering the fires of love, muleteer, you would be in more of a hurry to see Venus. I love a young and handsome boy; I beg you, spur on your mules. . . . You've finished your drink, let's go; take up your reins and shake them. Take me to Pompeii where my sweet love is waiting.[10]

In 80 BC Pompeii was rededicated *Colonia Cornelia Veneria Pompeianorum* in honour of the goddess Venus. Although the cult of Venus (formerly Aphrodite) had religious roots in the city as the worship of a goddess of life and death, the Romans transformed her into a goddess of love and beauty.[11] A marble temple in the Corinthian order was constructed in an enclosure, with porticoes on three sides. The Pompeians took to Venus easily and her influence is everywhere. The Venus of Pompeii was a favourite subject for artists and her name was invoked in graffiti by the amorous. 'Portumnus loves Amphianda, Januarius loves Veneria. We pray Venus that you should hold us in mind. This only we ask you.' But Venus could also be the subject of derision if love turned sour. 'Calling all lovers! I want to break Venus' ribs with clubs and cripple the loins of the goddess. If she can pound my soft chest, why shouldn't I be able to smash her head in with a club?'[12]

Above all the gods stood Jupiter. The Temple of Jupiter maintained the most prominent position in Pompeii at the north end of the Forum. During the Romanization of Pompeii the original modest temple was transformed into the Temple of Jupiter Optimus Maximus Capitolinus, or simply the Capitolium. This

The Temple of Venus. The goddess was a figure of particular veneration among the people of Pompeii. Sulla's colony at Pompeii was dedicated to her in 80 BC. The temple complex was undergoing expansion at the time of the eruption. Today, little remains of the formerly magnificent Corinthian structure which once stood near the Via Marina.

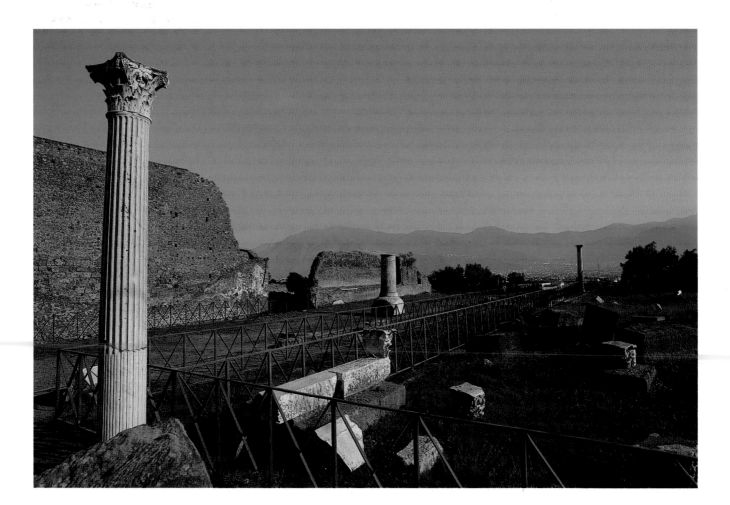

grand and imposing structure, rising above the Forum, its effect enhanced by the silhouette of Vesuvius behind it, was dedicated to the worship of Jupiter, Juno and Minerva, the triad of gods who were the protectors of the Roman state. Once again the state and the divine came together: the chambers below the main hall were used to store not only sacrificial offerings but also the treasury of the city. In the earthquake of AD 62, the Capitolium was severely damaged and its fine portico collapsed, as depicted on a bas-relief in the house of Lucius Caecilius Iucundus. The worship of the holy triad was then transferred to a smaller, much older Oscan temple in the Theatre District traditionally known as the Temple of Jupiter Meilichios.

By the first century AD, Apollo, Venus and Jupiter, with their powerful and well-established cults, were not the only gods and goddesses to be venerated. New cults which offered their initiates an alternative to state-sanctioned, materialistic religions began to surface. They took a more personal approach, requiring more participation and the acceptance of prescribed mysteries. These mystery cults, often eastern in origin, introduced new religious concepts such as moral codes and the belief in an afterlife. The two most fashionable of these cults were those of the Egyptian goddess Isis and of the wine god Bacchus, also known as Dionysus.

The cult of Isis was one of the fastest growing religions in the Roman empire and had reached a high level of popularity in Pompeii, which held two annual festivals dedicated to the goddess and dramatic daily ceremonies. Isis, the glory of women and the goddess of ten thousand names, offered her followers initiation into the mysteries of Egypt, where she had resurrected her husband Osiris. Her power was such that she could deliver the same to those who worshipped her. The Temple of Isis in Pompeii was located near the Theatre District, hidden behind a high wall to shield its ceremonies from view, and lavishly adorned with frescoes and reliefs. It even housed a subterranean reservoir containing sacred Nile water.

Initially, the congregation consisted mainly of those slaves and freedmen who could afford to pay the temple dues, but the cult's popularity was growing among

ABOVE LEFT The Capitolium sat at the north end of the Forum and served as the Temple of Jupiter, Juno and Minerva, the triumverate of gods which protected the Roman state. Beneath this imposing structure was the city treasury, whose vaults contained large hordes of gold.

ABOVE RIGHT The Temple of Isis was the main centre in Pompeii for worship of the Egyptian goddess, whose mystery cult promised life after death and commanded one of the wealthiest followings in the city.

the upper classes. The wealth accumulated by the cult became legendary, and the temple was one of only a few to have been completely rebuilt following the earthquake. According to the inscription on the temple, a freedman, Numerius, paid for this restoration, yet he gave the credit to his son Popidius Celsinus, who was admitted to the decurionate – and therefore admitted to the upper classes – when he was only six years old.

While Isis enchanted with the ancient mysteries of far-away Egypt, Bacchus offered a darker inward journey into the uncontrollable elements of human nature. Bacchus, god of the vine, was the son of Jupiter who died each winter and rose again in the spring. His unrestrained worship inspired orgiastic stupor or spasmodic dancing, blurring the boundaries between sanity and madness, life and death.

Novices to the cult were required to abandon themselves to the deity and to undertake the rigorous and sometimes terrifying Dionysian rites in an attempt to reach spiritual union with Bacchus, who, like Isis, offered the promise of life after death. A form of these rites, carried out by a series of mythological characters, is depicted in striking colour on the walls of the Villa of the Mysteries. The cult of Bacchus was not looked upon favourably by the imperial authorities, who thought its expressive and emotional rites too lascivious and a threat to public order. Their condemnation and prohibition of the religion only made it stronger, as the clandestine nature of its worship gave it an added attraction. Like the Temple of Isis, the Temple of Bacchus, which was in a secret location south of the city, on what is now known as the Hill of Sant'Abbondio, was soon rebuilt following the great earthquake.

RIGHT A fresco depicting the pageantry and mystery of the cult of Isis during its daily ritual of the ceremony of the lustral waters. Such sensational ceremonies were one of the chief draws of the cult.

OPPOSITE A painting of Bacchus at the foot of Mount Vesuvius. Below him writhes the serpent Agathodemone, meaning 'the good god'. This painting was found in the lararium of the House of the Centenary.

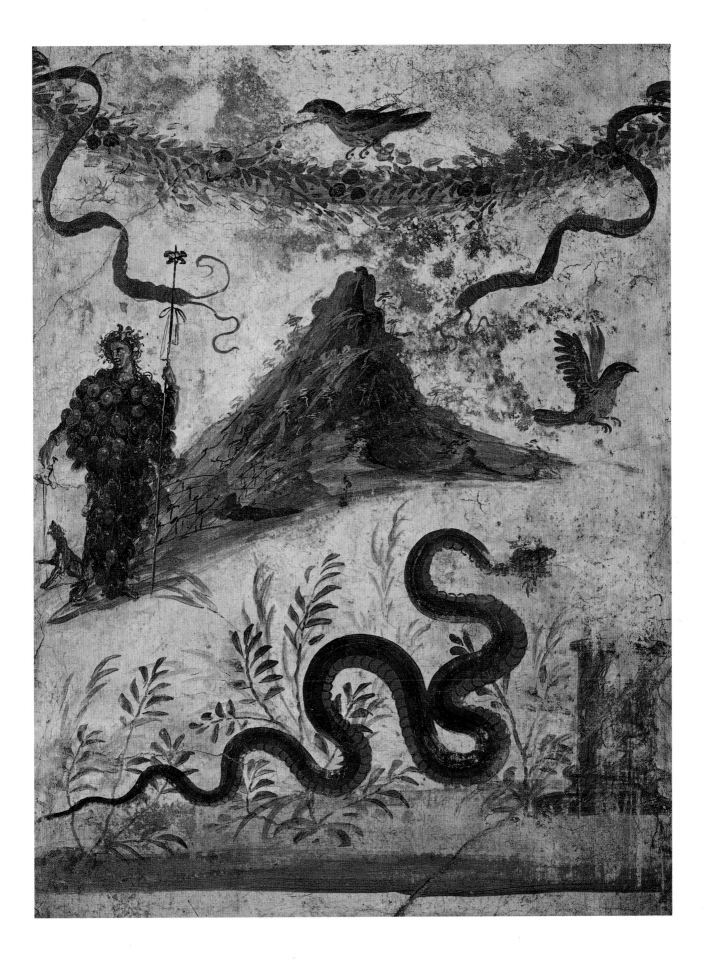

LUCRUM GAUDIUM: PROFIT IS JOY

The ruined doorways of an endless series of shops line the Via dell' Abbondanza, Pompeii's main commercial street in the first century AD. Once, this street bustled with crowds buying and selling, drinking and eating, as they promenaded from the Forum to the Amphitheatre. On summer days, the street is often still bustling as the city's new consumers, tourists, stroll down its cobbled length.

In the Roman world the pursuit of profit was considered almost a sacred duty. Those who accumulated wealth were seen as favoured by the gods, while those who did not were objects of scorn. 'I detest beggars. If somebody asks for something for free, he is an idiot; let him pay his cash and get what he wants.'[13] Images of Mercury, the god of commerce, were displayed prominently in order to obtain his blessing. A commercial spirit ran through all classes of society and the opportunity to make money was not the exclusive right of the patrician families. During the last stages of Pompeii's development there were many freedmen who had amassed fortunes, while some aristocrats were forced to rent out rooms.

For most of Pompeii's history the Forum, which served as the seat of politics, was also the city's commercial centre. This changed later on as shops began to spring up everywhere. As Pompeii grew in wealth, work that used to be done in people's homes was reduced by, for instance, the growth of the baking industry and the opening of public laundries. The development of service trades had a significant effect on Pompeii's urban fabric. The Via dell'Abbondanza, once lined with fine mansions, eventually became a bustling thoroughfare of trades and services as shops took over the front chambers of houses. Shops also appeared around other centres of activity such as the main bath complexes.

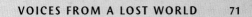

Hic habitat felicitas
('Here dwells happiness')

INSCRIPTION ON A BAKERY
WALL IN POMPEII

The Macellum, located on the
east side of the Forum, served as the
primary market for Pompeii. Within its
walls took place a bewildering range of
activities, from the purchase and sale of
meat, fish, fruit and olive oil to the
worship of the imperial cult and the
exchange of currency.

The Forum still held strong as the traditional centre of commerce and the
headquarters of many of the markets and guilds of the city. Beneath its
colonnades, stalls were set up selling everything from shoes to items imported
from across the Roman world and beyond. Evidence has been discovered that
Spanish olive oil, Indian ivory and furniture from nearby Naples or Capua were
all for sale in Pompeii as consumers sought superior products from other
countries as well as purchasing homegrown items.[14]

The main market building on the Forum was the Macellum. Patrons passed
through a shrine to the emperor (*chalcidicum*) and entered a dynamic world of
sights and smells, with stalls selling meat and fish, auctioneers hawking their
goods and money-changers counting coins, all under the nonchalant gaze of the
statues of the imperial family and other local notables. On market days vintners
and farmers from suburban Pompeii came into the city to sell their products to
shop owners and the public. Wine, olives and grain were the primary agricultural
products of the estates and farms in the vicinity of Pompeii.

Pliny was a great admirer of the wines of Campania. The wines referred to as
'Vesuviana' were among his favourites, as the rich volcanic soil seemed to produce
superior grapes, said to be the result of the victory of the gods of wine over the
gods of grain.[15] There was also a specific group of wines known as 'Pompeiana';
however, Pliny complained that they had a lifespan of only ten years and tended
to produce the most brutal of hangovers. Pompeians preferred to mix their wines
with water and to add other ingredients, including honey, milk, ashes, lime,
almonds and seawater, to enhance their flavour.[16]

Pompeii and its environs were also renowned for olive groves and pressing
facilities. Cato, in his treatise on farming written in the second century BC,
specifically mentions the mills in Pompeii and nearby Nola as being the best in
Italy. The pressing of olives normally took place on the farms outside the city and

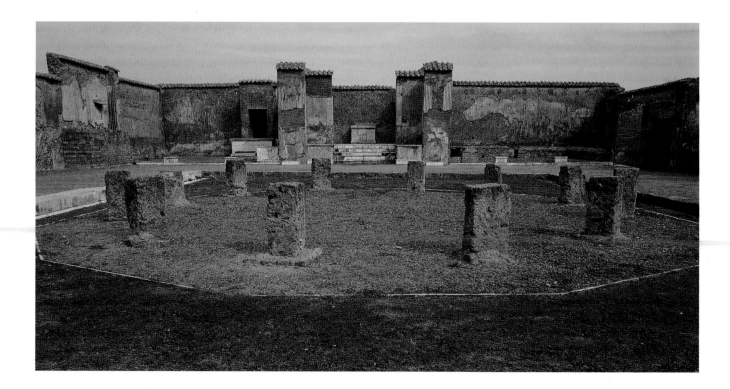

LEFT Wine played an important part in the life and commerce of Pompeii. Vineyards proliferated in the volcanic hills around the town and wine was widely consumed. Particularly popular was hot wine sold at taverns throughout the city. These amphora, used for storing wine, are now kept near the Forum.

BELOW A food counter in Pompeii. Counters such as these provided the ancient equivalent of fast food or ready-prepared meals to be eaten at the counter or on nearby tables.

BOTTOM A fresco from the House of the Vetti depicts winged cherubs pouring and drinking wine. Scenes of drinking were common subjects for frescoes.

ABOVE LEFT A petrified loaf offers a glimpse into the daily life of Pompeii, which continued until the day of the eruption. Bread was one of the main staples of the Pompeian diet and Pompeii boasted no less than thirty-one bakeries and cake shops. This type of bread with a circular shape and cut into slices became popular during the reign of the emperor Augustus.

ABOVE RIGHT Mill stones carved from lava-rock were used to grind flour for the use of the bakery. The mechanism was rotated by a donkey. Milling areas were kept paved to prevent the animals from digging treads in the ground.

OPPOSITE Mural in the Bakery of Sotericus. Archaeologists have found evidence that often bread was made in bakeries and then transported for sale to storefront shops such as the Bakery of Sotericus on Via dell'Abbondanza. This mural found in the shop is a rare image of daily commerce: a shop owner hands over a loaf to a patron, whose apparently hungry son reaches for the bread.

the oil was then carried in to be sold in shops alongside other produce. There is even a theory that there was a specific olive market situated in the Granary (*holitorium*) of Pompeii.

The Granary is thought to have occupied a building located directly across from the Macellum on the west side of the Forum. It was here that dried cereals were sold to individual buyers and to the bakeries. There were about thirty of these small independent bakeries occupying what were formerly private residences. Once the grain was purchased it was brought back to the bakery for refining. This was done using mills made from volcanic rocks. The mill consisted of three separate parts: a fixed conical stone called a *meta*, a masonry base with a *lamina* to collect the flour and a *catillus* described as 'a moving element with a double truncated-cone shape whose upper part served as a funnel wherein the grain is poured'.[17] As the *catillus* was turned by a mule, the grain was crushed and filtered down into the *lamina*.

Bread was baked in ovens alongside the mills. These were heated by burning vine faggots. Once the oven bricks became white hot, the cinders were removed, the oven was cleaned and small round loaves with sectional cuts were placed in the ovens for baking. Bread loaves were then transported to separate shops along the main avenues and stalls at the different markets. At the Bakery of Popidius Priscus several of these loaves of bread, nearly two thousand years old, were recovered during excavations. They serve as a startling reminder that daily living continued in Pompeii to the very end.

Another mainstay of the Pompeian diet, and one of the major industries of the city's economy, was *garum*, or fish sauce. Pompeii had a small port on the River Sarno. Here, fishermen from the Bay of Naples hauled their catches into the city markets for sale. The Macellum had tanks for live fish and sold salted fillets as well, but many fish were purchased for the production of *garum*. This

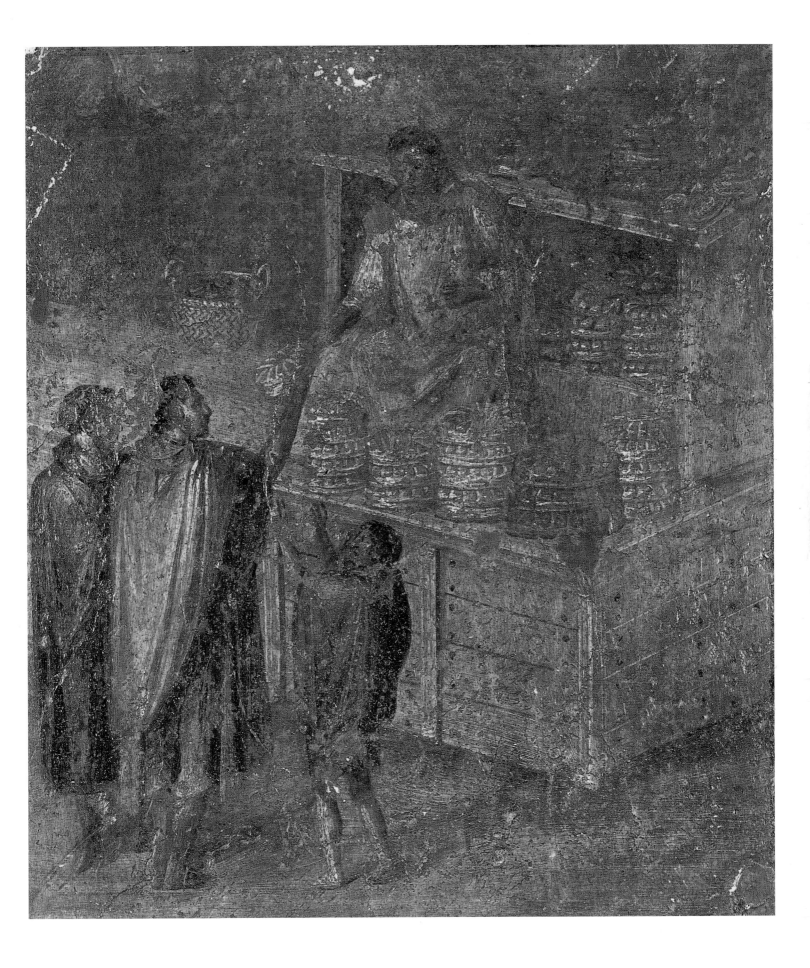

sharp-flavoured sauce was made from the entrails of sardines mixed with ground-up fish parts and roe. This potent concoction was hammered, crushed and left to ferment and evaporate in the sun over a period of six weeks. Once completed, the pulp was placed in great sieves to allow an oily deposit to filter through. The remains, called allec, were served as a delicacy, and the oil was jarred and sold as *garum*. A prominent figure by the name of Marcus Umbricius Scaurus, whose name appears in inscriptions as the benefactor of buildings and gladiatorial spectacles, made his fortune in the *garum* business.

This mosaic depicting the *fruiti di mare* shows the various species of fish and molluscs that were familiar fare in ancient Pompeii.

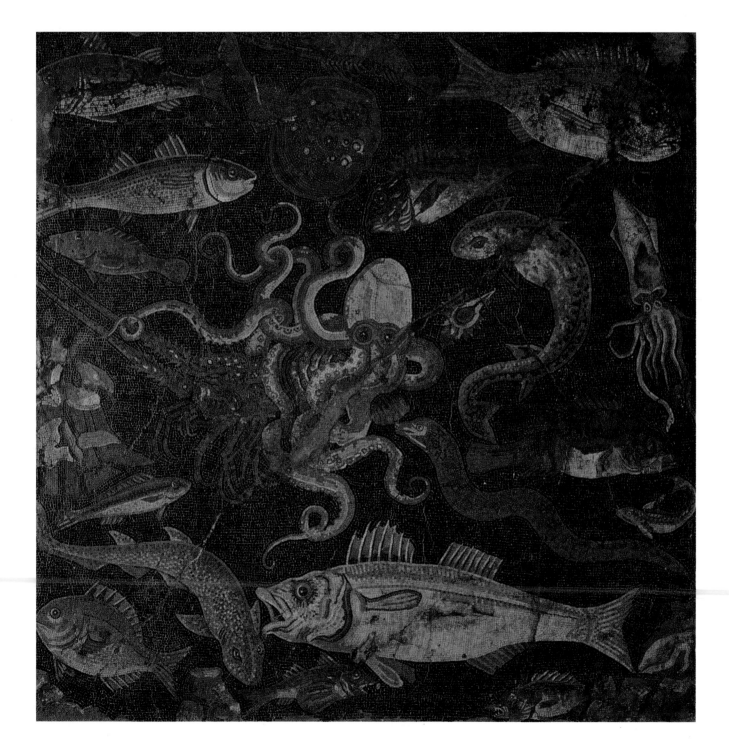

Besides the production and sale of foodstuffs and perishable items, Pompeii's most important industry was wool. Herds of sheep roamed the lush fields of the southern end of the Bay of Naples, and each season they were shorn and the wool taken to market. It has been conjectured that the wool market was based in the Eumachia, an impressive building on the east side of the Forum, and that this edifice was the headquarters of the Fullers' Guild, who were responsible for the washing, dyeing and manufacture of wool cloth. Actual fulling was carried out in separate laundries located all over Pompeii. Here raw wool was washed, stretched and dyed. These establishments often produced fabrics and cleaned clothing as well.

The Eumachia was built and dedicated in her own name to Augustan Concord and Piety by the priestess of the imperial cult, Eumachia, and in the name of her son Numistrius Fronto, the future duovir, who was at the time running for election.[18] Eumachia was perhaps Pompeii's greatest female citizen and the only one known to be the patroness of such a prominent public structure. She was a scion of an old and influential Pompeian family that owned vineyards and brickworks, also playing a part in local politics. Eumachia was inspired by Livia, who had built and dedicated her own collonade to Augustan Concord in Rome, upon the ascension to the throne of her son Tiberius in 7 BC.[19] Eumachia placed a statue of the empress Livia as Concordia Augusta in the central apse overlooking the courtyard. Another statue was later erected of Eumachia herself, carrying the inscription: 'Dedicated by the Fullers to Eumachia, daughter of Lucius.'

There were many other guilds in Pompeii, such as Carpenters, Fruitsellers, Goldsmiths, Wheelwrights and Plumbers. While these guilds were not as powerful as the Fullers, they nonetheless contributed much to the rich diversity of the city's economy.

BELOW A detail of the intricately carved architrave of the monumental entryway to the Eumachia building in the Forum.

BOTTOM The Eumachia building was named after Pompeii's most prominent female citizen, the priestess Eumachia. It was possibly used as a wool market.

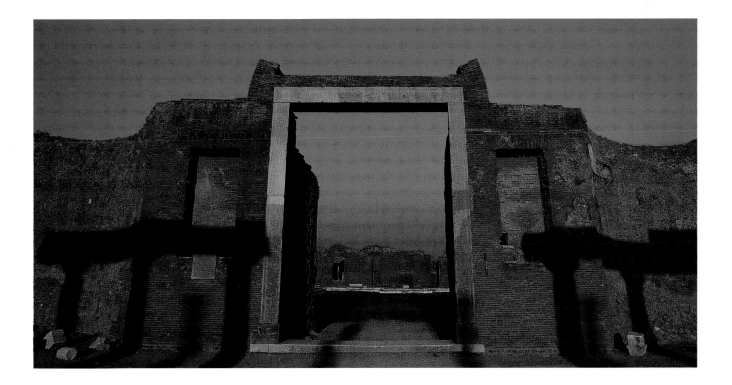

LET THE GAMES BEGIN!

Not far from Pompeii, in the Villa Pisanella, a curious but revealing set of artefacts was found: splendid silver cups carrying the image of a skeleton and an inscription 'Enjoy life while you still have it.' Skulls and skeletons appear in mosaics and frescoes all over Pompeii and its environs. Michael Grant, in *Cities of Vesuvius* (2001), has described this type of decoration as evidence of the Pompeian's belief in a 'low-grade' Epicureanism – a philosophy that denies the existence of any life after death and seeks a life free from pain. Whereas Epicurus, teaching in Athens in the fourth and third centuries BC, believed in achieving this through austere living, by the first century AD many interpreted this philosophy as an endorsement to indulge themselves. Whatever the reasons for the Pompeian quest for diversion and pleasure, during its final decades the city provided its citizens with numerous distractions from the uncertainties of life and the hereafter.

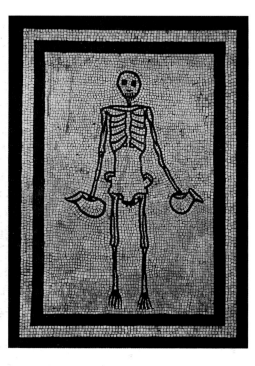

ABOVE A skeleton holds pitchers, perhaps of wine. Skeletons and skulls were a popular theme throughout Pompeii, ever reminding its citizens to 'Enjoy life while you still have it.'

RIGHT The sun illuminates a corridor used by audience, gladiators and actors alike to gain entrance to the pit of the Large Theatre.

Pompeii's earliest venue for entertainments and spectacles was probably the Forum. Here, festivals were celebrated and parades took place. However, some time between the end of the third century BC to the middle of the second century BC, a large theatre was constructed in a natural hollow adjacent to the ancient Triangular Forum. During the pre-colonial period the theatre, or the Large Theatre as it became known, was used for gladiatorial matches, spectacles and plays. During the Augustan period, the freedman architect Marcus Artorius Primus dramatically transformed this rustic theatre, enlarging it to seat 5,000 people. He gave the theatre a veneer of fine marbles and an enormous scenery wall (*scaenae frons*), all paid for by Marcus Holconius Rufus, a pre-eminent Roman colonial official of the period, and his brother Marcus Holconius Celer, who were honoured with commemorative plaques, statues and a *bisellium*, the proverbial best seat in the house.

The Large Theatre of Pompeii was initially used for gladiatorial games and blood sports. This use later changed during the years of the Sullan colony and the Augustan period, when the theatre was embellished with fine marbles and enlarged to allow larger audiences to enjoy Greek tragedies and Oscan comedies.

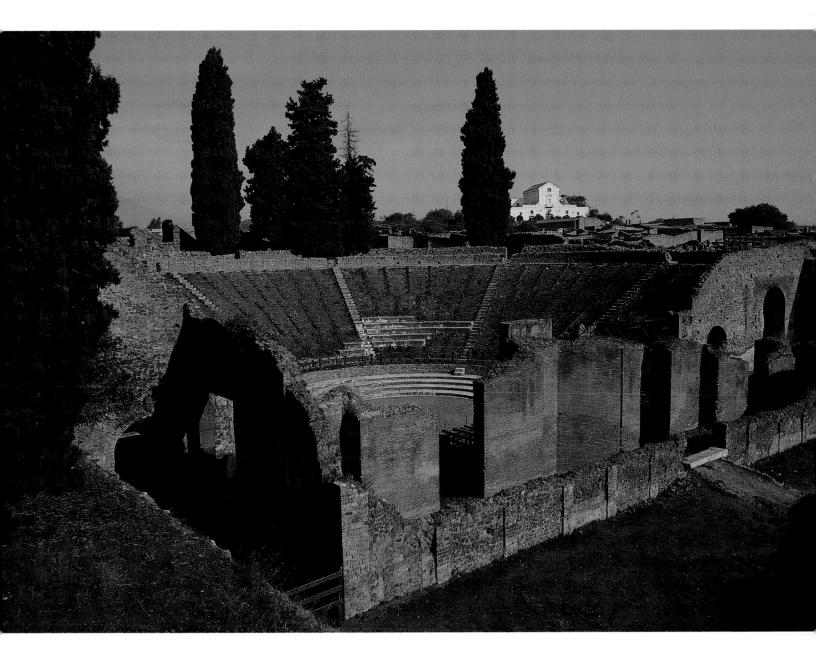

Early Pompeians most likely enjoyed plays in Oscan portraying the bawdy antics of Maccus the Fool, Bucco the Simpleton, Pappus the Cuckold and Dossenus the Trickster.[20] Later, these plays would run alongside more sophisticated Greek tragedies and comedies by Seneca. A particular favourite was the work of Menander, who wrote comedies of manners depicting the lives of different classes of society.[21] Pompeii even had its luminaries of the stage. Inscriptions tell of the prowess of the actor Lucius Domitius Paris, friend of the emperor Nero. Paris had his own fan club and was described as 'Paris, pearl of the stage'.

The second great venue for the performing arts in Pompeii was the Odeon. Described classically as the *theatrum tectum*, or roofed theatre, the Odeon was the first public structure to be completed by the new colonial class in 80 BC and accommodated up to 1,500 people. With its steep seating and small size, it was acoustically perfect for speeches and performances. It was built by two wealthy and prominent colonial philanthropists, Gaius Quinctius Valgus and Marcus Porcius. At first the Odeon served as a place where the new colonial class could come together, but later it evolved into a venue that was used for lectures, poetry readings, concerts and more refined dramas.

In terms of entertainments, the greatest architectural contribution of the early colony was undoubtedly the construction of the Amphitheatre, the oldest known structure of its kind built specifically for gladiatorial combat entertainments. An inscription proudly proclaims the beneficence of its

RIGHT A mosaic from the tablinum of the House of the Tragic Poet. The house, whose original owner is unknown, is named after this mosaic, which depicts the preparation for a performance of a satyr drama.

OPPOSITE:

ABOVE Tiers of seats at the Odeon, Pompeii's small yet sophisticated performance arena. Although it was used at first as a meeting place for the Sullan colonists, it later evolved as the premier venue for lectures, poetry readings, concerts and refined drama.

BELOW LEFT A carved Atlas punctuates the great arc of the tiered seating.

BELOW RIGHT Seating at the Odeon was arranged by class. Here, the carved rows of seats of the general public give way to the broad slabs of the lower tiers where the magistrates and their guests placed comfortable chairs brought from home.

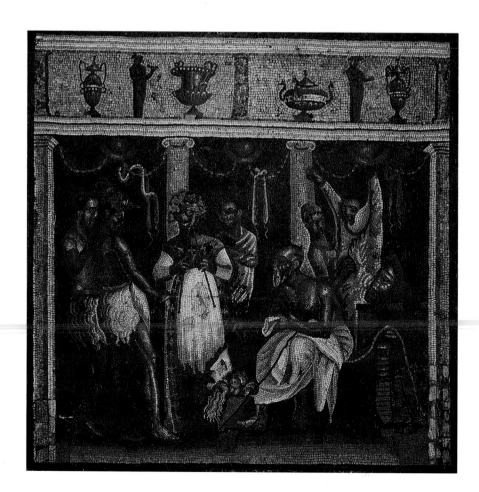

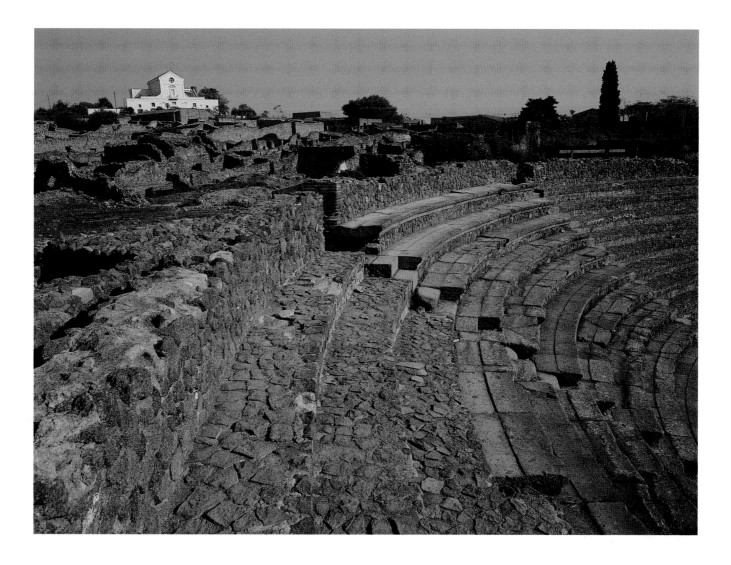

patrons: 'Gaius Quinctius Valgus, son of Gaius, and Marcus Porcius, son of Marcus, in their capacity as duovirs, to demonstrate the honour of the colony, erected this place of spectacle at their own expense and donated it to the colonists for their perpetual use.' The Amphitheatre, or *spectacula*, was an elliptical structure with thirty-five rows of seating capable of holding 20,000 spectators.

Gladiatorial games were by far the most popular form of entertainment in Pompeii. The tradition of gladiatorial combat came to Pompeii from its Samnite ancestors and continued through the centuries. The games were usually split into two parts: first, combats between ten to forty-nine pairs of gladiators, then combats with animals. Gladiators were trained in special schools and were recruited and sponsored by wealthy impresarios, many of whom had political ambitions. Sponsoring matches was always a popular method of winning votes. Gladiators in Pompeii were also honoured as heroes and portrayed in frescoes and mosaics. One particular celebrity was 'the ladies choice', Celadus the Thracian, and Crescens the net-fighter was also known for his sexual prowess, as graffiti on the wall of the Gladiators' Barracks declared that he gave girls 'the medicine' they needed at night. Inscriptions about gladiators, proclaiming matches, heralding victories and praising heroes are numerous and attest to the fact that Pompeii was caught up in a fever for the sport:

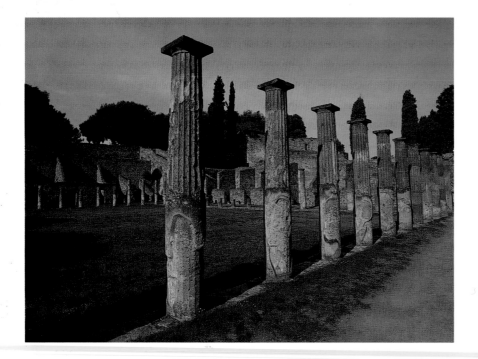

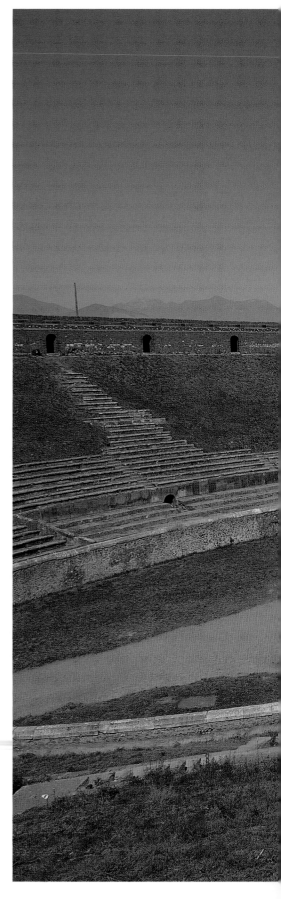

ABOVE **The Gladiators' Barracks, located within the Theatre District. It is widely supposed that this building served as a gathering place between theatre acts. However, gladiatorial equipment found here suggests a change in use in the last years before the eruption.**

RIGHT **The great Amphitheatre of Pompeii, another of the civic improvements during the years of the colony, which played host to gladiatorial games and blood sports.**

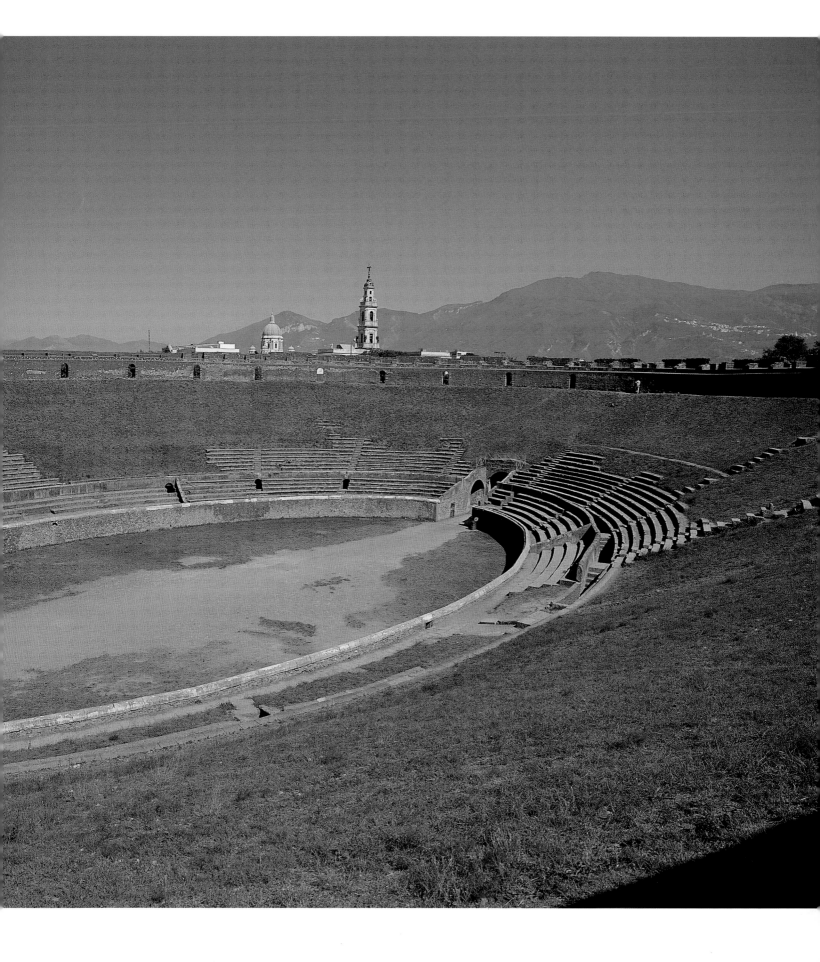

Twenty pairs of gladiators of Decimus Lucretius Satrius Valens, lifetime *flamen* [priest] of Nero Caesar son of Augustus, and ten pairs of gladiators of Decimus Lucretius Valens, his son, will fight at Pompeii on April 8, 9, 10, 11, 12. There will be a full card of wild beast combatants, and awnings.

A centre for competitive athletic and military-style training, the large Palaestra was situated next to the Amphitheatre. The building, which comprised a large open field flanked on three sides by a portico, was also equipped with a swimming pool and a chapel devoted to the imperial cult.

Pompeians' dark obsession with the bloodsport of the gladiatorial games was seldom criticized or seen as in any way contradictory with the mores of the time. The violent nature of the sport, however, encouraged fierce rivalries between the Pompeians and their guests from local cities. One visitor scrawled on the wall of the Amphitheatre: 'Happiness to the people of Pozzuoli! Prosperity to all from

Nuceria! The meathook for the Pompeians and those of Pithecusa!' It was the rivalry between Pompeii and Nuceria that lead to the infamous riot in AD 59 in which several Nucerians were killed, after which the games were shut down for ten years and its officials sent into exile.

Sport and competition had more positive manifestations in Pompeii's athletic fields next to the Amphitheatre, known as the Palaestra. The emperor Augustus believed that it was his responsibility to prepare the youth of the upper classes for their future in public service. It was his belief that he could improve the mental and physical condition of these young men through the encouragement of athletics and games. Once the athletic grounds in Rome were completed they were copied throughout the empire. Pompeii's Palaestra was a large enclosed area lined with plane trees with colonnades on three sides and a large swimming pool in the centre. It was decorated with statues displaying male physical perfection such as the perfectly proportioned male nude *doriphorus* (lancethrower) of Polyclitus. The field was used for a variety of activities ranging from exercise and sports, such as wrestling and discus throwing, to slave auctions and cockfighting.

There was a distinctly military flavour to the endeavours of the Palaestra. Augustus had sparked a movement known as the *Juventus*, which organized the regimen of the Palaestra into military activities such as parading in armour and equestrian battles in the style of the Trojan Games, also revived under Augustus. These events were open to the public, who enthusiastically came to watch. This type of paramilitary activity was essentially just for show: few young upper-class Roman men of the peninsula would be called to the service of the empire, which was largely left to professional soldiers and barbarian mercenary armies.[22]

Sport and exercise were by no means only for gladiators and young people in Pompeii. Bath complexes throughout the city and its environs offered their own athletic facilities in tandem with the various bathing rooms on offer. A visit to the baths was one of the central social and physical distractions of Pompeii. Five bathhouses have been excavated in Pompeii: the Stabian Baths, the Forum Baths, the Central Baths, the Amphitheatre Baths and the Suburban Baths. There was even a small private bathhouse run from the Praedia of Julia Felix. The number and size of these various complexes attest to their importance as well as their popularity. These buildings are some of the largest in Pompeii, taking up entire city blocks and using elaborate architectural elements such as concrete domes not generally employed on other buildings. Following the great earthquake in AD 62, the restoration of the baths was one of the highest priorities of the municipal authorities and they were restored with incredible speed. The baths were a hive of activity with people exercising, socializing, selling and working. Seneca once made the mistake of taking lodgings near the baths:

If you want to study, quiet is not nearly as necessary as you might think. Here I am, surrounded by all kinds of noise (my lodgings overlook a bathhouse). Conjure up in your imagination all the sounds that make one hate one's ears. I hear the grunts of musclemen exercising and jerking those heavy weights around; they are working hard, or pretending to. I hear their sharp hissing when they release their pent breath. If there happens to be a lazy fellow content with a simple massage I hear the slap of hand on shoulder; you can tell whether it's hitting a flat or a hollow. If a ball-player comes up and starts calling out his score, I'm done for. Add to this

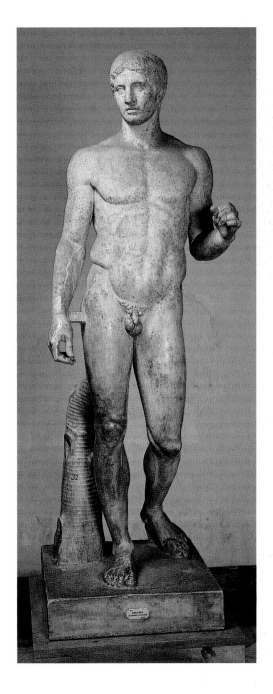

This marble statue of the *doriphorus* (lancethrower) was placed in the Palaestra as an example of male physical perfection. It is a Roman copy of a bronze statue by the Greek sculptor Polyclitus.

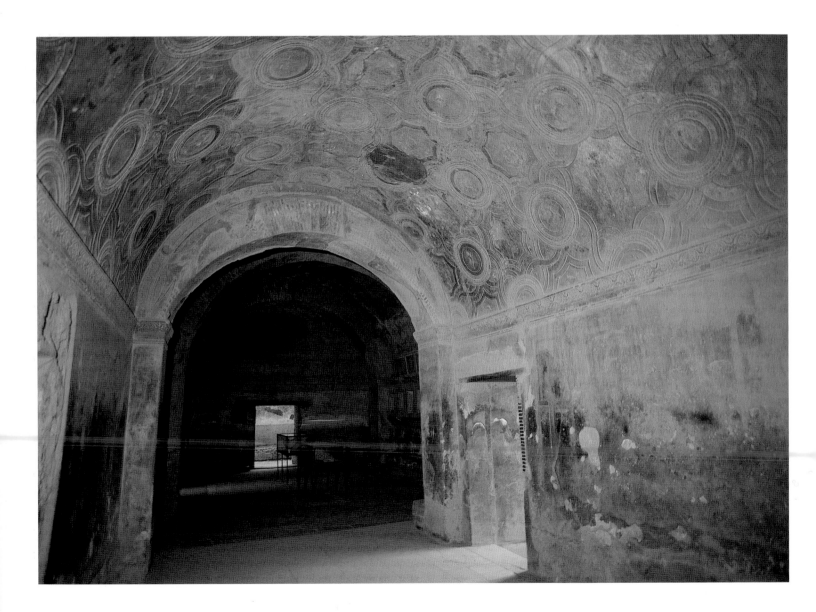

the racket of a cocky bastard, a thief caught in the act, and a fellow who likes the sound of his own voice in the bath, plus those who plunge into the pool with a huge splash of water. Besides those who just have loud voices, imagine the skinny armpit-hair plucker, whose cries are shrill so as to draw people's attention and who never stops except when he's doing his job and making someone else shriek for him. Now add the mingled cries of the drink pedlar and the sellers of sausages, pastries and hot fare, each hawking his own wares with his own particular peal.[23]

The baths opened around midday following the lighting of the furnaces. With the sound of gongs and shouts from the slaves, patrons were called in. The baths consisted of a series of rooms to allow visitors to circulate from cold to hot. Many of the rooms were luxuriously adorned with mosaics and plasterwork. The baths catered to men and women of all classes with separate sections for each sex. Bathers entered off the street and proceeded to the *apodyterium*, where they would disrobe and where servants waited for their masters. Patrons were usually

OPPOSITE The lavishly decorated Stabian Baths was one of the largest bathhouse complexes in the city, with separate bathing rooms for men and women. Its decoration in polychrome stucco included not only complex architectural and geometric patterns but mythical and athletic figures as well.

BELOW The *caldarium* of the Forum Baths. Bathers would drink cool water from this large marble basin as they sat surrounded by steam.

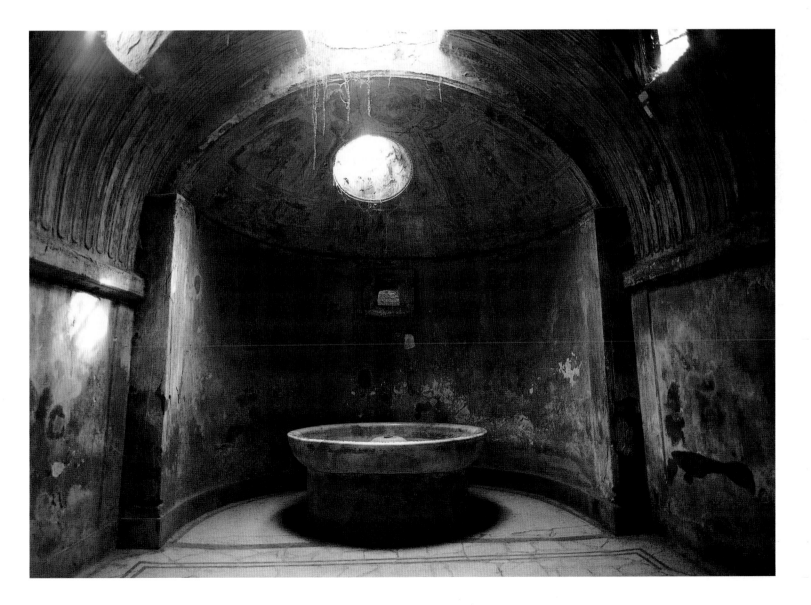

required to bring their own supplies such as oil, soda, scrapers and towels. Once undressed, bathers proceeded to the *tepidarium* (warm room) where they could store their bathing items and take warm baths. After this they moved into the *caldarium* (hot room), which was filled with steam at a temperature of 100°F. Bathers sat and drank cold water from the large marble basins or bathed in tubs provided. Following this they would return to the *tepidarium* for the application of oils and a massage. Finally, the last step in the process was a plunge into the cold pool of the *frigidarium*. Baths were also sometimes equipped with a *laconium*, a sauna with underfloor heating. Before or after bathing, patrons could use the gymnasium or swimming pools for either exercise or sunbathing.

Theatre, gladiatorial combats and bathing were not the only earthly delights that Pompeii had to offer. Pompeii was a large commercial centre with a constant flow of visitors. It housed this transient population in a multitude of taverns and inns. These establishments also catered to those with a taste for wine, which was often served hot as in Asellina's Tavern. While drinking, patrons could also watch a cabaret of dancing girls with castanets and pipes who performed in the gardens of certain inns:[24]

BELOW AND OPPOSITE The *frigidarium* of the Stabian Baths. Bathers plunged into a large pool of cold water and then cooled down as they sat in the niches, which were decorated with plasterwork, now almost completely lost. This room had a dome 20 feet in diameter with a large opening at the top. The dome was originally painted with a starry sky.

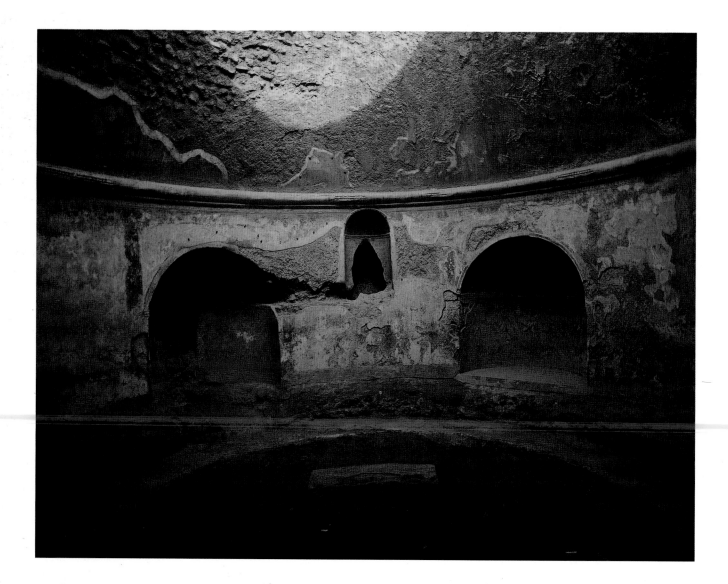

BELOW AND BOTTOM The restaurant of
Vetutius Placidus. The painted inscription
on the front wall declares him to be the
owner of the shop and of the house next
door. Many of these hot-food counters
were also attached to taverns and had
larger rooms at the back. There is a
lararium on the back wall dedicated
to Mercury and Bacchus.

A tavern-girl from Syria, head turban-wound Greek-style, an artist with her
sinuous hips, keeping time to the castanet – after a few drinks she dances
seduction in the smoky tavern, elbows flashing to the shrill of the flute.
What more pleasurable for a tired man than avoiding the summer's dust
reclining on a couch made for drinking?[25]

Gambling was another activity as popular at the baths as in the gaming parlours
and taverns. In an inscription in one tavern a gambler praised his winnings and
his honesty; other inscriptions listed the names of gamblers in arrears and the
amounts they owed, with interest.

Carnal pleasures were not to be neglected either. Alongside its host of taverns
and gambling establishments, Pompeii had an abundance of brothels, which
served the major commercial quarters and bathhouses. Here, customers were
usually freedmen or slaves, as wealthier patrons could afford to have prostitutes
brought to their homes or could simply take advantage of their own slaves or
servants.[26] At the brothels there was a choice of young women or men who were
there to offer their services for a fee. The brothels were by no means luxurious:
the rooms were usually small, with a straw mattress and sometimes erotic art on
the walls. Although there was a stigma attached to being employed as a prostitute,

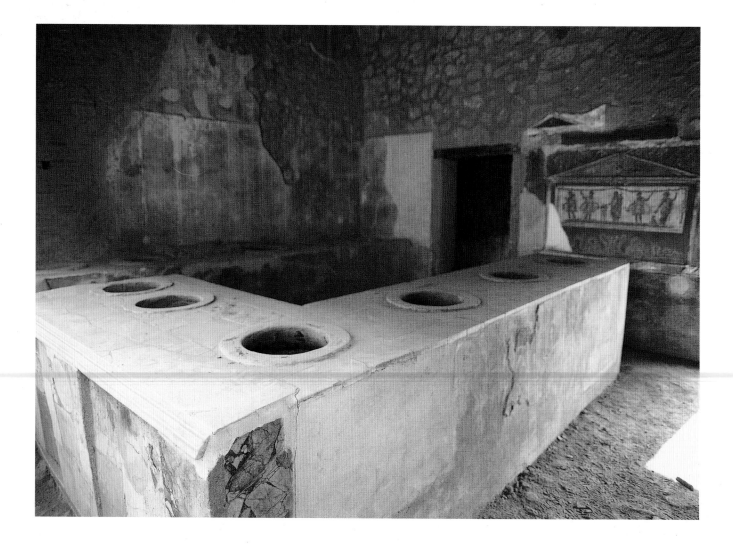

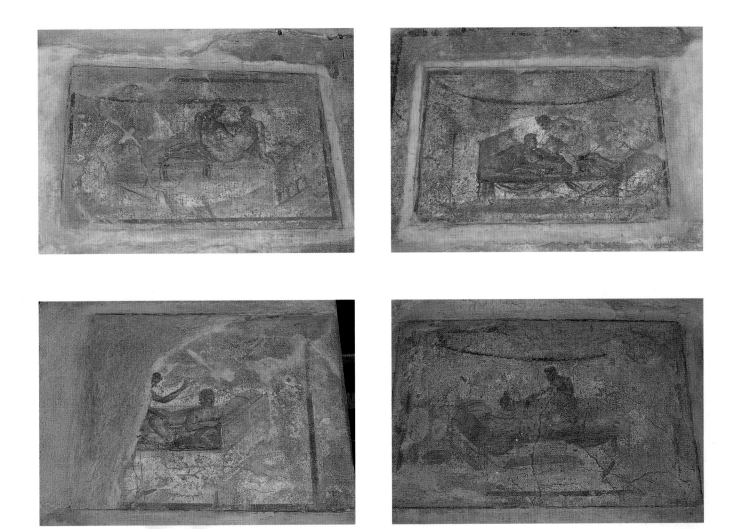

there was little dishonour in patronizing brothels unless you were of the upper classes or an office holder; nor was there any particular shame attached to heterosexual or homosexual acts.

Pleasure came easily to the Pompeians. The variety of attractions and distractions led the city to develop a rich and diverse world of leisure, which was used to the full by its doomed populace. It was almost as if they somehow knew they stood before the abyss, the twilight descending.

Now the crickets pierce the thickets with their repetitive cry, now even the speckled lizard takes shelter in the coolness. If you are wise, lie back and make a libation with summer-weight glassware, or, if you wish, we'll bring out the new goblets of crystal. Come, you are weary, rest in the grape arbour and bind your heavy head with a chaplet of roses. Cull kisses from a tender maid. Forget about those who raise old-fashioned eyebrows! Why keep fragrant garlands for ungrateful ashes? Do you want your bones to lie under a garland-carved stone? Set out the wine and the dice. To hell with him who cares for the morrow. Death plucks your ear and says 'Live now, for I am on my way!'[27]

There were twenty-five organized brothels in Pompeii at the time of the eruption. The majority were simple affairs with small rooms and straw mattresses. Scenes such as these would commonly adorn the walls of rooms to help to inspire customers, not necessarily as advertisements of particular skills.

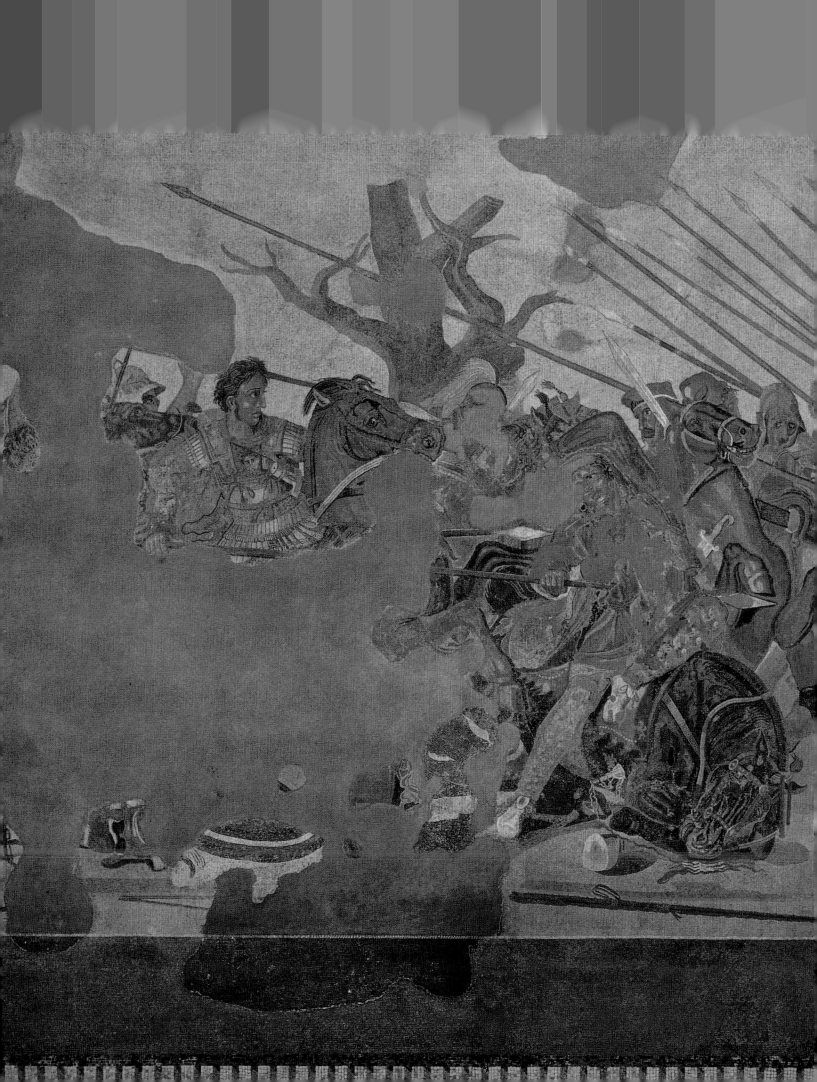

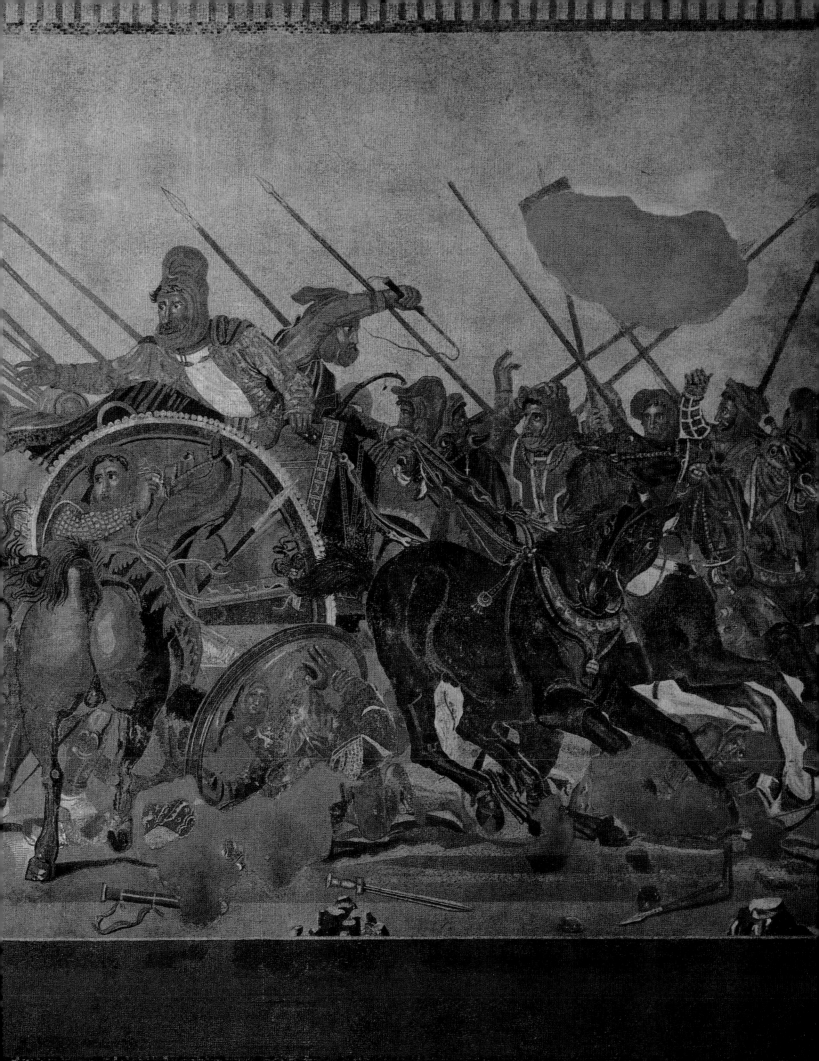

PREVIOUS PAGES An epic mosaic depicting the Battle of Issus, between Alexander the Great and Darius III, in 333 BC. Measuring 10 x 18 feet, the mosaic was found in the House of the Faun.

RIGHT The atrium of the House of the Silver Wedding. Built in the first century BC, this house is an example of a partially restored Pompeian mansion.

THE POMPEIAN HOUSE has been the subject of exhaustive study and research. The excavation gave archaeologists and historians their first collection of Roman houses spread throughout an urban setting. Such a wide range has allowed them to study and examine the evolution of Pompeian houses as the town grew from its infancy into a city of the Roman empire. Their observations of the changes in layout and design of these houses over time has led to a greater understanding of the lives of ordinary Pompeians, and perhaps even ordinary Romans. Much has been revealed about their occupants: their wealth, social standing and ambition, as well as the nature of privacy in Pompeii.

The houses in Pompeii possessed a self-contained grandeur. It was not uncommon for the grandest of houses to have shops along the street frontage or to give no exterior indication of the treasures within. These dwellings were designed to face inwards and few had ostentatious façades or overly ornate entrances. This was partly for security, as there was no police force in ancient Roman times and burglaries were common, but also because of the way the house functioned. The Pompeian house had not only to handle the climatic conditions of southern Italy, it must also create a private retreat where the owner could present himself to and entertain his friends and colleagues. It should be a safe environment for his family and servants:

> The slave shall wash and dry the feet of the guests; and let him be sure to spread a linen cloth on the cushions of the couches. Don't cast lustful glances or make eyes at another man's wife. Don't be coarse in conversation. Restrain yourself from getting angry or using offensive language. If you can't, go back to your own house.[1]

This inscription from the House of the Moralist provides insight into the environment one owner was trying to create. His rules show the visitor that this house was a sacred place, a private realm different and set apart from the vulgarities and filth of the public and the street. You could choose to leave that world at the door or, as the owner suggests, return to your own home. The inward-looking architecture of the Pompeian house reinforced this notion of a private domain turning its back on the public sphere, surrounding the occupants in a world of intimate rooms, courtyards and bubbling fountains.

HOUSING TYPES IN POMPEII

Professor Andrew Wallace-Hadrill, in his work *Houses and Society in Pompeii and Herculaneum* (1994), has studied meticulously the Pompeian house and its place in the urban texture of the city. During his investigations of various residential areas of Pompeii, he identified four types of house found throughout the city at the time of the eruption. Categorized largely by size, function, architectural features and decoration, the four types are a helpful way to begin to understand the variety and the evolution of the Pompeian house.

Type I comprises the smallest of dwellings: the shops or workshops. These utilitarian structures are generally made up of just one or two rooms. Not all of them served as residences and many were left unoccupied at night as their proprietors lived in other areas of the city, returning to these shop fronts to work. There were numerous shopkeepers, however, who lived in rooms behind or above

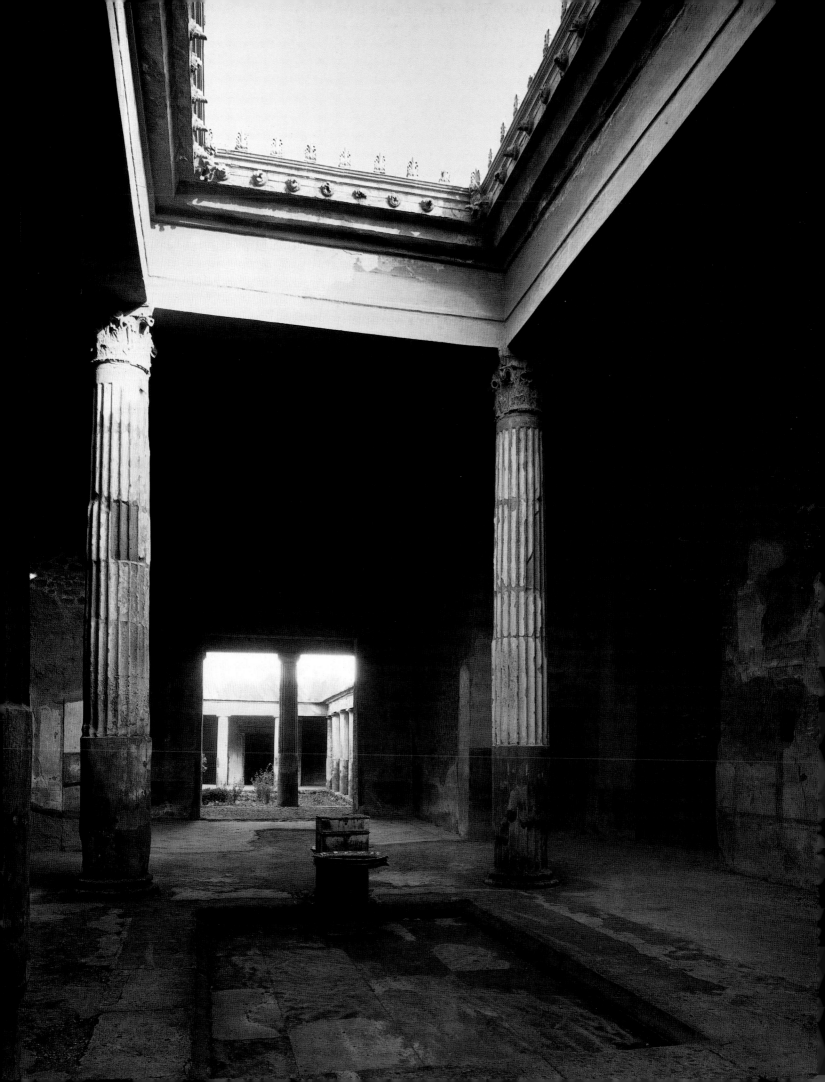

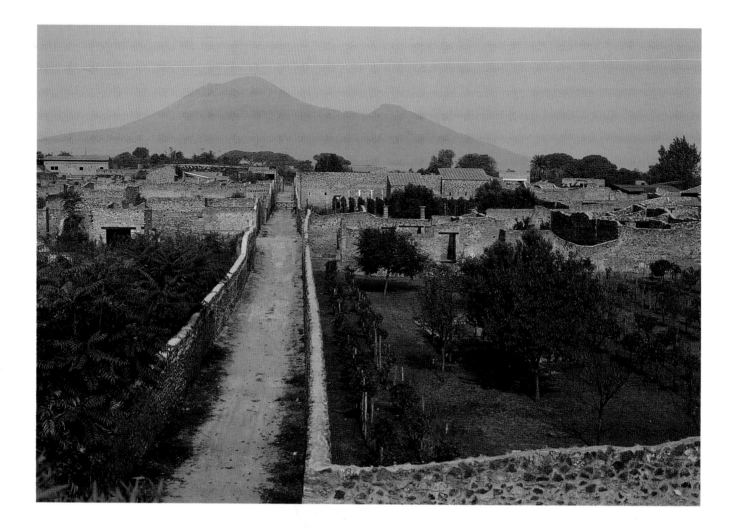

The Via Stabiana, one of many long avenues in Pompeii lined with richly decorated houses. At street level, there is little evidence of the treasures to be found behind the houses' modest doors. In this southeastern district of the city near the Amphitheatre, many houses have large gardens and even small vineyards.

their businesses. These units are commonly incorporated into larger houses, but some remain separate buildings entirely.

Type II are larger workshops/residences with anything from two to seven rooms on the ground floor. Lacking any regular plan, some of these houses have a few features in common, such as an atrium (a large central circulation space) and an impluvium (a rainwater basin), but these appear only in the largest houses of this type. Smaller houses tended to have, instead of an atrium, a circulation space referred to as the medianum that separates the shop front from the back room. It is noted that, in spite of their modest proportions, there are houses of this category that are richly decorated; Wallace-Hadrill gives the example of the House of Fabius Amandio.

Houses that would be considered the average Pompeian residence fall into Type III. This kind of house has an average of eight rooms, with thirteen being the maximum. The majority of these houses contain workshops or shops either in the interior of the house or integrated into the street frontage. Most of the houses that are open to the modern visitor to Pompeii fall into this category. The plans of these houses are more symmetrical than those of other house types, and exhibit several standard architectural elements such as atria and colonnaded gardens.

Type IV houses are the largest of Pompeii's residences. Within this group are Pompeii's town palaces, richly decorated with layouts designed for

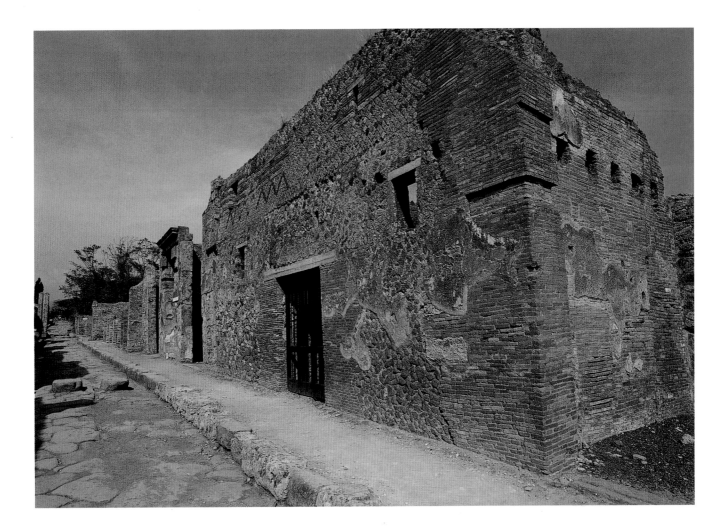

entertaining and to house large slave populations. Almost all of the houses of this type have one and sometimes two atria and colonnaded peristyles. Within this group are houses with large ornamental gardens. There are a few curious characteristics of some houses of this category, such as multiple entrances, which indicate that they may have been created by the amalgamation of several smaller residences.

This system of categorization is helpful, but is not without limitations. Although it establishes a relationship between the size of a house and its conformity to classical architectural models, it is not able to demonstrate a similar correlation between the size of a house and the status of its occupants. Some smaller houses are sumptuously adorned with frescoes and mosaics, while larger houses reveal a remarkable lack of ornamentation. Also, because of the nature of the disaster, the site's excavation and subsequent deterioration, it is not always easy to ascertain the use of a particular house at the time of the eruption or its status as a single-family or multi-family unit. This is particularly true in the case of the larger dwellings, many of which were badly damaged by the earthquake of AD 62. This led to abandonment of the houses by their owners or the division of some of these houses into multiple units. A few, including the House of Sallust and the Praedia of Julia Felix, were either split up or entirely taken over for commercial purposes.

Even the grandest houses in Pompeii had austere façades. Decoration and architectural finishes were reserved for the interior, the private realm of the master and his family.

THE EVOLUTION OF THE POMPEIAN HOUSE

The design and plan of Roman houses followed a recognizable pattern of spatial organization. This pattern evolved from traditional domestic architecture based largely on utility, and became refined to include more aesthetic factors in response to the cultural and intellectual development of the Roman world and the changing functions that the house assumed during the first century AD. By then the house was a place where family life, business, religion and entertainment all took place, each with its own particular space. This is best understood by taking a virtual tour of the Pompeian house, moving through its rooms, as a visitor would have in the last days before the eruption.

The oldest inhabited houses in the city were located in the southeastern quarter of the city. At the time of the eruption, these were occupied by poorer residents and showed none of the grandeur of their modern counterparts. Yet they each possessed a similar plan and design, which demonstrated the Pompeian house in its infancy but poised for growth. These houses were free-standing, with façades on the street, each with a monumental doorway, seemingly oversized for its position. Inside there was a small narrow corridor known as the fauces (literally, 'throat') leading to an atrium, with several chambers off it: smaller rooms to the left and right and larger, more open rooms, with a passage between them, on the side opposite the entrance.

The atrium was the traditional heart of the house. It was a spacious room, rectangular in shape with a high ceiling. Its name has been said to derive from the word *ater*, meaning 'black', as in earlier centuries atria would have had their walls caked with soot from the open hearth which once burned in the centre of the room. Within this atrium most of the regular activities of the house took place. The small rooms of equal size along the sides of the atrium served as bedchambers and storage units, while one of the two rooms opposite the entrance was used as a dining room. A passage ran between these two rooms to a rear courtyard or garden, called the hortus, where the slave quarters, kitchen, laundry and latrines were located.

These were the predominant characteristics of Pompeii's 'testudinate' (covered) atrium houses,[2] which remained popular throughout the republican era. They are a far cry from the lavish palaces which are regularly depicted in reconstructions of Pompeian houses. How was the transition made from these spartan abodes to the familiar versions of the classical house? It began with the introduction of a common architectural element, the compluvium. The testudinate atrium had been fully covered over, and the cross-axis pitched roof directed water down to the front or back of the house where it was collected in gutters and pipes that led to the sewers or to a cistern. Natural light was lost when houses were constructed flush with each other, as there were no windows at the sides. The compluvium pierced the ceiling, creating a square aperture, open to the sky, which filled the rooms beneath with sunlight. Directly below the compluvium was the impluvium, a shallow pool that collected rainwater from the gutters on the roof. The water was stored in cisterns below the impluvium, which proved extremely useful before the arrival of piped drinking water with the construction of the aqueduct in the early part of the first century AD. This new version of the atrium became known as the 'impluviate' atrium.

The change from the testudinate atrium to the impluviate atrium was described by Vitruvius, the father of classical architecture, in his work *De architectura*. With his six principles of design – order, arrangement, proportion,

OPPOSITE ABOVE **The monumental portal of the House of the Faun. This unusually grand entranceway led to one of the largest and most lavish mansions in Pompeii.**

OPPOSITE BELOW *Cave canem!* **'Beware of the Dog.' This mosaic greeted visitors in the vestibulum of the House of the Tragic Poet.**

symmetry, propriety and economy – Vitruvius sought to define rules and standards of architecture and therefore raise the significance of architecture beyond mere function.[3] He identified four types of impluviate atria: Tuscanic (non-columnar and by far the most common in Pompeii), tetrastyle (columnar), Corinthian (with Corinthian columns) and displuviate. While the first three were widely used in Pompeii, the last and earliest of these forms was rarely used as it shed water outwards on to gutters along dividing walls, creating the potential for water damage, rather than inwards to the impluvium where it could be stored.

The second century BC had seen growing prosperity in Pompeii following its allegiance to Rome in the Punic Wars, and significant social and architectural development in the Pompeian house. The single Tuscanic atrium house became the choice design and was employed in the construction of several grand houses of this period, notably the House of Sallust. This style of house was almost always entered directly from the street. In an urban setting such as Pompeii, grand façades with courtyards or *porte-cochères* were unheard of; Pompeian architects instead used ornate monumental portals with pilasters, stylized capitals and massive wooden doors to indicate the importance of the residence beyond. By the first century AD, if the house was entered from a main thoroughfare, the entrance would be found amid a row of shops with lofts and balconies above, while on secondary streets where shops were absent the doorway would be the primary feature of a stark wall often with small windows. This restraint of façade once again indicates the closeted nature of Roman domestic architecture. The entrance was a mere taste of the grandeur that lay within.

The house was entered through a narrow entrance way sometimes divided into two halves by a double or single door. The primary space or corridor directly off the street was the fauces, which was in turn followed sometimes by the vestibulum, or hallway, leading into the house beyond. Where it appears, the vestibulum is noted for its interesting 'doormat' mosaics declaring *Salve* ('Greetings'), *Salve lucrum* ('Welcome Fortune') or *Cave canem* ('Beware of the dog', with an accompanying depiction of a snarling canine). The fauces, in contrast, were always extraordinarily decorated with frescoes featuring symbols of luck and good fortune or fertility such as Priapus; some even possessed fine plasterwork like that in the House of the Faun. From this transitional space the visitor would have experienced a marvellous vista as room after room became visible in a graduated procession that led deep into the house.

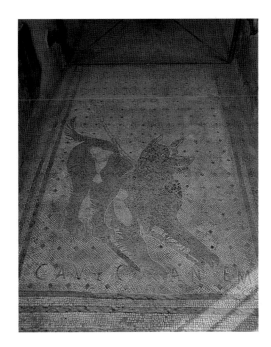

Vitruvius recommended that the atrium serve as a grand entrance to the home: 'Propriety [perfection of style] arises from usage when buildings having magnificent interiors are provided with elegant entrance-courts to correspond; for there will be no propriety in the spectacle of an elegant interior approached by a low, mean entrance.'[4] Standing at the edge of the atrium, visitors were now confronted with something so much more glorious than anything the original testudinate atrium houses had to offer. Before them lay a splendidly decorated room that soared above their heads, the aperture of the compluvium allowing sunlight to fill the room, illuminating all of its recesses. In the centre of the great room was the shallow impluvium, surrounded by potted plants and statuary. Vitruvius states that the atrium had become a foyer or lobby, built to impress visitors and allow for circulation. The room no longer functioned as the principal zone of activity. New rooms were introduced to fulfil the original function of the atrium, making its purpose now largely ceremonial.

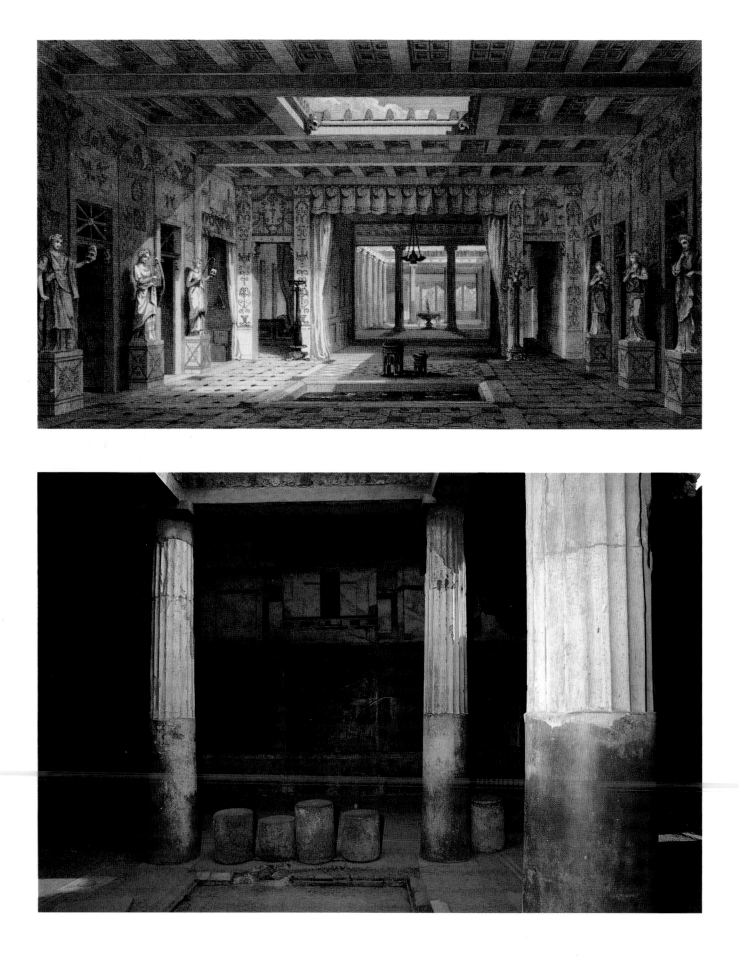

Relieved of bustling domestic activity, the atrium acquired an air of sanctity as the traditional location of the hearth. This is why the lararium, or shrine to the household gods, was often placed here. Each house had its own particular *lares*: deities which protected the house from evil spirits and misfortune. The chief of these household gods was the *genius*, who protected the individual members of the family. The lararium appeared in various forms. It could either be a small niche in which to place figurines or a full altar placed upon a podium. Beneath the shrine it was common to find the image of a snake, believed to be the bringer of peace and prosperity.

The walls of the atrium were lined on each side with doors leading to small individual chambers called cubicula. Cubicula were used as bedchambers or storage chambers just as they had been in the old style. Although they were usually windowless, receiving light only from the atrium, they tended to be richly decorated, sometimes with erotic scenes.

Directly across the atrium, on the same axis as the vestibulum, was a room known as the tablinum. This room had evolved from the large room at the far end of the atrium, which had been used variously as a dining room, a study and a bedroom for the master of the house.[5] This had changed with the transformation of the function of the atrium. The tablinum now served as the main reception room where the family documents and finances were kept and where the daily business of the master of the house was carried out. It was surrounded by the images and death masks of ancestors, who looked on at the

The suite of rooms seen at once from the entrance, must have had a very imposing effect: you beheld at once the hall richly paved and painted – the tablinum – the graceful peristyle, and (if the house extended farther) the opposite banquet-room and the garden, which closed the view with some gushing fount or marble statue.

EDWARD BULWER-LYTTON,
THE LAST DAYS OF POMPEII

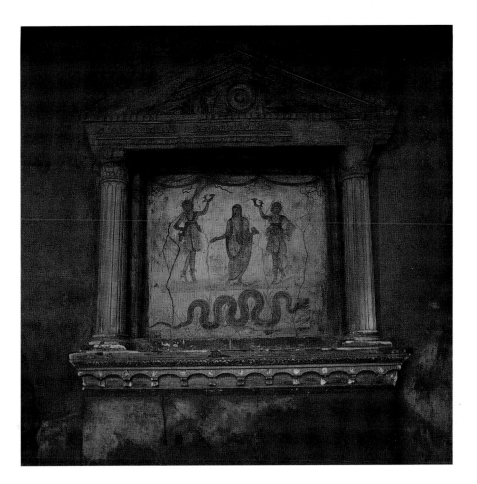

OPPOSITE ABOVE Restoration of the atrium of the House of Pansa, an engraving from *Pompeiana* by Sir William Gell and John Gandy, 1818. Such nineteenth-century views were highly idealized, but the tradition of archaeological reconstruction has continued to this day.

OPPOSITE BELOW The atrium of the House of the Ceii. This is a small house noted for its frescoes. Lavish decoration was sometimes used to compensate for lack of space.

LEFT The lararium of the House of the Vettii. Framed in its aedicule, the genius of the family is flanked by two spirits (*lares*). Below them is Agathodemon the serpent.

BELOW Mosaic floor of the tablinum in the House of the Faun. The geometric pattern of interlocking perspectival cubes is believed to have been influenced by the sanctuaries of the Temples of Apollo and Jupiter.

RIGHT This tablinum in the House of the Ancient Hunt holds some of Pompeii's most intricate and vibrant frescoes. Its walls are painted to imitate azure carpets interspersed with architectural fantasies and mythological figures, while below faux marble panelling gives way to vignettes of hunting scenes and Nile River landscapes.

house's business with haughty stares. One particular tradition, which had died out by the time of the eruption, was to place a bed between the tablinum and the impluvium. This was traditionally the bed on which the master's marriage was consummated and in former times was where the lady of the house would receive visitors.[6] The tablinum was always the most elaborately decorated room in the house, flanked by pilasters and fully open to the atrium. Its walls were painted with murals and its floor was paved with mosaics. It could be isolated for privacy with curtains or wooden shutters.

Architecturally, the tablinum is important as the culmination of the axis of the house starting from the fauces. This line of sight was the backbone of the Pompeian house, its main axis of key domestic spaces planned according to the principles of classical design. This axis acted as a processional route, which led to the heart of the house where the master was waiting. It was Vitruvius who prescribed this, as it enhanced the order and propriety of the house and indicated the importance and sophistication of the owner of the house.

The tablinum was usually flanked by two alae ('wings'), which lay in the far corners of the atrium. Before the emergence of the compluvium, these had served as light wells. With the advent of the Tuscanic atrium the alae became the offices for the clerks and secretaries who served the master of the house. These

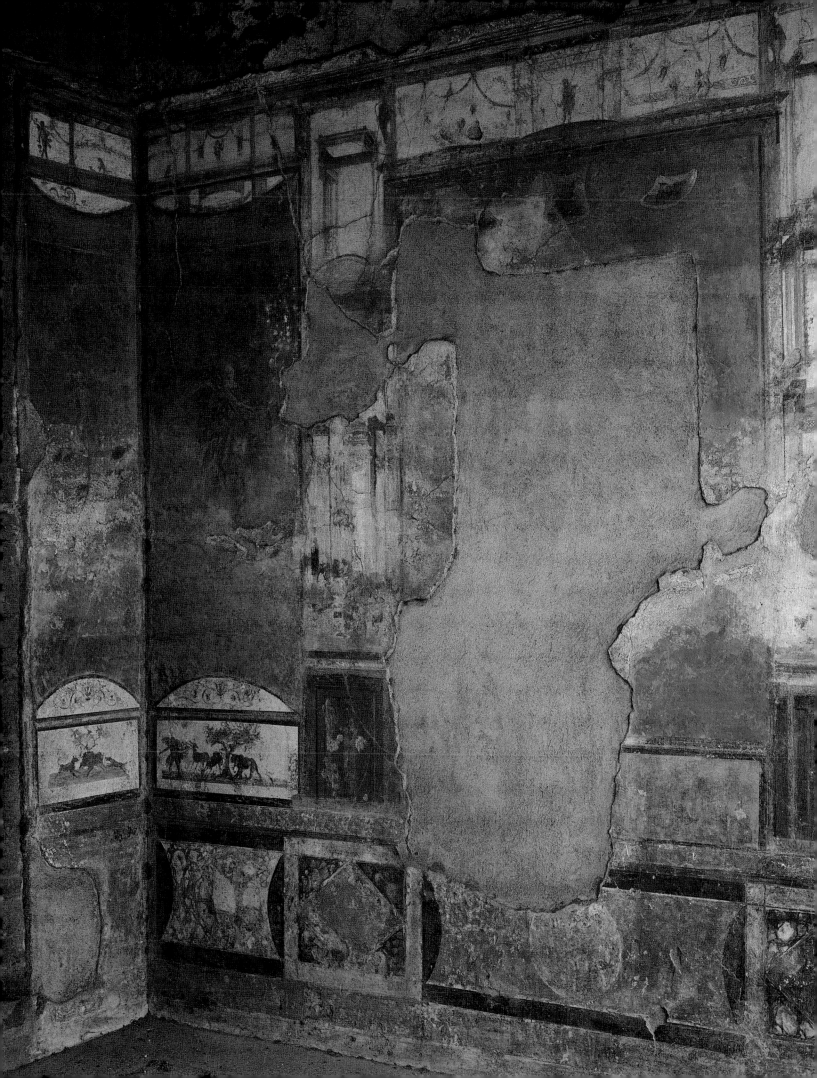

spaces were necessarily tucked into the corners to avoid disturbing meetings in the tablinum, but were as close as was practical, to enable the clerks to bring scrolls or other documents to the master and his guests.

The final room in the makeup of the Pompeian single atrium house was the triclinium (dining room). Triclinia were generally placed on either side of the tablinum. Meals were particularly important events for the Romans, and it was customary for houses of means to have more than one dining room: one used for winter and another for summer. The word triclinium means literally 'three couches', which were arranged in the dining rooms of wealthy households. This made dining rooms rather cramped as they would commonly hold nine people, three to a couch. Placement of guests therefore became very important. Diners reclined on pillows while they gorged themselves on multi-course meals. Distinguished guests were seated in the far left-hand seat of the central couch to allow them to see out into the atrium and to observe the activity of the house.

It was not long before changes in the size of Pompeian households made the single atrium house overcrowded and eventually obsolete. The addition of the second atrium was the solution to this problem, as it added extra room for the domestic activities of the women, children and slaves of the household, who had previously been forced to remain out of sight – behind closed doors or in the back garden – during the conduct of business. This second atrium was generally smaller than its predecessor and was tetrastyle (or columnar) as opposed to the Tuscanic, which lacked columnar support and was therefore more open. The tablinum of this atrium was missing and it was not held to the rigid order of the primary atrium. Instead the secondary atrium was lined with cubicula and alae, which were used as reception rooms. The use of the secondary atrium appears in such well-known dwellings as the House of the Large Fountain and the House of the Faun.

LEFT **Plan of the House of the Faun.**

KEY
1 Large peristyle
2 Exedra
3 Small peristyle
4 Tablinum
5 Alae
6 Atrium
7 Tetrastyle atrium
8 Vestibulum

RIGHT Reflecting a synthesis of Roman and Hellenistic architectural influences, the House of the Faun achieved a level of sophistication and elegance in its planning which was unsurpassed in all of the city. The house is named for its statue of a dancing faun, which was made in Alexandria in the second century BC.

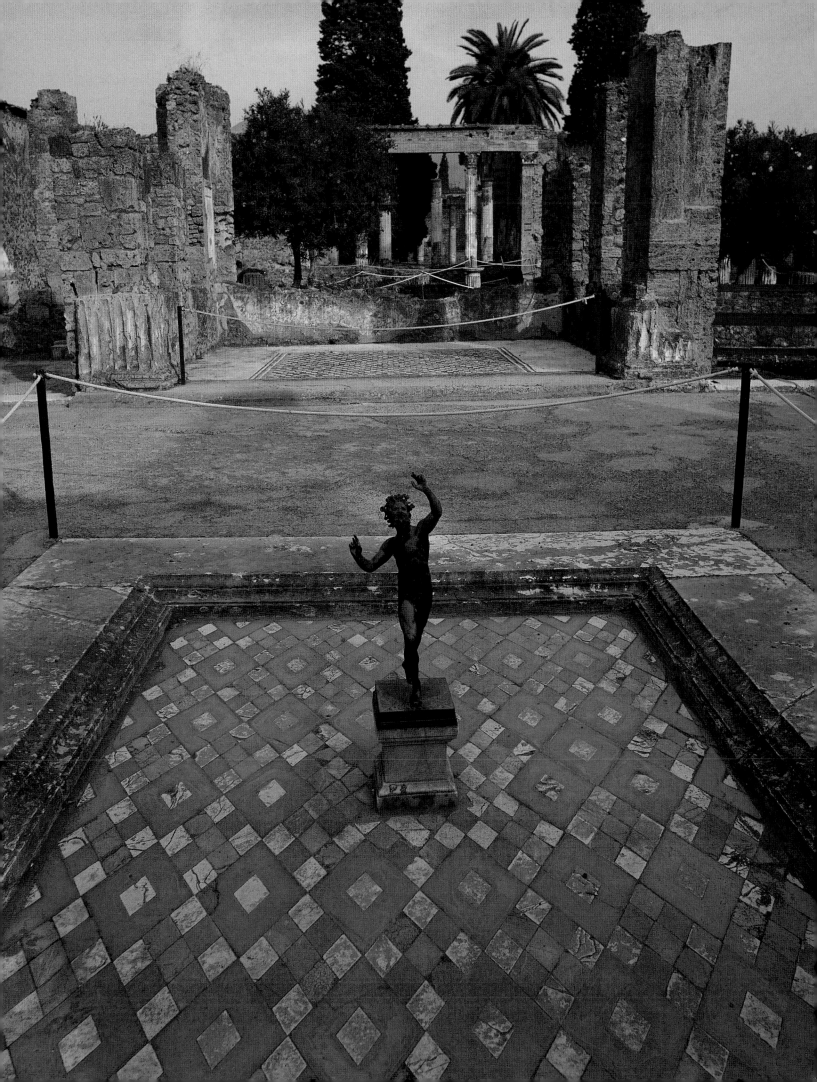

The final architectural development, which completes the composition of the average Pompeian house, was the advent of the peristyle. Of the houses identified by Wallace-Hadrill as Types III and IV, almost all contain the basic elements of the Pompeian house signified by the presence of atria and peristyles arranged along a central axis.[7] The peristyle, however, was sometimes preceded by a portico. This consisted of a row of columns holding up a roof, which acted as an awning and a place to sit and look out on the back garden of the house, which was usually small. The House of Sallust, the House of Marcus Lucretius Fronto and the House of the Small Fountain all include this transitional element.

For those houses with larger gardens the portico was insufficient to reclaim the area for the rest of the house. The peristyle, an architectural feature handed down from the Greeks, was the preferred response to the problem of creating

Such was the skill of ancient architects that the atrium of the House of Menander projected the illusion of perfection in symmetry and perspective. In reality the house was a warren of rooms gradually added on over the years.

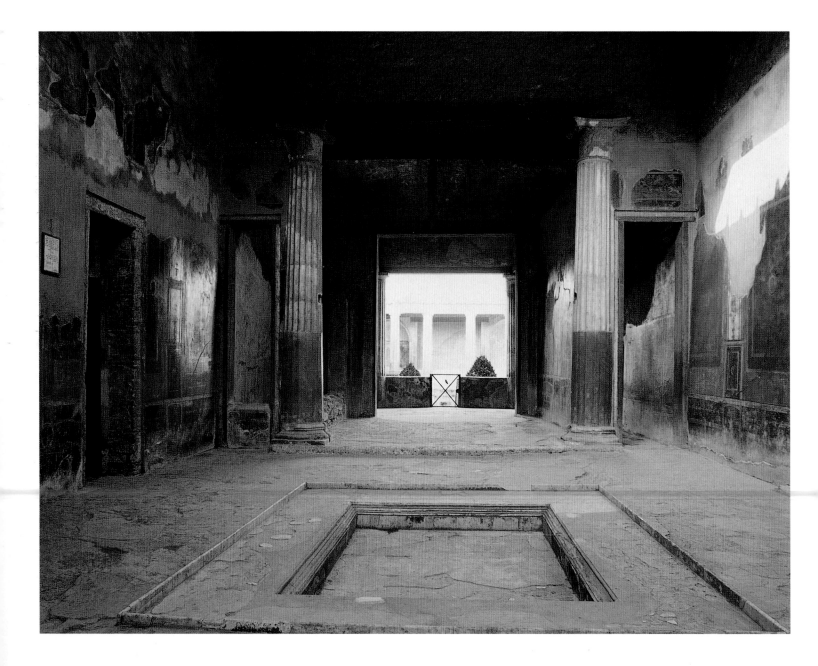

extra space for the private domain of the house and also brought in more light and air. The peristyle was a large cloistered area surrounded by colonnades, in some cases overlooked by a loggia containing yet another dining area that could be closed off with shutters. Eventually the peristyle would replace the second atrium as the favoured way to expand the house and add rooms.

With the rise in use of the peristyle in Roman houses after the second century BC, architects were careful, if possible, to continue the axis of the house through the tablinum to the far wall of the peristyle.[8] The tablina of this period were open on two sides, looking out on to the atrium in front and into the peristyle behind. The awkward windows or doors, which prevented the continuation of the axis, were dispensed with, opening up the house further. This preserved a sight-line from the doorway through to the deepest recesses of the house. Architects of Pompeian houses also played visual tricks such as

Another perspective from the House of the Menander. The peristyle, as viewed from the large exedra, appears to be symmetrical. However, a third column in the portico across the garden betrays the illusion.

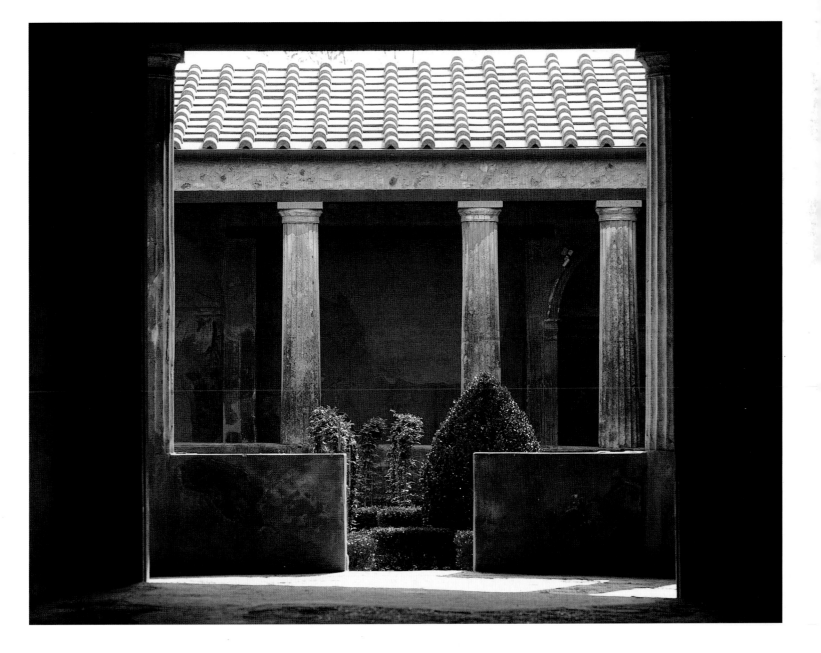

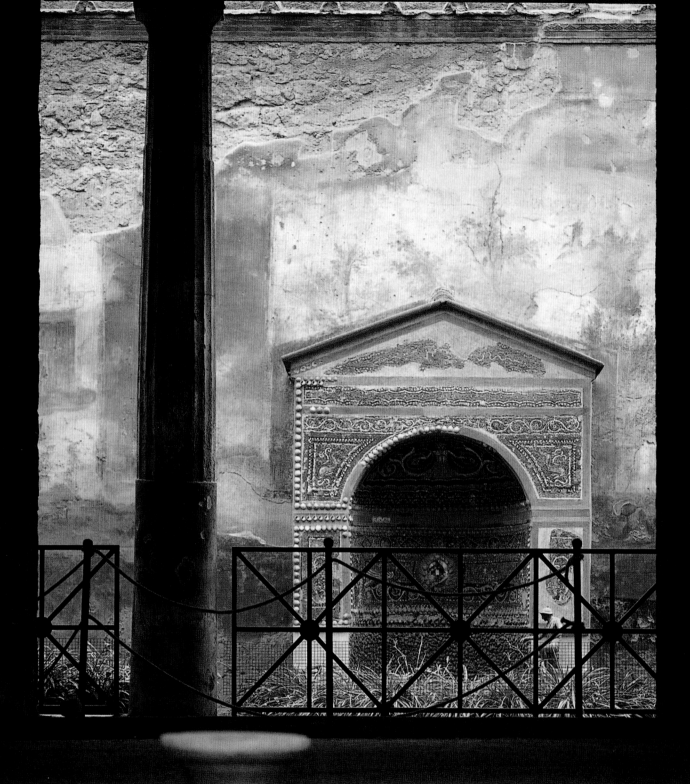

altering distances between columns to create false perspectives and make peristyles appear larger than they actually were.[9] This style of house came into vogue largely during Roman colonization. The houses of this period, such as the House of the Silver Wedding, the House of Menander and the House of the Faun all contain these magnificent axes and represent the apex of Roman architectural design at Pompeii.

In Pompeii, the peristyle was the most private part of the house, into which only the closest friends of the family were invited. While the Greeks had originally paved their courtyards with mosaics or tile, in Pompeii these areas were given over to ornamental gardens with fountains and benches. The peristyle provided the Pompeian house with the flavour of the country in an urban environment. They were also places of retreat and contemplation. The gardens in the centre of the peristyle were arranged with flowerbeds and beaten paths. Larger ones contained reflecting pools and copious amounts of statuary. Plants other than flowers were grown in these gardens. They included medicinal herbs and plants used in the making of wreaths, useful in the everyday life of the house.[10]

The peristyle was also an alternative location for the lararium or for special grottoes dedicated to a certain god or goddess. The god Bacchus was a favourite choice for the garden as he was also the god of vegetation. His followers were

LEFT The House of the Small Fountain. The gardens of the peristyle were intimate places reserved only for the family and their closest friends. Here, peace and tranquillity was disturbed only by the trickling of fountains.

BELOW A row of columns stand solemnly in the second peristyle of the House of the Faun. Before the eruption this would have been an enormous garden surrounded by a portico and overlooked by shuttered windows.

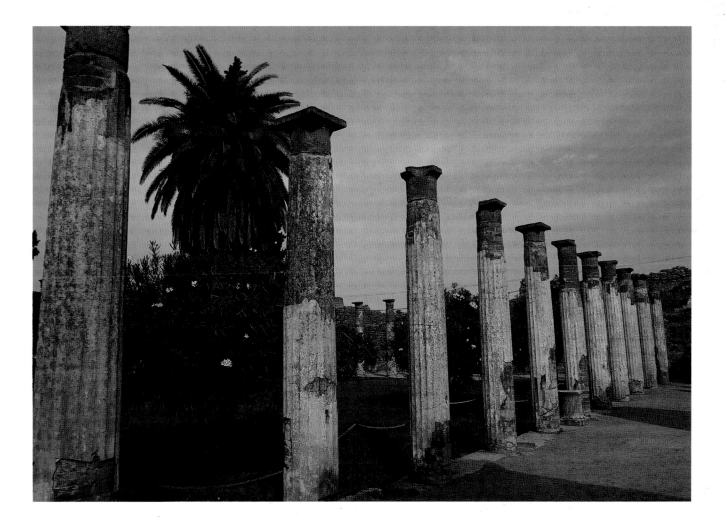

promised a paradise after death, a paradise whose earthly symbol was the garden.[11] Placing a dining room or triclinium alongside the peristyle was also particularly popular.

Another room, which appeared off the peristyle, was the exedra, or garden room. The exedra was a generously proportioned room used for entertaining and for larger banquets. It was decorated with frescoes depicting natural scenes with animals and plants, extending the theme of the garden. It was also known to possess the most outstanding mosaics in the house. The mosaic of Alexander the Great in battle with Darius was found in the exedra of the House of the Faun.

During the last decades before the eruption, the growth of villa culture in the suburbs of Pompeii began to exert some influence on the design of houses in central Pompeii.[12] This influence generally translated into the remodelling of gardens and peristyles. Houses with plenty of land chose to remove or truncate their peristyles and open up the garden to fill the entire space. The portico reappears in this scenario as a spacious veranda that looks out over a long watercourse leading in turn to a shrine, in imitation of the gracious gardens of the country villas. The House of Loreius Tiburtinus (really the House of Octavius Quartio) best represents this late trend in the development of Pompeian domestic architecture. Paul Zanker, in his book *Pompeii: Public and*

The peristyle garden in the House of the Venus.

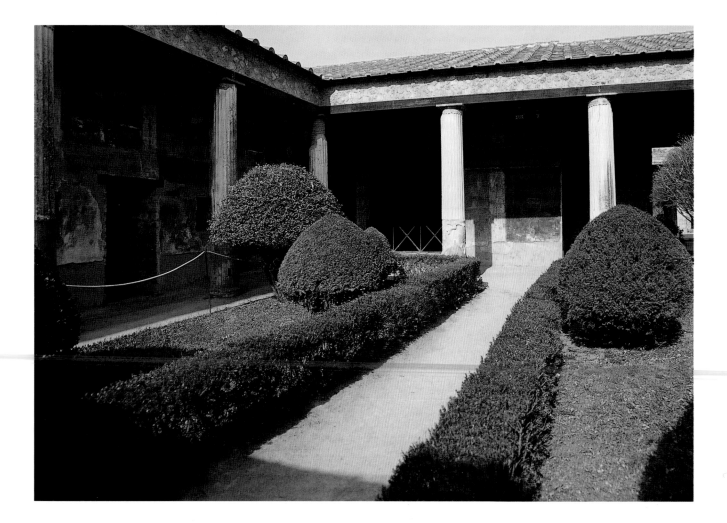

Private Life (1998), describes how this process often distorted the arrangement of the house:

> The main room or tablinum behind the atrium was replaced by a kind of truncated peristyle … The truncated peristyle connects – but also collides and competes – with two further rows of roof supports, bringing utter confusion into the ground plan. A regular porch in front of the shrine has two columns between piers with engaged columns. The pier on the garden side is flush with a row of sturdy brick supports for the more than sixty-five-foot-long pergola extending across the rear of the house. The pergola shades a small ornamental canal, only about three feet wide, which runs along the axis of the shrine; it is spanned by two bridge-like structures and ends in a biclinium (dining area with two couches) with a fountain on the other end of the terrace.

All service areas were the realm of the slaves. Slavery was a fact of life in ancient Rome and the Pompeian house made provision for this. The slaves' quarters were humble and unadorned, set off in the corners or upper floors of the house away from view and the main areas of the house. The rise in use of the peristyle eliminated the rear courtyard or hortus, which consequently displaced the general service areas of

The reconstructed garden in the House of Loreius Tiburtinus. This house is a prime example of a growing trend during the first century BC to create a 'miniature villa' within the city.

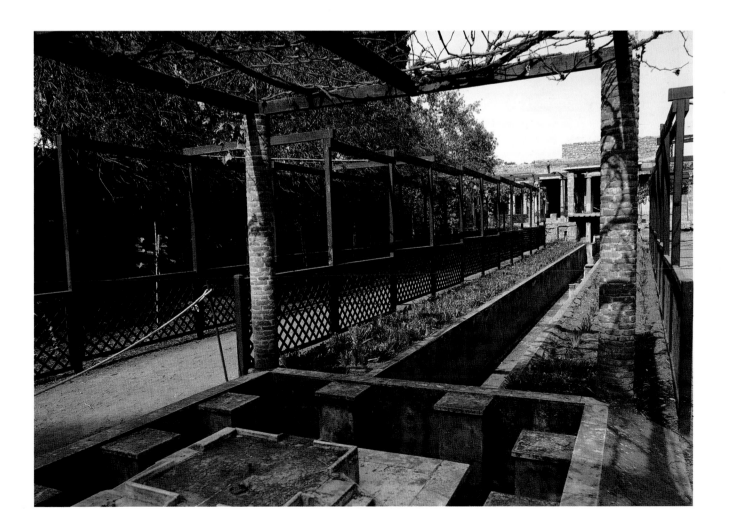

ABOVE LEFT The public lavatories in the Forum in Pompeii. Reputably rather luxurious for the time, Pompeii's public lavatories were superior to those in most houses. Urine was also collected for use in the fulling of wool products.

ABOVE RIGHT The Laundry of Stephanus. Pompeii had numerous laundry and washing facilities.

the house. As a result, spaces for service areas and slave quarters grew scarce and architects struggled to include them where they could and to place them as logically as possible without disturbing the arrangement of the main rooms.

All the meals and banquets of the house were prepared in the culina (kitchen). Pompeian kitchens are surprisingly small, with usually only enough room for one slave. Within these cramped areas was a raised hearth, which used wood or charcoal for fuel. Lacking chimneys and with little provision for ventilation, these claustrophobic spaces became very smoky and suffered frequent fires. Because of this kitchens were tucked away from view, often relegated to the rear of the house or behind the dining rooms. Many Pompeian kitchens were provided with sinks and running water. Drinking water was brought into the house by a series of carefully monitored pipes, which were connected to the main municipal system served by an aqueduct constructed during the reign of Augustus. This brought water from the springs of the River Acquarus near the modern-day Mount Avellino. It was rare however for latrines in private houses to have running water. This seems to have been offered only in more luxurious locations such as the public latrines at the Forum or the baths. In the private house the lavatories were equipped with pipes which led down to trenches, flushed into the sewers by rainwater. Private lavatories were spartan affairs tucked away like the kitchen and, too often, right next to it.

These various rooms and elements formed the general components of the average single-family Pompeian house. However, use of these various elements was by no means universal. Under the influence of economics, fashion, urban topography and natural disasters, the Pompeian house was altered to meet the needs of its inhabitants and a range of variations took shape. Even during the summer of AD 79, as twilight descended on the city and its inhabitants, the Pompeian house, however altered, was still serving its functions and the rituals of domesticity – religion, business and entertainment – carried on to the very end.

THE VILLA

Through excavation and study, there is today more information about the houses of Pompeii than about any other kind of building at the site. However, in addition to these town dwellings, there is another type of domestic architecture which also deserves mention. The suburban or country villas in the environs of Pompeii are

some of the most spectacular ruins unearthed so far at Pompeii, yet there is precious little information about the history and development of these monumental structures. What is known is that they offered a different lifestyle from that of the city dweller and that the size and decor of these country homes indicated great wealth and refinement – something aspired to by the average Pompeian but achieved by few.

The Bay of Naples has always been one of the most fashionable holiday resort areas in Italy. The Romans were no strangers to the attractions of Campania and the delights of the Amalfi Coast. The gradual adoption of Hellenistic culture by the Roman upper classes chafed against the traditional conservatism of the Roman republic.[13] They yearned to express their wealth and power in their daily surroundings, but cultural prohibitions prevented them from doing so. In response to this the Romans began the development of their agricultural estates as places of refuge, where they could let their exuberance for life and pleasure show proudly.

Following the eradication of pirates from the coastal regions, seaside villas became popular. At Pompeii villas began to appear in the suburbs around 50 BC. They often started out as farmhouses, with collections of barns and sheds surrounding them. As they began to be used more for entertaining and holiday visits, the villa became separated from the functions of the estate. It was composed of many of the same elements that made up urban dwellings. The atrium, the tablinum, the peristyle, the portico and the triclinium were all present and generally followed Vitruvian guidelines for their arrangement. However, where the urban house looked inwards, the villa was designed to look outwards as well.

The peristyle of the Villa of the Mysteries viewed from the atrium. Pompeii had several sumptuous villas in its suburbs. Attached to working estates and vineyards, these sprawling houses were often occupied as holiday retreats.

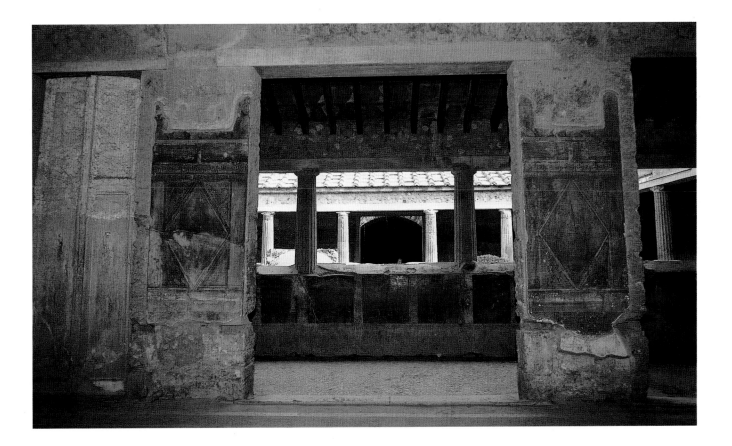

ABOVE Plan of the Villa of the Mysteries

KEY
1 Vestibule
2 Wine-press (torcularium)
3 Lavatory
4 Peristyle
5 Kitchen (culina)
6 Entrance to cellar
7 Baths
8 Bedroom
9 Tetrastyle atrium
10 Cubiculum
11 Atrium
12 Reception room (oecus)
13 Tablinum
14 Cubiculum
15 Triclinium
16 Veranda
17 Garden

RIGHT The oecus of the Villa of the
Mysteries. Oeci were dining and reception
rooms, but unlike the triclinium, their
shape varied and their size was much
larger which made them better suited
to large villas. This oecus was decorated
with grand frescoes.

As the villa was placed to maximize views over the sea or the rolling countryside, the architecture was altered to accommodate this. Windows became larger, walls were removed and colonnades appeared in abundance. The house sprawled outwards in all directions to take advantage of every possible view. Immense gardens were planted and surrounded with colonnades and pergolas. The common elements of the house were multiplied and expanded, unencumbered by the boundaries of city streets or other houses. The villa lifestyle was about embracing indoor–outdoor living in a manner impossible for those living in the city. The walls were sumptuously decorated throughout; many of the finest mythical and architectural frescoes have been recovered from villa excavations. The two greatest villas in suburban Pompeii were the Villa of the Mysteries and the Villa of Diomedes.

The Villa of the Mysteries was begun in the second half of the first century BC. It is believed to be Pompeii's oldest villa and was expanded over the decades to become a mansion of more than sixty rooms. In this villa the vestibulum opens into the peristyle rather than into the atrium, as it does in city houses.[14] The vestibulum, the peristyle, the atrium, the tablinum, and the exquisite apsidal exedra all lie on a central east–west axis. On each of its façades there are porticoes and hanging gardens above a cryptoporticus. The villa was also equipped with its own baths and had facilities for pressing and storing its own wine. The Villa of the Mysteries, however, is best known for and named after its celebrated murals depicting the Dionysian ritual. Set against a background of blood-red walls, the scenes show a young female initiate suffering the pains and pleasures of communion with Bacchus.

The Villa of Diomedes was the ultimate country retreat equipped with extensive porticos, lush gardens and even its own bath complex.

The discovery of the Villa of Diomedes in 1771 caused a sensation throughout eighteenth-century Europe. During the excavations the bodies of eighteen women and children were discovered huddled together in the cryptoporticus beneath the villa, apparently trying to shield themselves from the falling lapilli. The French writer Théophile Gautier would write a short story about this site and the death of the fictitious Arria Marcella. The excavation was the first villa structure unearthed in the suburbs of Pompeii. The villa was constructed flush with the Via Oplontis and was entered through a doorway flanked by two columns that stood at the northeast corner of the peristyle. To the west lay a private baths complex complete with *apodyterium*, *tepidarium*, *caldarium* and *frigidarium*. To the south was a series of bedchambers and living rooms, including a unique apsidal bedchamber, which looked south over the city and onwards to the sea. To the east lay the tablinum, whose west side led on to a terrace overlooking a walled garden. The garden is of particular interest as it is sunk below the principal storey. A range of rooms has been added to the garden level of the house sheltered by the cryptoporticus. Extending from the cryptoporticus is a gallery which completely surrounds the sunken garden, providing a pleasantly shady walk for the villa's wealthy owners.

The Pompeian villa is now rightly seen as the model setting for an ideal of domestic life. It combines the practicality of spacious courtyard planning with an intensity of decoration and brilliance of natural light in the public rooms. The beauty of the surviving houses at Pompeii has an added poignancy as one ponders today the fate of the inhabitants.

In the Villa of the Diomedes the dark atrium was dispensed with altogether in favour of an open peristyle. Extra windows, colonnades, gardens and fountains helped promote the indoor-outdoor living that was characteristic of suburban villas.

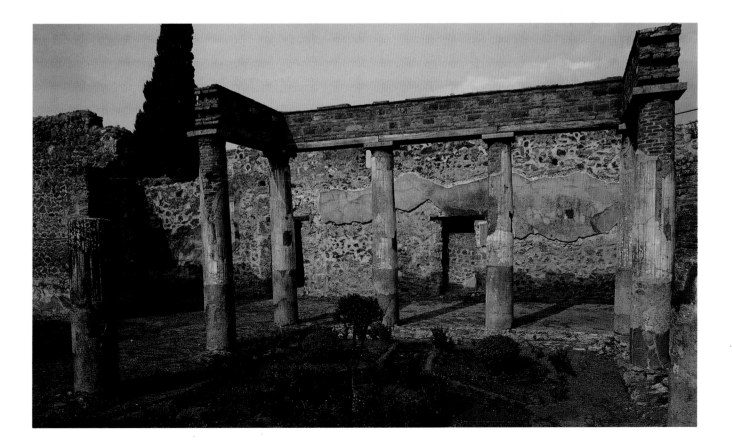

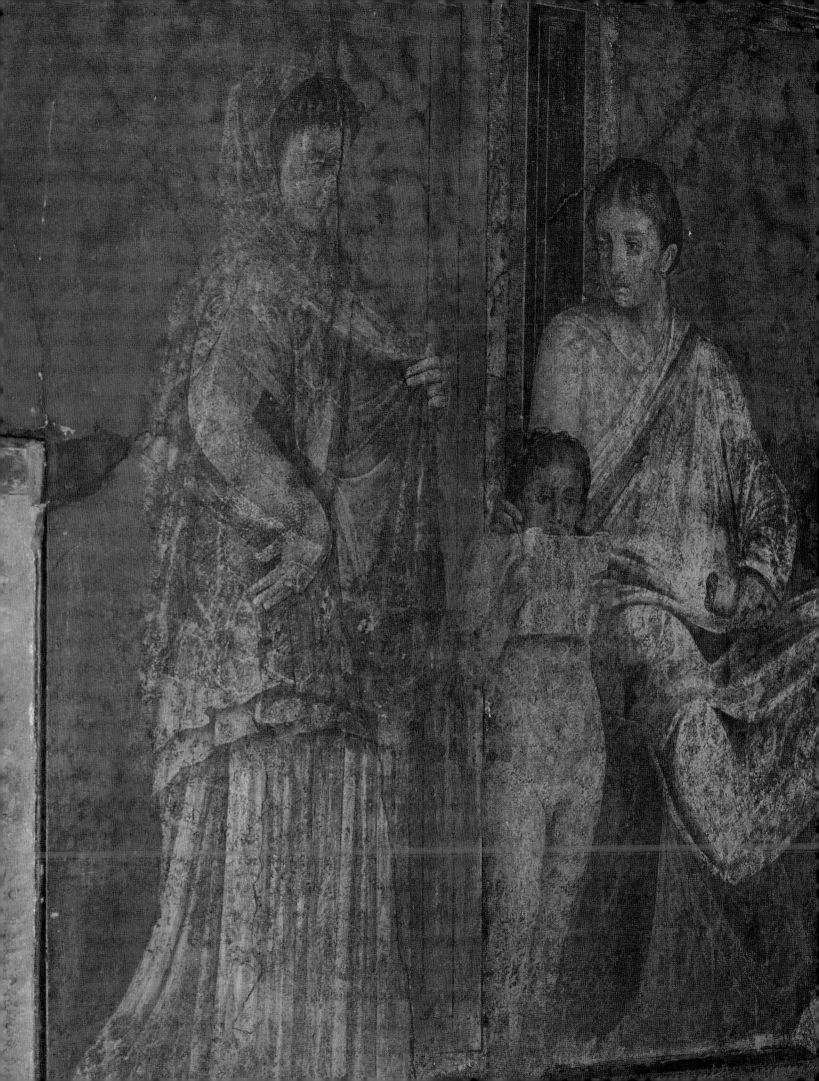

LIFE AND ART

SPEND A DAY AT POMPEII and you can easily imagine that you are taking part in the daily life of the city. Add to your itinerary a long visit to the inspiring National Archaeological Museum in Naples and you will receive real insight into the art and life of Pompeii. Tragic though the sudden elimination of the city was, its burial preserved it, and excavation, continuing in a minor way today, is a constant process of education. We can become part of the ancient world by looking with imagination beyond the tourist crowds. Everything is there – frozen but real. Sigmund Freud understood archaeology as an analogy for the exercise of psychoanalysis: 'Stones speak,' he wrote. Through close examination, meaning can be found in every fragment of mosaic or fresco. That meaning will be part of a much larger whole. Writing about Wilhelm Jensen's novel *Gradiva* – a romance written in 1902–3 and set in Pompeii – Freud mentions Pompeii as a city once petrified but 'out of it stirred a feeling that death was beginning to talk'.

Goethe remarked that the deaths of the two cities were significant not for the brevity of life but for the perpetuity of art. Art seems to have had an important place in the lives of the inhabitants of Pompeii. Many of the wall paintings, mosaics and sculpture were closely related to daily life, while many murals also recycle scenes from Greek art and theatre. But it was not always 'art for art's sake': murals, stucco reliefs and mosaics were clearly designed to be integral to the architecture, design and function of the rooms in which they were placed. Although some art historians may regard both Pompeii and Herculaneum as *provincial* centres, nevertheless the scale and sheer quantity of the art that survives gives the clearest picture of Roman life.

Of course, archaeological evidence of urban life in the second and third centuries AD does survive from places such as Ostia, and there are numerous written accounts from social satirists such as Martial and Juvenal, novelists such as Petronius and brilliantly descriptive letters from Pliny the Younger and Cicero. But visitors to Pompeii are always struck by the domestic and public life that can be visualized from the remains.

Naturally it is the human interest that evokes the strongest response. Everyone is familiar with the countless temples, porticoes and lines of columns that can be mentally reconstructed into epic vistas that Cecil B. De Mille or the makers of *Gladiator* would envy. What is different about Pompeii is the fact that you can enter a bedroom or the baths and see in the murals exactly what went on: private lives are suddenly public. In the brothel, the human desires and fantasies that we all have are seen. We can sense the complexity of human relations made more elaborate in Roman times by the acceptability of slavery and of hideous levels of public cruelty in the arena of the Amphitheatre. The contrasts are fascinating. On the one hand there is fine food on the tables and flowers in the gardens. On the other there are orgies in the bathhouses and a priapic presence throughout the town. It is amazing how the artistic and sexual energy of Pompeii endures. In AD 79 there were no cameras or televisions, but there is so much visual evidence in Pompeii that the twenty-first-century visitor has a sense of the virtual reality of the locals' lives.

PREVIOUS PAGES The epic Dionysian mural from the Villa of the Mysteries is perhaps the most famous artwork in Pompeii. In this section the initiate is preparing for her ceremonial coupling with the god Bacchus. The Dionysiac rite is being read by a boy overlooked by a cult priestess.

BELOW The eyes of the gods were everywhere. The lararium of the restaurant of Vetutius Placidus featured the images of Mercury and Dionysus, looking after diners and proprietor alike.

OPPOSITE A still-life fresco with fish. Pompeian artwork was not restricted to religious themes: secular subjects were portrayed as well.

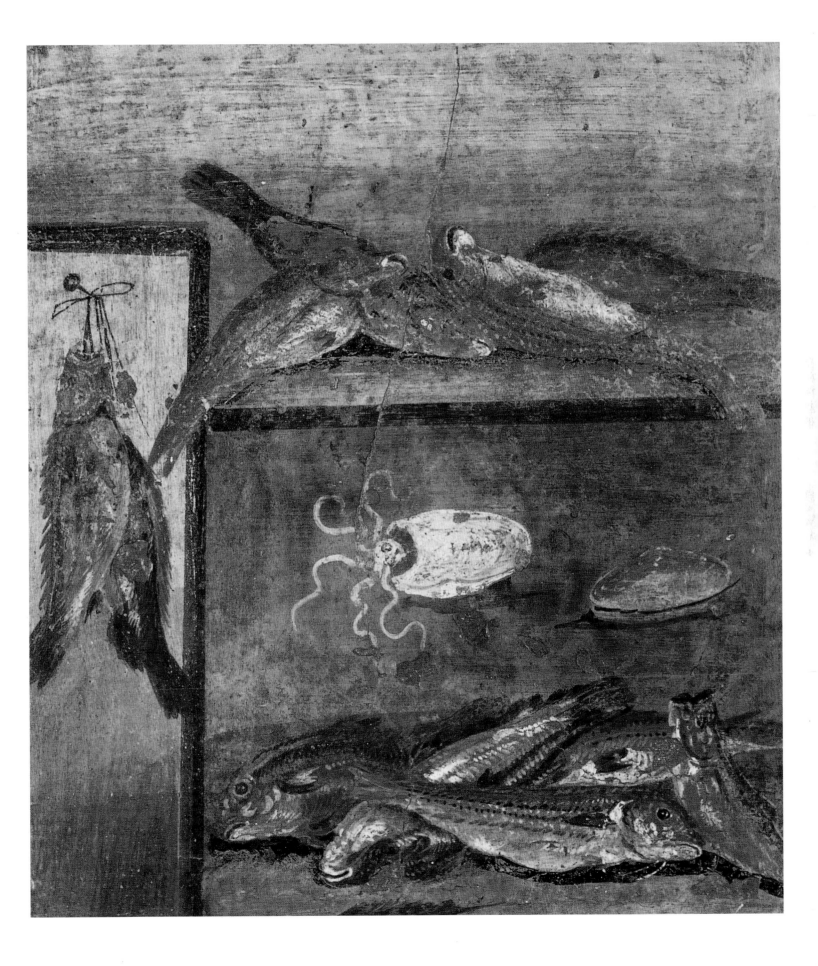

FRESCO STYLES

Four styles of Roman wall painting flourished at Pompeii, and they all in some way derive from techniques that were developed in Greece and the eastern parts of the Mediterranean. They give us a clear idea of the colourful nature of the classical world – something that we now find quite hard to envisage. We are so conditioned by the bleached appearance of the columns of the Parthenon today that the idea that its façades and statuary were once brightly coloured is almost unacceptable to us.

The chronological categorization of Pompeian wall paintings was first undertaken by August Mau in 1882. He seized upon a famous quotation from Vitruvius' *De architectura*: 'The ancients who introduced the fashion of wall decoration at first imitated the different types of marble revetment and later the varied placements of cornices and blocks.'[1] It was from this point that Mau established the four styles in a chronological succession, and his categories are still useful today.

It is important to remember that until the middle of the first century AD very few Pompeian houses had windows any larger than a slit in the wall. Seneca saw the arrival of the first glass windows during his lifetime, and he died in AD 65. So there was a lot of wall to cover and there must have been a strong desire to create a sense of space – many rooms were really quite small. The imposition of fantastic architecture and illusionistic views made these small rooms look amazing.

In a long passage explaining how wall painting developed, Vitruvius writes that the Romans later

> made such progress as to represent the forms of buildings and of columns, and projecting and overhanging pediments; in their open rooms such as exedrae, on account of the size, they depicted the façades of scenes in the tragic, comic or satyric style, and their walls, on account of their great length, they decorated with a variety of landscapes, copying the character of definite spots. In these paintings there are harbours, promontories, seashores, rivers, fountains . . . in some places there are also pictures designed in the grand style with figures of the gods or detailed mythological episodes, or the battles at Troy or the wanderings of Ulysses with landscape backgrounds . . . from real life.
>
> But these subjects, which were copied from actual realities, are scorned in these days of bad taste. We now have fresco paintings of monstrosities, rather than truthful representations of definite things. For instance, reeds are put in the place of columns, fluted appendages with curly leaves and volutes instead of pediments, candelabra supporting representations of shrines, and on top of their pediments numerous tender stalks and volutes growing up from the roots and having human figures senselessly seated upon them; sometimes stalks having only half length figures, some with human heads, others with the heads of animals.

Pliny the Younger was to credit the artist Studius, a painter from the time of the emperor Augustus, with the idea of introducing to Pompeii 'the delightful style of decorating walls with representations of villas, harbours, landscape gardens, sacred groves, woods, hills, fishponds, straits, streams and shores, any scene in short that took his fancy'.[2]

A *trompe-l'oeil* terracotta face peers out from a wall in the House of the Vettii.

THE FIRST STYLE
(LATE THIRD CENTURY TO EARLY FIRST CENTURY BC)

This is a simple style of architectural motifs executed in relief to look like a marble or stone wall. It would be made of stucco and painted and polished to resemble a rare or colourful marble.

During the second century BC all the major public and religious buildings, the gates and towers of the city and many houses of the richer citizens were decorated in this way. There are well-preserved examples on the walls of the Tower of Mercury on the Via di Mecurio and at the Basilica in the Forum. The best examples of private houses in this style are the House of Sallust and the House of the Faun. In the House of the Faun the entrance has imitation marble and stone slabs and several architectural details which are in fact skilfully painted illusions. A shelf projects to 'support' the façade of a temple with its central door and columns. This sort of complexity is rare in the First Style which is usually just a way of dividing up the wall plane and imitating expensive materials. In the first peristyle of the House of the Faun we get a sense of how painters represented both the materials and architectural structure of the walls.

First Style decoration generally depicted stonework or marble in relief, as shown in this view of the House of Sallust.

THE SECOND STYLE
(END OF SECOND CENTURY TO BEGINNING OF FIRST CENTURY BC)

This first-century style is much more architectural and theatrical. It introduces architectural and scenic perspective. The walls are divided into three distinct parts: bottom, middle and top. The middle section is frequently divided vertically with columns and pilasters.

This style came from Rome where many attempts were being made to emulate the great Hellenistic palaces in Athens (now lost). There seems to have been a strong link with designs for the theatre. Vitruvius has written that theatre backdrops influenced Roman interior design, even suggesting that styles representative of the three moods, tragedy, comedy and satyric drama, were used in different rooms. Satire seemed to demand a rustic or landscape setting while tragedy took place in palaces and comedy at home. The overall appearance is

Second Style decoration in the cubiculum of the House of the Silver Wedding. Hellenistic art greatly influenced the decoration of the Second Style. Tripartite division of the walls and architectural motifs were an attempt to give the illusion of greater space.

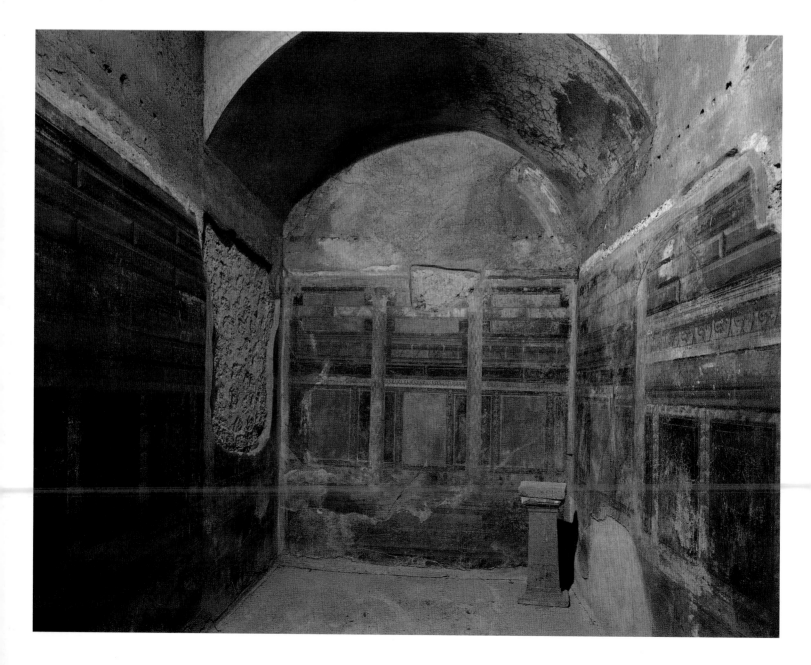

both strongly architectural and dramatic. Friezes, columns, architraves and cornices make any idea of a flat wall disappear. Whole buildings are added and windows open on to imaginary rustic landscapes.

The Villa of the Mysteries on the edge of Pompeii is perhaps the best example, and a little further afield are the Villa of Poppaea in Oplontis and the Villa of Publius Fannius Synistor in Boscoreale – both excellent and well-preserved examples of the Second Style. Within the Second Style we find a new element known as *megalography* or the representation of monumental figures within architectural frameworks. The best example is to be found in the triclinium of the Villa of the Mysteries (described in more detail on pages 132–4). In this room the artist has liberally imagined a cultic ritual and the giant figures (some twenty-nine in all) dominate, reducing any architectural elements to a mere border and background.

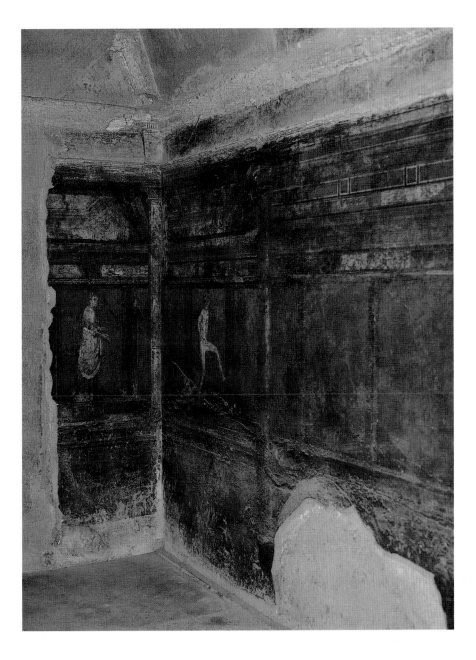

The Second Style could also be embellished with figures, as in this cubiculum in the Villa of the Mysteries.

THE THIRD STYLE (20 BC TO AD 40–50)

Spanning the reigns of the emperors Augustus and Nero, this is sometimes known as the ornamental style, although it is simpler and more orderly than the Second Style. The walls look more solid and there is less dramatic perspective, with more space in the middle zone for panels of scenic or mythological representation. Colours tend to be darker in the surrounds – often black. It is these individual panels that catch the eye although as the style develops everything becomes more complicated and the fantastic architectural surrounds tend to dominate. The style creates the most delicate framework for pictures of all kinds. There are foliage arabesques, candelabra, masks, all surrounding areas of colour that are the foil for a whole range of fresco pictures.

The finest example of the Third Style is in the tablinum of the House of Marcus Lucretius Fronto, where the lower part below the dado (sometimes called the socle) is painted as a marvellous garden. Miniature motifs surround the panels on bands known as *praedellae*, and the panel paintings have become smaller and are now carried on candelabra. Though small, these paintings are often wonderfully free and imaginative. The top part of the walls is painted with architectural perspective almost in the manner of the *scaenae frons* or backdrop scenery in the Roman theatre.

The Third Style tablinum of the House of Marcus Lucretius Fronto. Also known as the ornamental style, the Third Style has an architectural exuberance that is tempered with dark colours and often inset with panels depicting landscapes or mythological subjects.

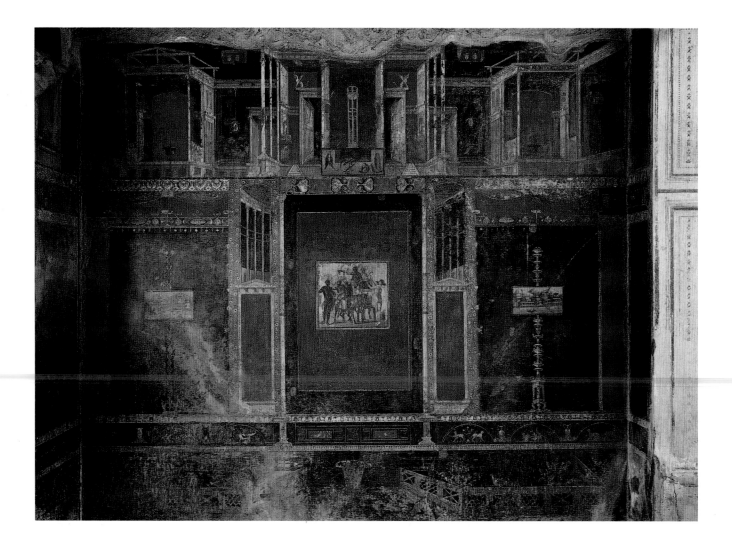

THE FOURTH STYLE

From the early first century AD things get a bit out of hand. This Fourth Style could easily be called the 'fantastic' style. It is widespread in Pompeii because it reaches its peak just at the time when the inhabitants of the city have a lot of restoration work to do to their houses following the earthquake of AD 62.

Its elaborate nature comes straight from Rome. Nero had gone to town with the decoration of his Domus Transitoria – his first imperial palace. The artistic reverberation spread through Italy and there were a lot of clients for it in Pompeii. Nero did nothing by halves and his second imperial palace, the Domus Aurea, begun in AD 64, was also to inspire many imitators. The style is complicated and develops a momentum of its own. The best known example, and one that art historians are agreed upon as most representative of the Fourth Style, is the House of the Vettii, one of the most lavish yet refined houses in the city. Architectural perspective returns in the main middle zone of the walls and the figurative paintings assume a highly decorative role among the pillars, frames and richly coloured backgrounds. There is a bold eclecticism across the whole range of the Fourth Style. Its richness prompted Pompeian artists to be incredibly inventive. Workshops strove to outdo Rome – and succeeded. More of their work survives in Pompeii than anywhere else in the world.

The House of the Vetti contains the greatest collection of Fourth Style frescoes in Pompeii. In the oecus of the house, the brilliant yellow walls are inset with scenes depicting the death of Pentheus on the left and the infant Hercules strangling snakes sent by Hera on the right.

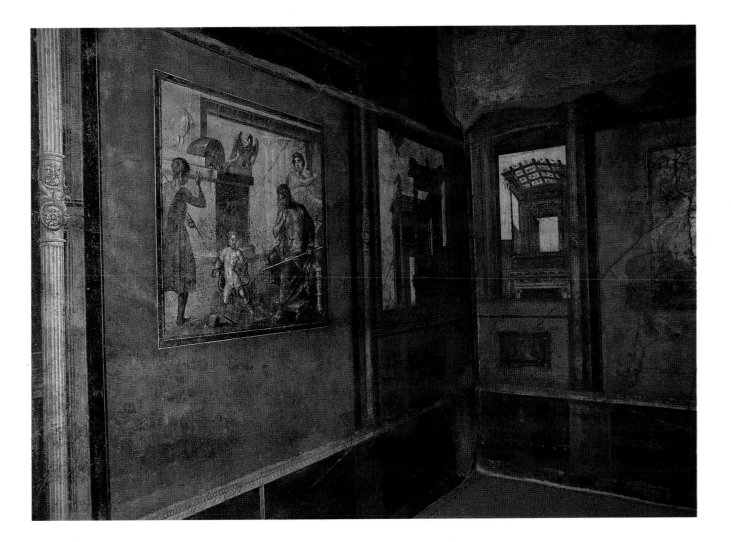

As well as the four styles of painting, the workshops' creativity extended to painting garden and rustic views, local animals and pets, fish, food and drink, to fill up all the walls. It is worth pointing out that the longevity of Pompeian wall paintings owes a lot to the techniques used to create them. The survival of some unfinished rooms in which the artist had abandoned his materials, has revealed that natural pigments were mixed in a solution of soap and lime and a little wax. To prevent damp from damaging the murals, seven layers of sand and lime were applied to the wall surface, often with one layer of ceramic fragments. The artist did his work on the top layer of lime and marble dust plaster while it was still damp, probably tracing the outline of the design to be filled in by artisan painters. The completed panels were then polished with a special hard polishing stone and buffed with a soft cloth. The subject matter

The Fourth Style, or fantastic style, seen here in the House of the Ancient Hunt, was popular at the time of the city's destruction. The bold colours and architectural eclecticism were influenced by decoration favoured by the emperor Nero in his Domus Aurea.

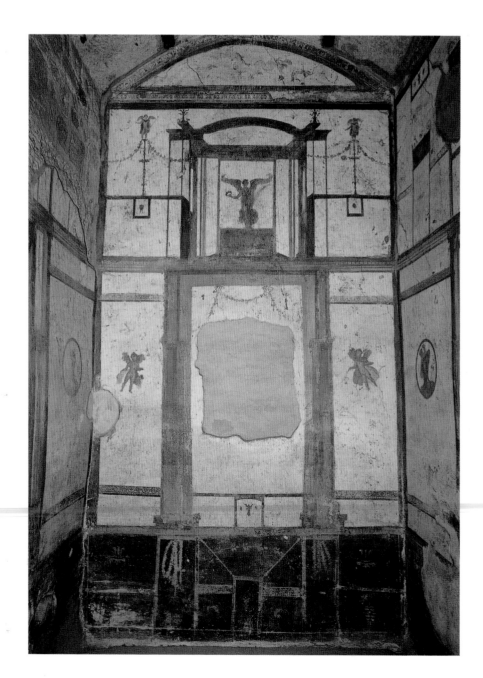

of these murals gives us many clues about the proclivities of Pompeians. Goethe, in his *Italian Journey*, observed:

> . . . their rooms, passages and arcades are gaily painted, the walls have plain surfaces with richly painted frescoes painted on them, most of which have now deteriorated. These frescoes are surrounded by amusing arabesques in admirable taste: from one, enchanting figures of children and nymphs evolve, in another, wild and tame animals emerge out of luxuriant floral wreaths. Though the city, first buried under a rain of ashes and stones and then looted by the excavators, is now completely destroyed, it still bears witness to an artistic instinct and love of art shared by a whole people, which even the most ardent art lover today can neither feel or understand or desire.[3]

A fresco depicting a variety of African animals. A lion chasing a bull, leopards pouncing on rams, hyenas and a wild boar all feature in this work of Pompeiian fantasy from the House of the Ancient Hunt.

ABOVE Cupids demonstrating the art of winemaking, from the triclinium of the House of the Vettii.

OPPOSITE An erotic mosaic depicting a satyr and a nymph, taken from the cubiculum of the House of the Faun and now in the National Archaeological Museum in Naples. Erotic scenes were used as subject matter for the decoration of both public and private rooms.

Stendhal, on the other hand, was not so impressed by the quality of the artistic production of Pompeii. After his visit in April 1817 to the Museum of Antique Painting at Portici, where there were some twenty-two examples of painted rooms, he wrote: 'They reveal a complete absence of *chiaroscuro*, a very limited range of colour, a passable feeling for design and considerable facility. . . . The general impression is of a series of bad works by Domenichino, albeit further still removed from greatness by the presence of numerous faults of draughtsmanship – errors which this fine artist would never have committed.'[4]

Stendhal may have thought that the artistic achievements of the Renaissance outshone those of Pompeii but his views reveal the limitations of judging the past by the value system of the present. So many of the interpretations of the art of Pompeii have been narrowed by that sort of approach that it is worthwhile to attempt to see life and art in the city through the eyes of the actual inhabitants.

THE PLEASURES OF VENUS

In their intimate lives the people of Pompeii appear to have taken seriously the dedication of their city to the patron deity, Venus. She was not only the goddess of love but she condoned all acts of love within a Roman moral code. In one of the most spectacular houses in Pompeii, the House of the Vettii, a wide range of complex Fourth Style murals can still be seen. The two Vettii brothers were freedmen who had made a fortune and secured high civic status for themselves. Their garden peristyle has twelve fountains and bronze and marble sculptures. The iconography of the decoration of this house is complicated but seem to be a mixture of mythology and symbols of commerce and manufacture, representative of the ways they made their fortune. Wine making, perfume production and the weaving of flower garlands are all intertwined with the more elevated themes of divine and mortal transgression. The patrons of the house are also the protectors of commerce, Fortuna and Mercury. More surprising is the decoration of the small room near the kitchen with a series of scenes of lovemaking: rather nonchalant nude displays of copulation painted in red and ochre on a plain white ground. Presumably they depict the master of the house

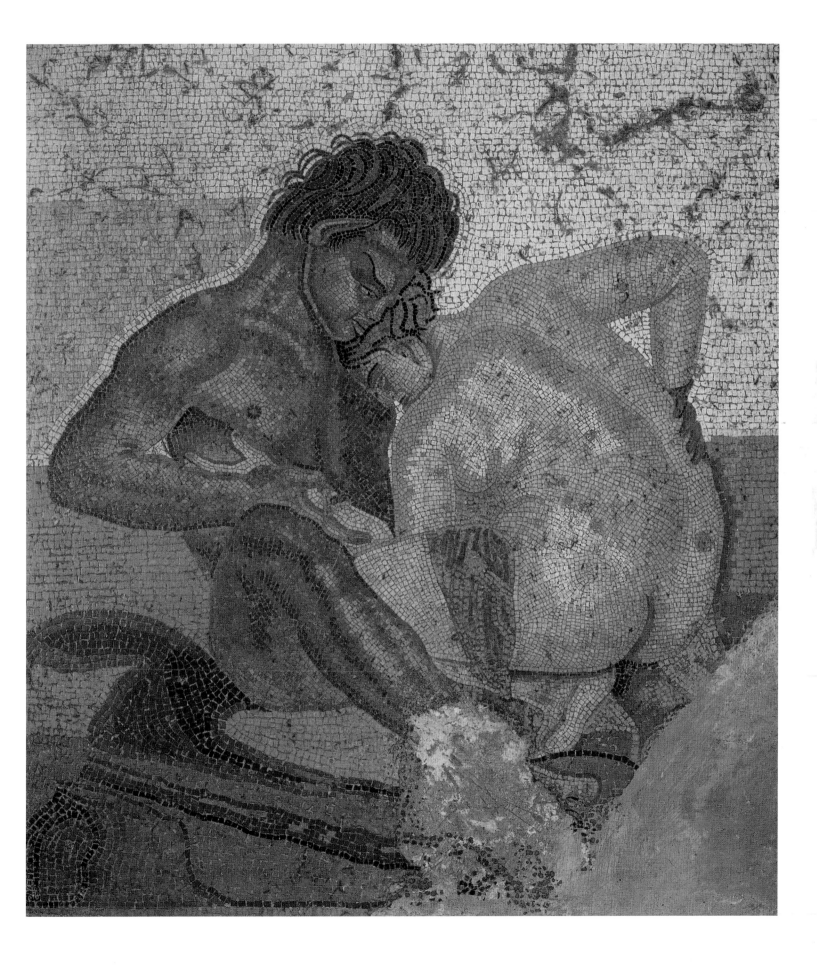

Priapus weighing his extraordinary member, from the vestibulum of the House of the Vettii.

THE PLEASURES OF BACCHUS

OPPOSITE The triclinium of the House of the Vetti. The Fourth Style decoration of the east wall frames a panel depicting the Punishment of Ixion, a story of infidelity, betrayal and ultimate punishment. The moral of the story indicated that 'benefactors must be honoured', a strong message from the Vettii to their guests.

exercising his droit de seigneur over his slave girl. It is not the subject matter that is surprising; it is the casual quality of the work. The sexual content is a natural sequel to the memorable sentinel who guards the main entrance to the house. It is a painting of Priapus, the god of fertility and abundance. He is weighing his enormous phallus against a sack of coins. This famous image is a coarse one compared to the idyllic scenes of less earthy and more romantic lovers – Hylas and the nymphs, Perseus and Andromeda, Daphne and Apollo, Dionysus and Ariadne – all to be found in the triclinium of the same house. Often the mural painters in the House of the Vettii seemed anxious to expound the value of faithfulness and legitimate love in the post-Nero age. Divine couples are seen as models for earthly couples, inspiring the fidelity of Pompeian wives. At the same time a free display of phallic achievement is a strong feature of the house – culminating in the fountain statue of Priapus in the peristyle spurting water from his engorged organ into a basin.

It is easy to imagine the successful Vettii brothers feasting and fornicating with friends and family in their pretentious house. They may also have decided to visit the taverns, brothels and baths of the city with their male friends. Perhaps they went outside the city boundary to the Suburban Baths where they could enjoy the murals of lovemaking between men and men, women and men, group sex and some strange sexual deformities. This, apparently, was the only bathhouse in Pompeii with a changing room that was shared between men and women. And it is the room where the friskiest murals are found. Many authors see this as evidence that sex in publicly viewed paintings was as much a subject for amusement and ridicule as for erotic pleasure and arousal. The scenes of pygmies performing sex acts and the lewd (perhaps only to modern eyes) performances by sex acrobats suggest that entertainments in Pompeii were similar to some of the imperial bacchanales in Rome or on Capri.[5]

In the Villa of the Mysteries we see another dimension of Pompeian life that brings religion, sex and ritual observance together in one place. In the remarkable dining room, the decoration consists of life-size figures forming a frieze that creates a totally enigmatic atmosphere. The room is some 16 by 23 feet opening on to a terrace and appears to be in the private quarters of the villa. The painted walls are strongly coloured and in the style of Greek vase paintings, recalling the rites associated with Bacchus, similar in style to those depicted on the third-century BC temple frieze at Pergamum in Mysia (modern Turkey), where Bacchus weds Ariadne.

These are some of the most vivid and telling murals in the city and they focus on the initiation rituals of pain and suffering necessary to achieve entry to the divine realm. We see a woman about to be scourged, a phallic object being unveiled and offered, another woman whirling in a dervish-like dance, and all the while the figures seem to be preoccupied in an almost spiritual way. One historian wrote that the people in the paintings appear to be 'beings entirely absorbed in their own existence, engrossed in their pursuits and abiding completely unconcerned about us, in a world apart from ours'. The mystic bride-to-be seems to have to undergo terrible torments of a physical and sexual nature to win salvation with Bacchus. The level of emotion and self-contained seriousness in these memorable paintings puts the Dionysian cult on a high plane. Often the

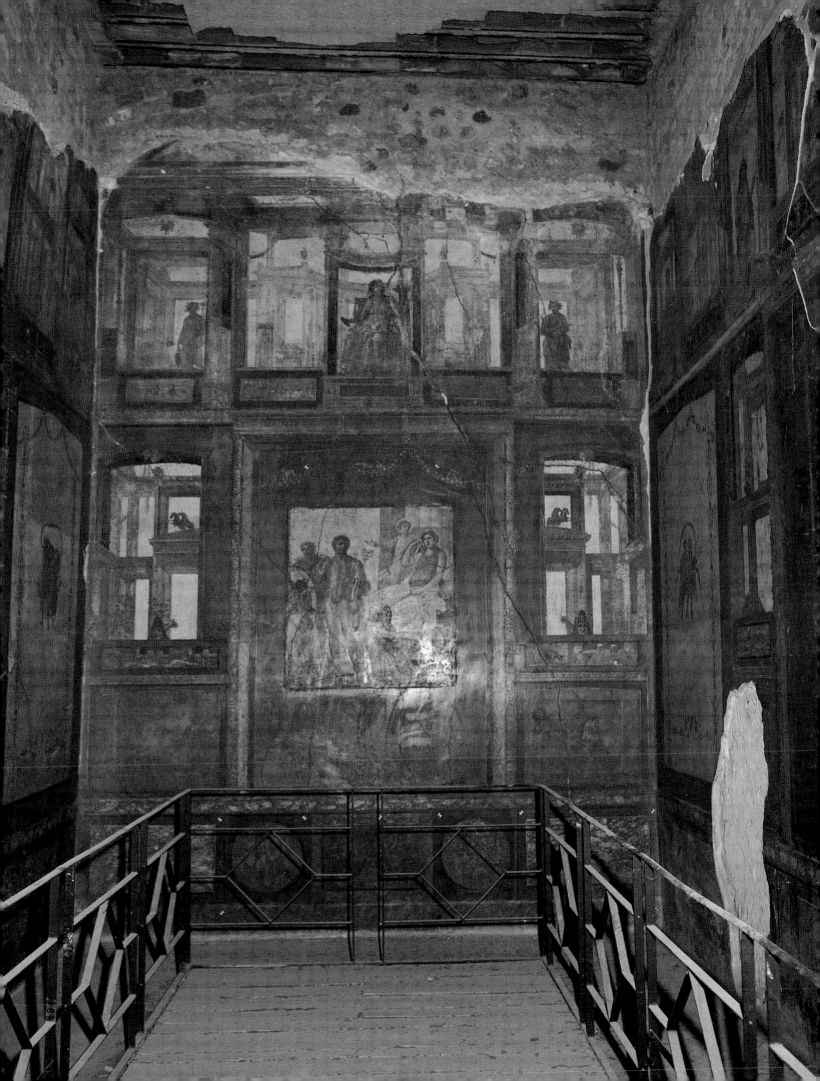

The Dionysian mural from the Villa of the Mysteries. The mural is a mythical interpretation of initiation to the cult of Bacchus. From the left, a girl makes a preparatory sacrifice, assisted by two attendants. Next Selenius plays the lyre for Bacchus and Ariadne, accompanied by a satyr on a pan flute, while the instrument's namesake suckles a fawn. The initiate shields herself at the sight of the god Bacchus, then uncovers the mystic cist which contains a ceremonial phallus. Once she is satiated, the initiate is whipped by a winged demon.

cult was much more to do with mere sensuality, portraying the joys of the afterlife as one long orgy of drink and sex. In Pompeii this seems to have been the more usual aspiration. The religious atmosphere in the city was easygoing – a kind of enjoyable materialistic Epicureanism of the 'eat, drink and be merry for tomorrow you die' variety. Petronius, writing in the first century AD, parodied the Dionysian cult, writing about the boorish freedman Trimalchio dressing a boy as Bacchus at a banquet to play the part as 'Deliverer, Inspirer and Liberator'.[6] Many have subsequently enjoyed a certain cruel puritan pleasure in the shocking inevitability of the fate of a city that lived for the present and was devoted to a casual materialism. The artist of the murals in the Villa of the Mysteries adds a rare depth to his view of humanity and the gods. Like the Greek sculptor Praxiteles in the fourth century BC, he conveys a sense of otherworldliness in his art.

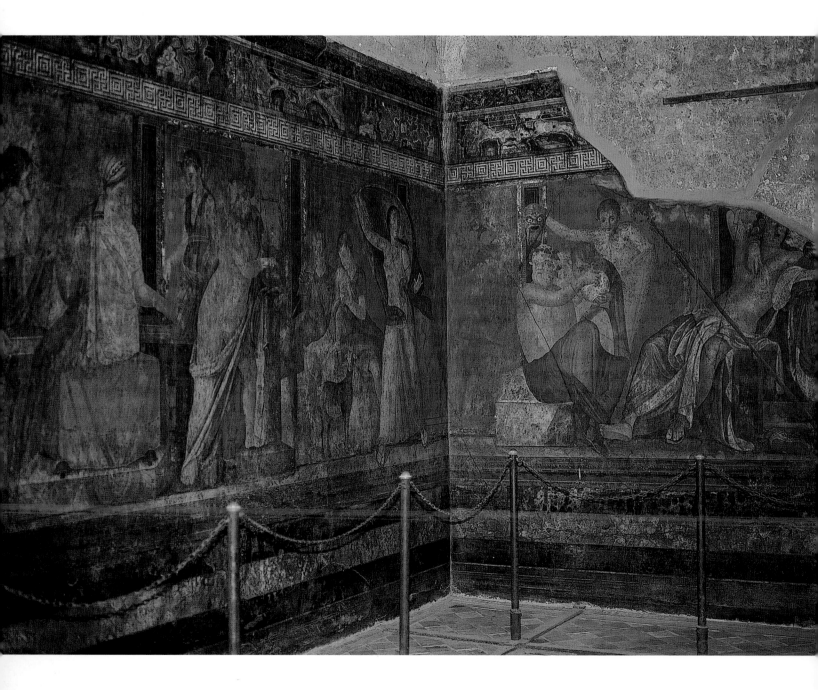

GARDENS OF EARTHLY DELIGHTS

Pleasure may well have been a primary motive for living in Pompeii – we can only judge from the art and artefacts that survive. The houses that we can reconstruct in our imagination seem to embody an ideal of domestic life. This ideal brought art into everyday life in a number of ways. Obviously the art of the mural painter was strongly evident, but the domestic arts – garden design, entertaining and fashion – were a major part of the prosperous and elegant lifestyle. Many surviving murals are important indicators of the architectural styles of the grander houses and seaside villas that they depict. They also show the enthusiasm in Pompeii for gardens. The poet Shelley observed that 'unlike the inhabitants of the Cimmerian ravines of modern cities the inhabitants of Pompeii could contemplate the clouds and landscapes of heaven'.[7]

THE PLEASURES OF LIVING

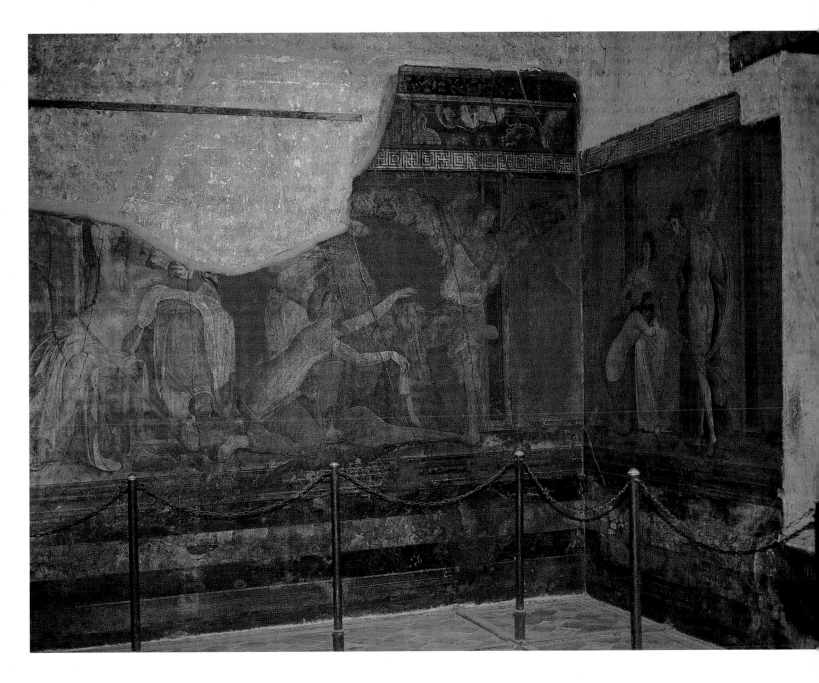

In many wall paintings the artist depicted imaginary landscapes with great delicacy and vision. A sense of Arcadia pervades the decoration of many houses. But there are also very detailed views of real gardens, which add to our knowledge of Roman horticulture, especially when considered alongside the actual restored gardens, such as the spacious hortus of the House of the Faun. The Faun garden is a very grand peristyle of Corinthian columns with a large mosaic floor in its exedra, showing the battle between Alexander the Great and the Persian king Darius (now in the National Archaeological Museum in Naples). Also in the Naples museum is a first-century BC fresco from a dining room showing carefully designed trellises dividing a garden into smaller outdoor rooms and arbours. It is astonishingly modern, with urns and vases and small splashing fountains in each little section. In another fresco, in the House of the Orchard, more densely woven laths create fences that define alcoves and bosky retreats. Beautiful and exotic birds parade around, giving scale to the lawns and trees. Niches and plinths abound to house and support the statues of various divinities. In the House of the Garden of Hercules there is a substantial niche with a statue of the powerful god. There are also outdoor stone benches for alfresco dining.

The agreeable climate and the fertility of the soil meant that many of the gardens, especially those of smaller houses belonging to the less well off, were also used for cultivating crops. Wine cultivation was crucial to the economy of Pompeii and there were hundreds of small vineyards in city plots. Recent palaeobotanical studies have demonstrated that many householders in the city grew plants that could be used to make perfumes. Gardens were quite frequently planted outside the formal peristyle and grew produce for the family table. At the Praedia of Julia Felix the large grounds included a fishpond, orchards and a vegetable garden. There is a large fishpond at the House of Loreius Tiburtinus which appears to have flowed down several levels, providing a miniature series of grottoes, pergolas, cascades and fountains. Recent examination of the imprints of the roots in the lava has revealed that the plants and trees growing there included pomegranates, figs, pears and chestnuts.

Gardening and an enthusiasm for the elegant introduction of nature into urban life (known as *rus in urbe*) played a key part in the lives of civilized Roman citizens. Water and plants and formal gardens were also seen as foreshadowing the beauties of paradise. Bacchus promised his initiates a new life in the gardens of paradise. Sophisticated poets like Virgil praised flowers and even vegetables for their beauty. Today, the land around Vesuvius is so rich and fertile that it feeds a large part of Italy. The lava slopes on the southern side of Pompeii encouraged a variety of styles of houses to be built making use of the land for terraced gardens.

Although it is some distance from the city of Pompeii itself, the Villa of the Papyrì – just beyond the western end of Herculaneum – deserves mention because it represents the apotheosis of Roman gardening in the region. Some eighty-seven marble and bronze sculptures, ranging from the archaic period of the seventh and sixth centuries BC to the first century AD, were excavated from this garden. Unusually, beyond the first atrium, peristyle and tablinum the garden had a very long and narrow colonnaded terrace that faced on to a planted area and central fishpond. Busts of Greek orators and Epicurean philosophers were mingled with statues of athletes and gods, drunken satyrs and animals. It is the greatest collection of ancient bronzes ever found and is now on view in the museum in Naples. It is this villa and garden that has been accurately reproduced

OPPOSITE A niche in the House of the Gilded Cupids pierces a mural of lush emerald foliage, birds and flowers, all thriving under a brilliant blue sky. Natural scenes such as this, including incredibly intricate paintings of flora and fauna, have helped archaeologists and historians to learn more about ancient Roman gardening.

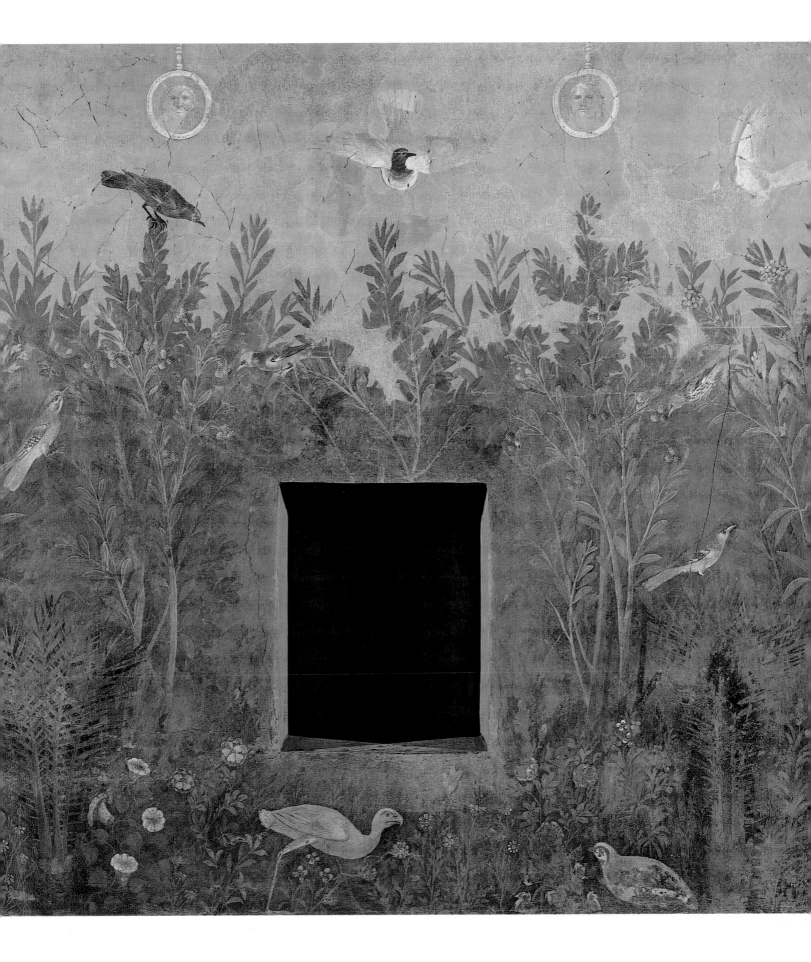

as the home of the antiquities collection of the J. Paul Getty Museum in Los Angeles. As part of the research for that project samples of soil and seeds from the Pompeii and Herculaneum region were analyzed to discover exactly which plants would have been grown in the region. So it is almost a necessity to go to California to see the perfect Roman villa garden. Conservators at Pompeii restoring peristyles and gardens have taken great care to plant only species that are shown in wall paintings or that were known at the time. The violets and roses and hyacinths that grow in many of the restored gardens are certainly authentic plants of the Roman world.

The Latin words used by Pliny the Elder to describe the art of gardening were *opus topiarium* (derived from the Greek word *topia* meaning 'landscape'). Pliny writes frequently about gardens and liked them to be as natural as possible, but the Roman taste was for formality, statuary and water. At the time of Augustus, Pliny writes about the invention of *nemora tonsilia* or 'barbered groves'. His own nephew's villa garden at Tifernum in Tuscany was famous for its topiary, with box trees clipped into animal shapes and scenes of hunting and sea battles. In Pompeii cypresses were undoubtedly clipped into stylish shapes and ivy was used as a backdrop for sculpture.

More solid evidence survives of the importance of water in the city's gardens. A magnificent fountain niche in the House of the Bear was built when running water arrived in the first century AD. It is encrusted with pumice stone and seashells and resembles the grottoes that were part of every nymphaeum – places sacred to the muses and the nymphs. Sometimes the gods of healing and medicine occupied such niches and fountains, associating health and healing with water. One of the most famous Pompeian water features is the canal and fountain garden of the House of Loreius Tiburtinus. Following the earthquake of AD 62 the owner decided to extend what had been an atrium house by removing the tablinum and adding an imperial peristyle while enlarging the garden so that it almost imitated

BELOW The House of the Venus is named for its famous peristyle mural of the goddess Venus reclining in a giant seashell.

OPPOSITE Frescoes in the garden of the House of Loreius Tiburtinus: Narcissus (above) and Pyramus and Thisbe (below).

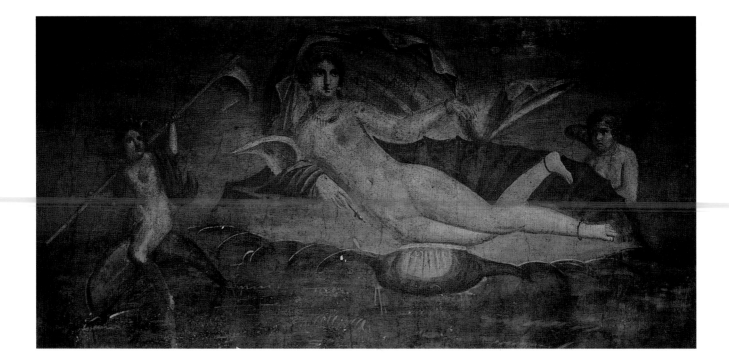

on a small scale the space around a country villa, set with streams and parkland. The upper garden with a trellised portico was much embellished with statues. Some evoked Egyptian themes associated with the rising cult of Isis. These stood alongside naïve paintings of Pyramus and Thisbe and the vain Narcissus. The lower garden is much more adventurous and recent reconstruction makes it possible to realize almost exactly what it was like and to sense how modern it is. The design would probably win a Gold Medal at the Royal Horticultural Society's Chelsea Flower Show. A long central watercourse is divided into three sections; possibly the divisions were to create three separate fishponds. The water issues from a nymphaeum decorated with a mask of the sea god Oceanus and a statue of Eros. Representations of the goddess Diana and the handsome nude Actaeon flank the grotto, suggesting more links to bathing and hunting. Poor Actaeon is in fact being set upon by Diana's hounds as a punishment for spying on the goddess while she was bathing. Open pergolas cover the waterways, with trellises for vines, and paths run down each side with sculptures at their edge. The combination of shady arbours and running water would have created a most atmospheric garden that could have been used as an outdoor summer room. The art of gardening had clearly reached a very high point in Pompeii.

Almost a generation later the young Pliny was to write of the pleasure he felt sitting under his vines as the fountain played into a marble basin. Plants flourished around the flowing water. Among the plants that have been definitively identified are box, cypress, plane trees, laurels, myrtles, acanthus, poppies, oleander, lilies, roses and viburnum. Pollen analysis and research into the carbonized plant material also suggests that many of the plants in the peristyle were grown for their fruits: fruit trees and vines and nut trees have all been identified. These would have added a special pleasure to alfresco dining.[8]

THE CULINARY ARTS

Dining was a major part of life in the city, the main meal being taken in the cool of the evening in the summer and often outside, in the Mediterranean manner. Reclining on your couch in the triclinium you could expect to enjoy a substantial evening meal. The first course was a kind of antipasto (*gustatio*) consisting of eggs, vegetables, seafood and wine sweetened with honey. This was followed by the meat and fish course (*prima cena*) when several dishes would be offered with vegetables. Dessert (*secunda cena*) was usually fresh and dried fruits.[9] A Roman imperial chef and gastronome, Marcus Gavius Apicius, has left behind a book, *De re coquinaria* ('On Cookery'), which gives an excellent idea of how the grandest meals were cooked and served. Some of his favoured dishes were undoubtedly served in Pompeii. The town was famous for its fish sauce, *garum*, made of fish macerated in brine. Apicius gives the recipe for a dish consisting of chicken cooked in *garum* with dill and leeks. He calls it Chicken Fronto. He offers pork cooked with honey and apricots and serves it with lentils cooked with chestnuts and coriander, or a sucking pig casseroled in *garum* and wine. Much of the wine was flavoured or diluted. Apicius favours steeping the leaves of roses (best when the dew has dried on them) in wine for several days to make the wine fragrant and seductive.

There was much feasting and entertaining in these sumptuous houses, but how orgiastic the evenings were is hard to tell. Odd graffiti and some murals suggest that more than food entered the mouths of diners and that men

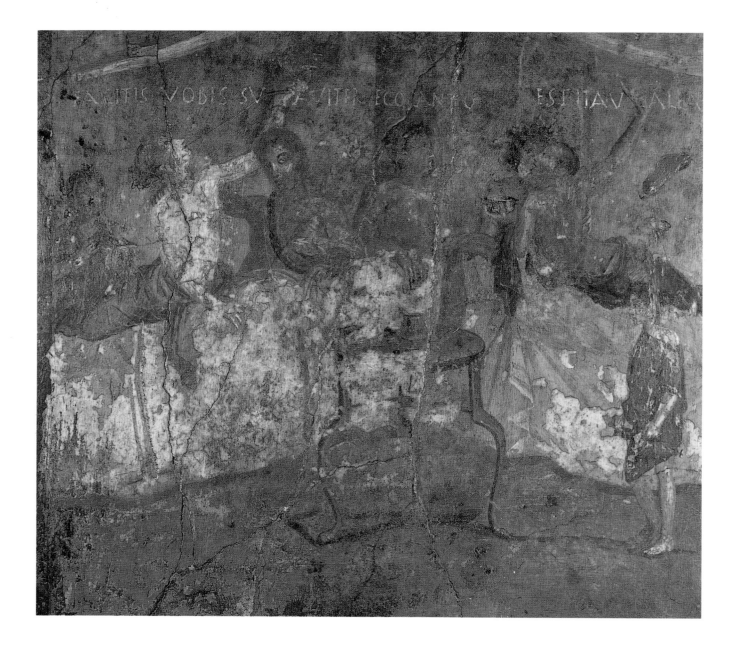

Fresco of a banqueting scene. Pompeians lounge on triclinum couches and toast each other.

sometimes engaged in sex after meals. In a back room of the Suburban Baths, a rather matter-of-fact graffito reads: 'Apelles the waiter dined most pleasantly with Dexter the slave of the emperor, and they had a screw at the same time.' Perhaps someone had spiked their wine. More appealing are the still-life paintings in Pompeii, which are wonderfully realistic portrayals of succulent game birds, fruit and seafood. These were known as *xenia* after the Greek for 'guest gifts': offerings of food that would be left by hosts for guests who came to stay or borrowed a villa for a holiday.

To entertain well it was essential not so much to supply music with dancing girls and boys (unless you were Nero at his Domus Aurea or Tiberius sampling the youths of Capri) as to show your wealth with good silver and glass. A mural from the House of Menander depicting silverware – plus actual finds of silver from nearby Boscoreale – show how well designed and elaborate it was, with embossed mythological scenes and patterns of plants and geometric designs.

BELOW:
Archaeologists have found numerous objects of metal and glass, such as these, which show an exceptional level of skill and refinement.
BELOW LEFT A tripod with ithyphallic Pans; the sinuous and virile Pans balance a basin upon their heads as they gesture caution. This object was very influential and was used as a model by many neoclassical designers.
BELOW RIGHT A Pompeian 'samovar' used to hold warm liquids such as water or wine.
BOTTOM LEFT A silver cantharus with olive twigs; this style was very popular during the Republic.
BOTTOM RIGHT A ribbed cup of blue glass; glass was prized by the Romans, who often preferred glass bowls and vases to those made of precious metals.

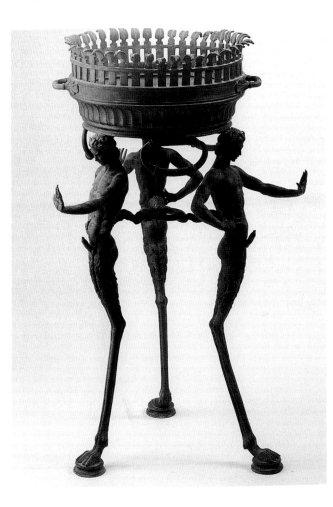

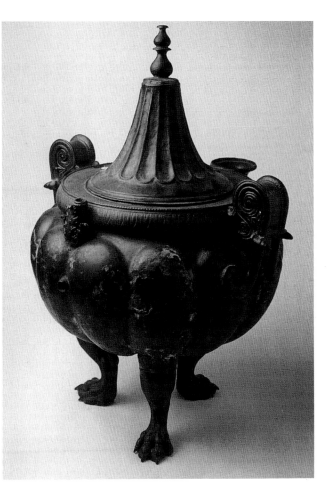

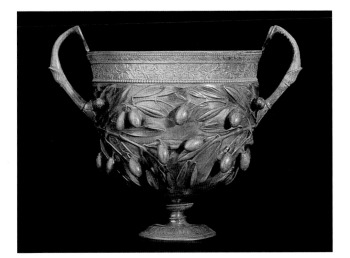

Glasses for drinking and bone-handled knives and good pottery were all on the tables of Pompeii and if silver was not affordable bronze vessels were used. Bronze was also used for lamps, which were often highly decorated. Many of the designs of lamps and furniture recovered from Pompeii became the pattern for eighteenth-century neoclassical furniture.

RELAXING AND SOCIALIZING

All the feasting and imbibing must have made it essential to repair regularly to the gymnasium and the baths. There were three major bathing complexes for the city itself: the Stabian Baths at the Holconius crossroads, the Central Baths at the junction of the *decumanus maximus* and the *cardo maximus* which were still unfinished at the time of the eruption, and the Forum Baths at the junction of the Via di Nola and the Via del Foro. There were usually separate baths for men and women and the establishments were elaborately staffed. Here again, artwork abounds, elevating the private act of washing to a social event embellished with images of grandeur and culture. These were some of the most beautiful buildings in the city with their fireproof concrete vaulted roofs, porphyry columns and stucco work. The baths housed some marvellous sculpture and figures of athletes, exemplars of a physical ideal.

We have little real idea of the bathing rituals of the *thermae*. We may know a few facts but it is not easy to put oneself into the body of a Pompeian citizen who probably went to the baths almost every day and spent a long time there meeting friends, washing, exercising and comparing his physical development with others. Everything was very public. From the moment you shed all you clothes there was no prudery or modesty. You were never alone. Bath attendants, often Ethiopian or black slaves from another part of Africa, seized you as you emerged from the dry heat or the steam and oiled, scraped and massaged you. If you wanted to answer a call of nature you would sit in a row of marble-topped latrines, leaning your elbows on armrests supported by bronze dolphins, and talk to your neighbour while accomplishing an appropriate daily elimination.

The swimming pools were extremely elegant, reflecting in their water the mosaic ceiling which was covered in glistening representations of fish and marine life. You would have had the sense of swimming in a blue grotto. In the great courtyard of the Stabian Baths there was plenty of room for ball games, wrestling, running, throwing the discus and boxing. Weightlifting was apparently supervised by a giant statue of the god of physical exercise, Mercury. It was in this courtyard that Pompeians worked up a real sweat before plunging into the *piscina* (cold swimming pool) before the first massage. After resting on a couch for a while the time would come to enter the actual baths themselves. Following the rituals of warm and hot baths or simply heating up in the very warm air from the underfloor heating gave the bather a real sense of well-being that was much enhanced by the beauty of the buildings. You could easily stay for hours and in the Central Baths – still being built at the time of the eruption – the architectural quality was going to be even more advanced than the older baths, with much more space and natural light from large windows. Because the baths were clearly *the* gathering place for the population, there were plans to add new facilities: libraries, restaurants, lecture rooms and large areas just for rest and conversation. All ages enjoyed the baths and they were undoubtedly busy, noisy and yet very democratic and civilized.

A winged figure, perhaps Icarus, emerges in plaster relief at the Forum Baths. Sculpted Atlases stand between niches where bathers could leave their possessions for safekeeping.

Today we can stand back from the noise and confusion to ponder the beauty of Pompeii and attempt to reconstruct its daily life. A sense of energy and activity emerges not so much from the remnants of the buildings as from the rare survival of works of art at the end of the period of the republic and the beginning of the empire. Rome itself has preserved fewer art works than Pompeii and Herculaneum and so it is vital for anyone who wants to understand Roman life to visit these two cities and the museum in Naples. We can enjoy the vast quantity of surviving art but it is more difficult to explain why almost all the houses were decorated with paintings. Artistic discernment seems to have been widespread at all levels of the population. Art was also something of a necessity. Many houses had a lot of small rooms, and after spending much of the day outside these southern sun-loving people needed the architectural vistas and sense of sky and landscape to be brought indoors. The fascinating question for us today is why was there such a need for illusion. The admiration for *trompe l'oeil* suggests a preoccupation with the reproduction of the real. This has been useful

Theodore Chasseriau's nineteenth-century representation of the women's day at the Forum Baths. Chasseriau attempted to recreate the lost interior of the Forum Baths while imbuing it with an erotic atmosphere.

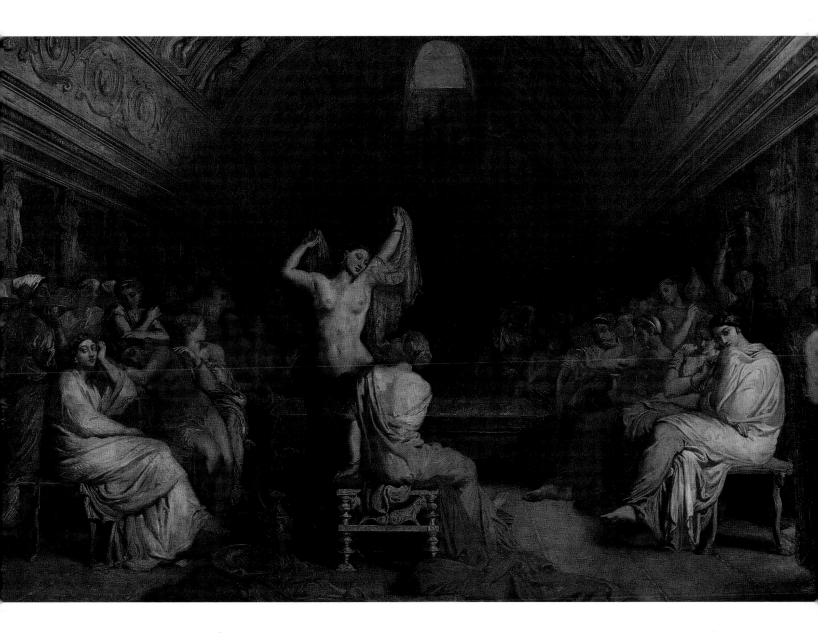

ABOVE With her stylus and wax tablets, 'Sappho' looks thoughtful, as if composing a poem in this famous portrait.

OPPOSITE Portrait of Paquius Proculus and his wife, now in the Museum of Naples. Their faces have captured the imagination of historians, as they represent a Pompeii not of temples and houses but of ordinary people whose lives and world vanished overnight.

for later generations as we feel we can safely trust the accuracy of the representations of a lost world. This applies especially to portraits, which can truly be read as reliable interpretations of character. The famous portrait of the baker and his wife, now in the museum in Naples, was actually found on the wall of their shop. It is full of character and not an attempt to flatter the sitters. There is a true sense here of art and life meeting. The man has a vigour and roughness about his face – he could be about to sell you a second-hand car today – while his wife is more reflective, perhaps about to do the accounts which her more physical husband is happy to leave to her. It is the wife who keeps the bakery afloat and will ensure that it is not just the customers who will have bread to eat.

The more learned-looking young woman known as Sappho, also now in Naples, has the same large eyes as the baker and his wife, but she is clearly pensive and holds the attributes of an educated person – the stylus and the wax tablets. Her elegant hair is held in place by a net of gold and she wears large golden earrings. She has the air of the Virginia Woolf of Pompeii about to record in her journal her thoughts about the men of the city. These are the faces that stay in the mind long after you have left. They speak to posterity all the more clearly because we know that they perished dramatically. The artists of Pompeii, working in both fresco and mosaic, unwittingly became the documentary recorders of the lost world, just as dramatically as if they had been Magnum photographers in wartorn Vietnam.

Pompeian artists also recorded simple everyday behaviour, stylized it and related it artistically to Attic pottery designs and myths: girls combing their hair, emancipated slaves at the baths, surgeons saving lives, couples making love – and everywhere there is food, drink and flowers in the presence of the gods. In doing so, they left us a vision of a lost world to which we can still relate. There is still immediacy in our response to Pompeian art. It was felt by Goethe, who was also prompted to philosophize on the precariousness of beauty, and the vulnerability of aesthetic and sensual pleasure. And the French painter Auguste Renoir sensed the vibrancy of the art of Pompeii, writing to Ambroise Vollard some one hundred years after Goethe:

Leaving Rome, I took the Naples road. You have no idea of the respite it was for me when I arrived at that city absolutely filled with Pompeian and Egyptian art. I was beginning to be a little tired of Italian painting, always the same draperies and the same virgins. What I so admire in Corot is that he gives you everything in a treetop. And, as you know, it was Corot himself who I found again intact in the Naples Museum with that Pompeian simplicity of workmanship.

Art and life still live together in Pompeii. The same sun still shines on those mosaics, gardens and peristyles. We can walk the same streets and wander into a painted house with no sense of being in a museum. As we pass the tombs it is thanks to the unknown artists that we can still greet the inhabitants as though we had known them.

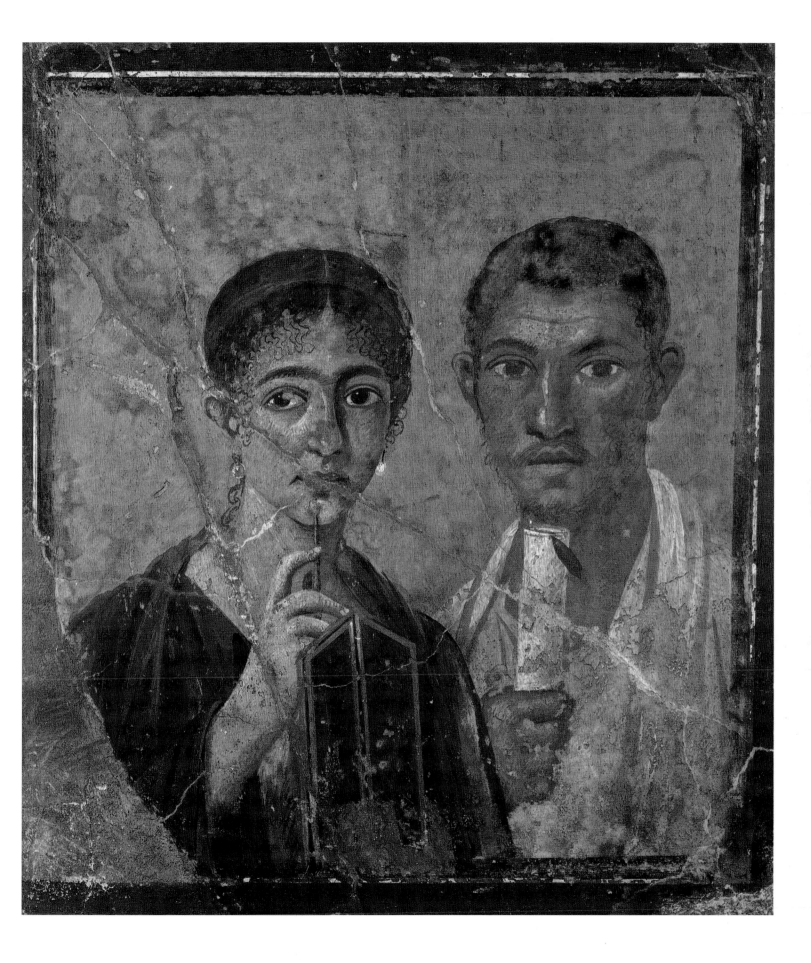

THE GRAND TOUR

A man who has not been in Italy, is always conscious of an inferiority, from his not having seen what it is expected a man should see. The grand object of travelling is to see the shores of the Mediterranean. . . . All our religion, almost all our law, almost all our arts, almost all that sets us above savages, has come to us from the shores of the Mediterranean.

SAMUEL JOHNSON, 1776

TODAY WE MAY HAVE THE ADVANTAGES of air travel, and our children may spend their gap year in Thailand or Africa, but the simple fact that we can travel so far so easily does not mean that we should forget the wise words of Dr Johnson. Nor should we forget that on sites as large, as extensive and as rich as Pompeii and Herculaneum, archaeological research continues to make significant discoveries. Money from the New World to the Old helps to ensure that both conservation and exploratory work will continue in both cities. The international nature of archaeology and its support of exciting ongoing projects will maintain the tradition of 'Grand Tourists' into the twenty-first century.

Pompeii was one of the great excitements of the Grand Tour throughout the eighteenth and nineteenth centuries; interest grew as excavations developed. The origins of the Grand Tour to Italy are in themselves fascinating – the reasons that aristocrats, writers, artists and architects of Great Britain and other European countries felt lured to Italy were both sublime and base. On the one hand they wanted to see for themselves the birthplace of European art. On the other hand many travellers were looking for business, hoping to earn large profits on works of art that they could buy and sell. Archaeology and collecting went hand in hand. This was partly out of genuine appreciation of the artefacts of the past but it was also a means of purchasing taste. There is no doubt that in England after 1688 collecting antiquities became part of the political 'programme of the oligarchy'.[1]

It was not just the English who were entranced by Italy. In the early nineteenth century the French novelist Stendhal wrote an account of his travels. He believed that only a few specially selected people could enjoy or understand the past in Italy. 'Le conseil d'aller en Italie ne doit pas se donner a tout le monde' ('Not just anyone should be advised to go to Italy') he wrote, beneath the admonition, in English, 'To the happy few . . .'.[2]

Artists shared this sense of being part of a travelling élite. In his journal, the Welsh landscape painter Thomas Jones (1742–1803) described Italy as a 'Magick Land', and he considered his enjoyment special: 'I suppose, I enjoyed pleasures unfelt by my companions.'[3] It is the aesthetic response of these travellers that has survived and continues to influence us today. It endures in the collections that they made in English country houses and in the major museums of Europe. It endures in the paintings and engravings they made and published. Above all, it endures in the buildings and rooms the architects designed that were so strongly influenced by the discovery of classical remains.

Goethe, as so often, reminds us why the travelling was so important:

The most decisive effect of all works of art is that they carry us back to the conditions of the period and of the individuals who created them. Standing amid antique statues, one feels as if all the forces of Nature were in motion around one.[4]

The creation by Pope Pius VI (1775–99) of the Pio-Clementine Museum in the Vatican brought many of the antique masterpieces admired by Goethe into the first great Roman museum and firmly linked the papacy with classical art. The art historian Francis Haskell argued that the very existence of this museum was a response to Grand Tourist greed and that the Pope was one of the few who

PREVIOUS PAGES *The Eruption of Vesuvius in 1767*, by Pietro Antoniani (c. 1740– c. 1781). Antoniani was one of a group of artists encouraged to come to Naples by Queen Maria Amalia, wife of Charles III. Artists such as Anton Raffael Mengs, Antonio Joli, Anton Maron and Pietro Fabris recorded and glorified all aspects of the Bourbon kingdom.

realized that defensive policies were needed to secure the classical past for Italy's future generations. He admires the papacy for 'the building, in stages, of an entirely new and vast [museum] in the Vatican, which soon became the finest of its kind in the world – and it is tempting to look upon its creation as the most beneficial consequence of the Grand Tour.'[5]

Meanwhile, the excavations at Pompeii and Herculaneum in the early eighteenth century were the beginning of the first 'instant museums' which, as well as providing material for collections, transformed inquisitiveness about the past into a more serious and direct learning activity. This is well explained by Richard Hamblyn:

> It is untrue to say that the eruption of Vesuvius of AD 79 destroyed the two villages of Pompeii and Herculaneum, for it was the eruption of Vesuvius that created them and produced a renewed reason for northern Europeans to visit Naples rather than turn round at Rome. There would be no reason to recall the name of Pompeii, or any other of the two hundred or so similar settlements in the region, were it not for the circumstances of its burial, discovery and subsequent status during the mid-eighteenth century as an instant museum.[6]

Giovanni Paolo Pannini (1691/2–1765/8) was one of the first painters to specialize in the creation of *vedute*, focusing on the ruins of ancient Rome. *Gallery Displaying Views of Ancient Rome* (1758) brings together views of well-known Roman buildings and famous antique sculptures in an imaginary gallery. His work was popular with Grand Tour patrons and an important influence on Piranesi.

ABOVE An engraving by Giovanni Battista Piranesi (1720–80) of the tomb chamber of Lucius Arruntius from his *Le Antichita Romane II*. 'The Antiquities of Rome' were published in four volumes in 1756 and the second volume was devoted to the funerary monuments in Rome and the Roman countryside. Piranesi's views of Rome created a lasting impression of Antiquity that was more sublime than the reality seen by Grand Tourists.

OPPOSITE *Goethe in the Campagna* (1787) by Johann Heinrich Wilhelm Tischbein is almost an archetypal image of the European intellectual tourist being inspired by the ruins of ancient Rome. Goethe is draped in a toga-like garment and seems to be absorbing the classical past by osmosis. Tischbein (1751–1829) took over the directorship of the Academy of Fine Arts in Naples in 1789 and travelled with Goethe to Pompeii.

The Grand Tour in the eighteenth century was a serious business – a trip could last for several years and follow a complex itinerary. As the century wore on, the itinerary began to extend further south. While Rome remained (as it still does) the *caput mundi*, the astounding rediscoveries of Herculaneum and Pompeii in 1738 and 1748 lured the travellers to Naples and beyond to the ancient Greek colonies of Paestum and Sicily. The scenes that travellers were to enjoy in Italy would gradually become part of the shared mental art collection of learned European travellers. In time the images and objects of the Grand Tour filtered into the shared consciousness of European artistic sensibilities. For European travellers, Italy became what Athens had been to the Romans themselves, while Rome itself remained the great magnet. It was here that Giambattista Piranesi had his engraving business, attracting the English as customers and the French as trainee engravers. His vision of the ancient world was one of the most powerful artistic influences on so many travellers because it succeeded in being both objective and imaginative. The library and collections of Alessandro Cardinal Albani drew many artists under the guidance of Johann Joachim Winckelmann, whose work helped to consolidate the principles of the Greek aesthetic ideal. In Naples the salon of the British envoy Sir William Hamilton was a statutory stopping place for Grand Tourists from all over Europe. His collections and his wife's astonishing performances of classical 'attitudes' – a series of 'tableaux vivants' that she would enact for specially invited audiences – drew Goethe, Wright of Derby, Jacob Philipp Hackert, Louis Ducros, Pietro Fabris and many others. The Italians, although naturally hospitable and friendly, had a very clear picture of their visitors from Albion. As the artist Thomas Jones wrote in his diary in 1778:

> The Romans arranged their English Visitors into three Classes or degrees – like the Positive, Comparative and Superlative of the Grammarians – The first Class consisted of the Artisti or Artists, who came here, as well for Study and Improvement, as emolument by their profession. The Second, included what they termed Mezzi Cavaliere – in this class were ranked all those who lived genteely, independent of any profession, kept a servant – perhaps – and occasionally frequented the English Coffeehouse. But the true Cavaliere or Milordi Inglesi were those who moved in a Circle of Superior Splendour – surrounded by a group of Satellites under the denomination of Travelling Tutors, Antiquarians, Dealers in Virtu, English Grooms, French Valets and Italian running footmen – In short, keeping a Carriage, with the necessary Appendages, was indispensable to the rank of a true English Cavaliere.

But there is no doubt that many English eighteenth-century travellers looked clearly and objectively at the land they saw. They were trained observers who wanted to learn. Their accounts are accurate and are not tainted by the romanticism which was to colour the nineteenth century's views. Nor were they like some of today's travellers who travel in the hope of finding themselves. The healthy lack of self-absorption gave them clear insights as they experienced Italy in the eighteenth century.

Goethe was the traveller *par excellence* and his *Italian Journey*, which describes his trip to Naples and southern Italy in 1787, is one of the very best accounts of a Grand Tour. He was perceptive to an extraordinary degree. At first, however, he seemed to be a little reluctant to travel south of Rome:

> When I think of Naples or, even more, of Sicily as I know them from stories and pictures, it strikes me that these earthly paradises are precisely the places where volcanoes burst forth in hellish fury and have for centuries terrified and driven to despair the people who live there and enjoy these regions.

GOETHE'S ITALIAN JOURNEY

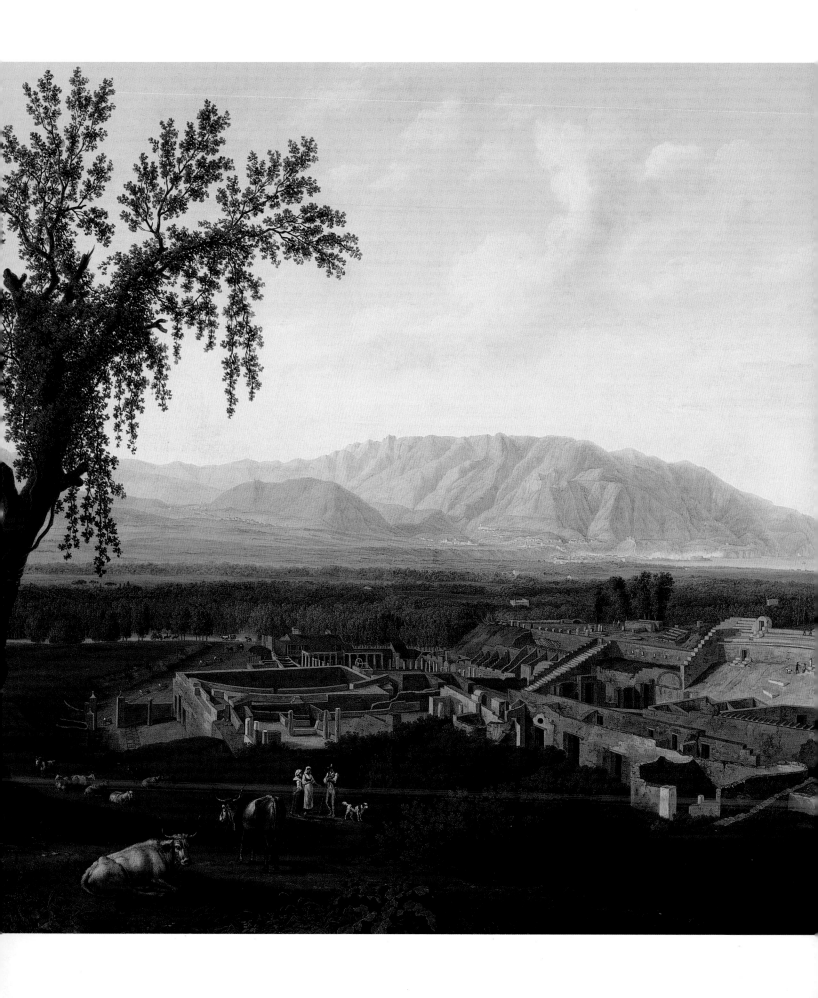

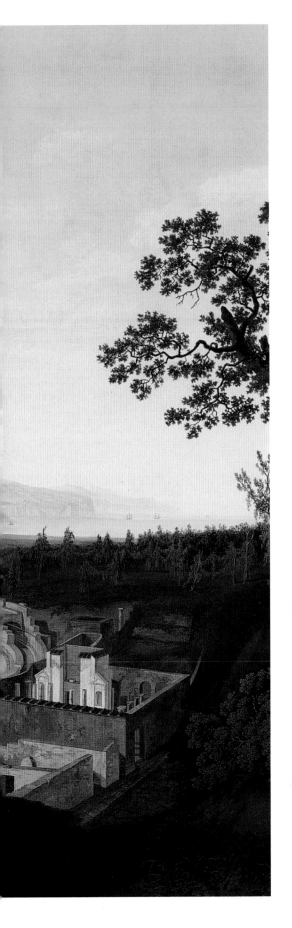

Eventually he leaves Rome with the painter Wilhelm Tischbein to travel down to Naples. Soon he is in Pompeii. It is worth quoting Goethe's observations in full:

> Considering the distance between Pompeii and Vesuvius, the volcanic debris which buried the city cannot have been driven here, either by the explosive force of the eruption or by a strong wind; my own conjecture is that the stones and ashes must have remained suspended in the air for some time, like clouds, before they descended upon the unfortunate city.
>
> To picture more clearly what must have happened historically one should think of a mountain village buried in snow. The spaces between the buildings, and even the buildings themselves, crushed under the weight of the fallen material, were buried and invisible, with perhaps a wall sticking up here and there; sooner or later, people took this mound over and planted vineyards and gardens on it. It was probably peasants digging on their allotments who made the first important treasure hauls.
>
> The mummified city left us with a curious, rather disagreeable impression, but our spirits began to recover as we sat in the pergola of a modest inn looking out over the sea, and ate a frugal meal. The blue sky and the glittering sea enchanted us and we left, hoping that on some future day, when this little arbour was covered with vine leaves, we would meet there again and enjoy ourselves.
>
> As we approached Naples, the little houses struck me as being perfect copies of the houses in Pompeii. We asked permission to enter one and found it very clean and neatly furnished – nicely woven cane chairs and a chest which had been gilded all over and painted with brightly coloured flowers and then varnished. Despite the lapse of so many centuries and such countless changes, this region still imposes on its inhabitants the same habits, tastes, amusements and style of living.

Goethe's observations are interesting for two reasons. His scientific view that the dust cloud must have hung in the sky for some time and then fallen, agrees with current thinking – the 'pine tree' theory that it grew upwards slowly and then fell to earth branch by branch. The other aspect of Goethe's account is that he might have been expected to ponder the imperial politics of the time or the status of the city, but no, he is interested in the domestic detail of how people lived, how they painted their houses and how responsive they were to art. Many travellers do feel an initial sense of gloom – the mummified aspects of the city can induce strong feelings of the immanence of death, and it is the casualness of random death which invokes a sense of fatalism. Goethe suggests that he is disappointed in some way with his first visit to Pompeii and so, despite the agreeable languor he feels when in Naples, he perks up and pays it another visit two days later:

> On Sunday we went to Pompeii again. There have been many disasters in this world, but few which have given so much delight to posterity, and I

A view of the recently excavated theatres in Pompeii by Jacob Philipp Hackert (1737–1809). He was the official painter to King Ferdinand IV and was to assist the King in the removal of the great Farnese collections from Rome to Naples. His paintings were much collected by British Grand Tourists and this one still hangs in Attingham Park in Shropshire.

have seldom seen anything so interesting. The city gate and the avenue of tombs are unusual. There is one tomb of a priestess, shaped like a semicircular bench and with an inscription carved in large letters on its stone back. As looked over it I saw the sun setting into the sea.

The visual pleasure of Naples and the relaxed style of life seem to have both pleased and worried Goethe – his German temperament perhaps found pleasure hard: 'In Rome I am glad to study: here I want only to live, forgetting myself and the world and it is a strange experience for me to be in a society where everyone does nothing but enjoy himself.'

The Neapolitan way of life may well reflect a continuity of the kind of relaxed life that was lived in ancient Pompeii. Certainly the climate and the fertility of the region encourage a life of pleasure. But Goethe perceived that the Neapolitan (and by inference the Pompeian) also lived in the shadow of the volcano. He paid a last visit to Vesuvius towards the end of March 1787 and witnessed an emission of lava. Calling Vesuvius 'this peak of hell which towers up in the middle of paradise', he sums up the atmosphere of the region in a way that still applies to any visit to Pompeii.

The Terrible beside the Beautiful, the Beautiful beside the Terrible, cancel one another out and produce a feeling of indifference. The Neapolitan would certainly be a different creature if he did not feel himself wedged between God and the Devil.

ENGLISH VISITORS

Many other visitors on their Grand Tours found Naples a place of wonder and relaxation and the extended tour from Rome became an essential part of any civilized traveller's itinerary. Naples, capital of the Kingdom of the Two Sicilies, was renowned as the residence of Virgil, whose tomb was close by at Posillipo. In the time of the emperor Augustus, a tunnel was cut linking Naples to Pozzuoli and visitors often went just beyond to see the remains of the Temple of the Cumaean Sybil and Lake Avernus from where – according to Virgil's *Aeneid* – Aeneas made his descent into the underworld. The gradual revelation of Pompeii in the years following 1748 unveiled a city and civilization that had last been described in the letters of Pliny. At that point in the eighteenth century the sites at Pompeii and Herculaneum (where excavation had begun in 1731) were open but closely guarded. One visitor, the Earl of Carlisle, complained in 1768 that he was unable to make any purchases there. Tourists also went to admire Vesuvius and the Bay of Naples and from 1759 the Bourbon monarchs Ferdinand IV and his queen, who was the sister of Marie Antoinette, were a curiosity to be observed. Their giant new palace at Caserta, designed by Vanvitelli, was much visited and the wolf hunts and other rustic pleasures held in its magnificent park were often enjoyed by the more aristocratic visitors. The presence in Naples after 1768 of Sir William Hamilton as the British Ambassador was a particular attraction. He was distinguished as a collector and antiquarian but his second marriage to Emma Hamilton in 1791 was to stretch his social credibility. Towards the end of the century the area south of Naples – Apulia, Calabria, and Sicily – became part of the Tour to include the whole of Nova Graecia with its dramatic Doric remains.

Waves of young British men travelled south later in the eighteenth century. In March 1763 Johann Joachim Winckelmann, the erstwhile keeper of the papal antiquities and personal assistant to Cardinal Albani, recorded that there were three hundred Englishmen in Paris on their way to Rome. Many were reluctant travellers doing a kind of 'gap year', described by the writer Laurence Sterne in the preface to A Sentimental Journey through France and Italy (1768) as the 'army of peregrine martyrs – young gentlemen transported by the cruelty of parents and guardians, and travelling under the direction of governors recommended by Oxford, Aberdeen and Glasgow.' Not all the Grand Tourists were unwilling younger sons trying to avoid their bear leaders and to find good wine or pretty girls and boys. The lure of Italy and its ancient sites was irresistible to architects.

Robert Adam (1728–92) arrived in Rome in February 1755, travelling with the Honourable Charles Hope and the French artist and brilliant interpreter of neoclassicism Charles-Louis Clerisseau. These two companions gave Adam all the best social and artistic introductions he needed. Clerisseau was to train Adam in drawing and to introduce him to another master of representation of the ancient world, Giambattista Piranesi. There must have been such a great contrast between

Joseph Wright of Derby (1734–97) travelled in Italy between 1773 and 1775 and was deeply impressed by the eruption of Vesuvius. In this view of Vesuvius from Posillipo he was developing his skills in the depiction of the moonlit landscape.

the two artists – Clerisseau careful and calmly atmospheric and Piranesi a vigorous and inventive draughtsman. Piranesi was a great inspiration to Adam, who described his engravings as 'the greatest fund for inspiring and instilling invention in any lover of architecture that can be imagined'. After Holy Week in Rome, Adam set off for the five-day journey by road to Naples.

Every day was spent seeing curiosities, but for some reason he does not record a visit to Pompeii, presumably because so little had been unearthed at that time. He does however spend a day in Herculaneum, where they climbed down holes to see the buried Amphitheatre. We know that Piranesi drew here and that they visited the collection of objects that had been rescued in the museum at Portici. Like so many visitors Adam was very moved by the sight of Virgil's tomb and he made many drawings of it. Equally powerful were his first impressions of Vesuvius, which he saw in the spirit of the sublime and terrifying. In a letter to his family in Scotland he wrote of . . .

. . . that great mouth which is immensely deep and which sends out a pillar of flame and sulphurous smoke of an immense volume, exceeded much my conception and from the growling thunder which every two or three minutes seemed to rise from the foundations of the hills surrounding the volcano, your ideas were converted into the most Hellish solemnity, whilst nothing but sulphur, burnt rocks and ashes all around augmented the savage prospect.

Robert's younger brother James (1730–94) was more persistent when he reached the south of Italy and he made it to Pompeii despite experiencing and recording some of the realities of travel in the eighteenth century. Outside Rome on his way south . . .

. . . for half an hour after going to bed I was so attacked in the flank, front and rear by six battalions of bugs and four squadrons of fleas, exclusive of several independent companies of zampones or muschetoes, that I was soon put to flight and obliged to take up my night's quarters upon three straw chairs in the middle of the room.

Despite the discomfort he must have felt, he enjoyed Pompeii, noting 'a room which seemed to have been painted with arabesques and had a very pretty mosaic pavement with a Medusa's head in the centre.'

The Adam brothers absorbed so much from their long and extensive Grand Tour that Pompeii and the area around Naples only formed a small part of their interests. But there is no doubt of the powerful effect of the volcanic region, and their later acquisition of Clerisseau and Piranesi's works meant that their own architecture was always to be heavily influenced by archaeology.

The title page of Giovanni Battista Piranesi's *Campus Martius*, published in 1762 and dedicated to the Scottish architect Robert Adam, whose name can be seen on the curved stone leaning against the slab of the title stone. Piranesi is here described as a fellow of the Society of Antiquaries of London.

Engraving by Domenico Cunego, after a 1763 pen and gouache painting by Clerisseau, of an ancient sepulchral building, which was visited by the Adam brothers on a journey from Naples to Pozzuoli, Paestum and Posilippo.

JOHN SOANE

The one British architect in the eighteenth century who enjoyed the benefits of the Tour for the rest of his lifetime is John Soane (1753–1837). He also left in his house and office (now Sir John Soane's Museum in London's Lincoln's Inn Fields), the most complete record of an architect's preoccupation with Italy to be found anywhere. He left England for Rome in 1778. He was twenty-four and was away for two years and three months. So profound was the effect of Italy and the ancient world upon him that he celebrated 18 March every year after his return as the anniversary of the day he departed for Rome. From 1806, when he was appointed the Professor of Architecture at the Royal Academy, he would refer constantly to Italy as the place where he had learned so much. As the son of a bricklayer, Soane did not always find the English class system easy. In Italy he found he was accepted and that architects and their patrons had uncomplicated relationships. Also, like so many travellers, Soane found it easier to meet people abroad and to establish friendships that he would not have made at home. Like Goethe and many others, Soane found real happiness in Italy. 'Oh it was a bright day, it flew on wings of down,' he wrote about a beautiful day in Rome.[7] In his professional career Soane was much influenced by both William Chambers and George Dance and they, in turn, had been enormously influenced by long periods in Italy.

Soane had won the Royal Academy Gold Medal in 1776, which gave him the King's Travelling Studentship to fund his journey to Italy. He left Rome to spend the winter in the warmer climes of Naples with the much-travelled Frederick Hervey, Bishop of Derry (he became Earl of Bristol in 1779), who was then on his third Grand Tour and Thomas Pitt (cousin of William Pitt the Younger). They set off with others for Naples on 22 December 1778, climbing to the top of Vesuvius in January 1779. There is a romantic view that Soane wanted his first view of Pompeii to be at midnight in the moonlight. Entry to the site was forbidden at night but Soane achieved his ambition and, fascinated

by the excavation of the Temple of Isis, made his first romantic drawings of this structure. Later Soane was to admit that the Bourbon authorities in Naples denied access to visiting architects and artists, even supervised. However, he told his students at the Royal Academy that his own drawings of the Temple of Isis had had to be 'made by stealth and moonlight'. This was the temple, excavated in 1764–6, where human remains had been found on the altars, but Soane was more prosaically interested in the strange hybrid architectural style, which he called Roman-Egyptian. His moonlight encounter underlines the way Grand Tourists wanted to experience the ancient world in a romantic fashion, as far as possible bringing a sense of mystery and discovery into their visits to these newly unearthed sites.

Soane also wanted to study the Via delle Tombe. He had always been interested in the commemoration of death in classical antiquity and had by this time visited the Via Appia on the outskirts of Rome. In his subsequent Royal Academy lectures Soane was to refer back to these streets of tombs and hold them up as examples to the modern age of how to bury the great and the good at the entrances to cities to avoid the overcrowding of urban churches. Soane was undoubtedly influenced in his choice of subject by the work of Charles-Louis Clerisseau. He was later to own Clerisseau's remarkable gouache and watercolour *The Interior of a Sepulchral Chamber* (1772), which had been exhibited at the Royal Academy. This painting is a fantasy of elements from a rich variety of antique sources: a dramatic collection of urns and sarcophagi 'animated' by a group of figures carrying a corpse. Soane was also fascinated by the decoration of the interiors he saw and particularly enjoyed the use of strong colours. He picked up a piece of stucco which was coloured what we now call Pompeian red. He would use the colour in his own house in Lincoln's Inn Fields,

OPPOSITE A view by Joseph Michael Gandy (1771–1843) of the dome area of Sir John Soane's Museum in Lincoln's Inn Fields, London. This 1811 watercolour gives the London house, with its collection of ancient fragments, the atmosphere of a Piranesian catacomb.

BELOW An engraving of the Via delle Tombe, which was visited and much admired by Sir John Soane. From *Pompeiana: the Topography, Edifices, and Ornaments of Pompeii* by Sir Wiliam Gell and John P. Gandy (1817).

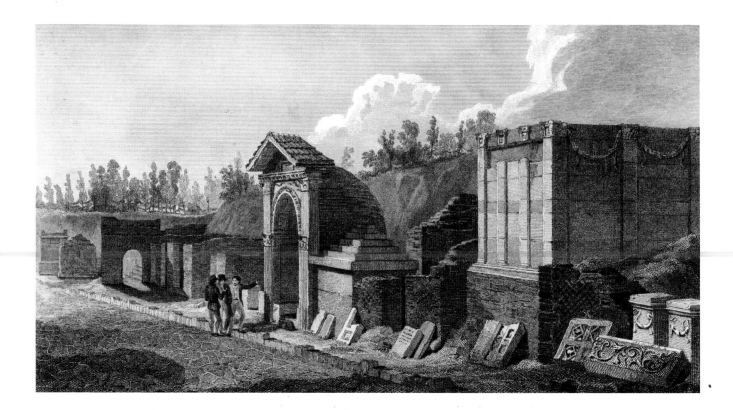

in London. In his museum to this day is 'a piece of cinder from Vesuvius' which he collected on his climb with the Bishop of Derry in January 1779. There are also fragments of mouldings and mosaics that friends brought back for him from Pompeii. His house is itself an extraordinarily intact record of a Grand Tour – the tour of a great architect and collector. One of his important and evocative purchases was a large cork model of the excavated city of Pompeii, which remains in the Soane Museum with his collection of models of ancient temples, many of them acquired on his Grand Tour.

SIR WILLIAM HAMILTON

There was one very grand visitor to the Naples region who came and stayed. He was fascinated by Pompeii, the excavations in the area and the natural beauty and energy of Naples. He was Sir William Hamilton (1730–1815), British envoy to the Court of King Ferdinand IV from 1764 until 1800. He was by far the most influential Briton living in Italy and he was at the very epicentre of interest in Pompeii. His two houses – the Villa Angelica at Portici and the Palazzo Sessa in Naples as well as his little casino by the sea in Posillipo were constantly visited by scholars, collectors and participants in the Grand Tour and anyone of importance coming to the region. His house at Portici on the slopes of Vesuvius commanded 'a prospect of the whole of the city and bay of Naples, which is justly considered as one of the most interesting and beautiful in the world.' (This is the description on a watercolour of *Naples from Sir William Hamilton's Villa at Portici*, by John 'Warwick' Smith *c.* 1778.)

William Hamilton was the son of Lord Archibald Hamilton, the seventh son of the third Duke of Hamilton. His mother was the daughter of the sixth Earl of Abercorn and was regarded in society as the mistress of the Prince of Wales. Whether she was or not, she occupied an official post at court as Mistress of the Robes and her son William was raised almost as a foster brother to the future George III and served him as an equerry. William married an heiress, Catherine Barlow, in 1758. In London he was active as a collector and was a member of the Society of Arts and a friend of the architect James 'Athenian' Stuart. By 1765 he had already sold two collections of pictures, bronzes and terracottas.

In 1764, Hamilton asked, pleaded, to be sent to Naples. There were two reasons for this. Firstly, he was an antiquarian and a geologist with a fascination for volcanoes, and secondly, his wife was ill with a weakness in her lungs and she needed the warmth of the Mediterranean climate. Even though he had left the army and had just won a seat in Parliament, Hamilton was ready to give everything up on hearing that Sir James Gray, who had been His British Majesty's Envoy Extraordinary to the Kingdom of Naples since 1753, was reluctant to return to Naples because of the plague and had been appointed Ambassador to Spain.

Hamilton and his wife arrived in Naples on 17 November 1764. The atmosphere in the city was grim and the poor were really suffering. Plague victims filled the hospitals and the king had decided to postpone his return to the city. But the horror passed and the visitors and Grand Tour participants soon returned and the excavations recommenced at Pompeii. 1764 was an important year. Apart from the arrival of Hamilton in Naples, Edward Gibbon visited the city and Johann Joachim Winckelmann (1717–68) published his crucial book *Geschichte der Kunst des Alterhums* ('The History of the Art of Antiquity'). This was his

OPPOSITE Sir William Hamilton at the centre of a meeting of the Society of Dilettanti, painted in 1777 by Sir Joshua Reynolds (1723–92). The Society, originally founded largely as a social and convivial gathering, became more serious in the 1760s when it sent Stuart and Revett to Athens and published their researches. Hamilton is surrounded by friends including Watkin Williams Wynn and Joseph Banks. One of Hamilton's vases is in front of him, amongst the claret.

magnum opus and the first analysis of the aesthetic, stylistic and ideological basis of Greek art. Hamilton would have known this vital work, considered by many to be the book that founded the discipline of art history. Winckelmann was in Rome as papal antiquary and was widely admired as the most respected authority on the art of Greece and Rome until his tragic murder in Trieste in June 1768. He visited Naples and Hamilton for the last time between September and October 1767. He was to act as cicerone to Hamilton on his first visit to Rome between January and April 1768 when he no doubt recommended Antonius Maroni to paint Hamilton's portrait, as he had himself just sat for him.

It was in 1738 that Charles III began building a royal villa facing the sea at Portici at the foot of Vesuvius and with his queen Maria Amalia, daughter of the elector of Saxony and king of Poland, set about collecting and exhibiting finds from the excavations at Herculaneum. The site at Portici had been chosen so that the king and queen could follow the excavations closely under the direction of the royal antiquary, the marchese Marcello Venuti. At the death of his elder brother in 1759 Charles III inherited the throne of Spain, and he left his younger son, Ferdinand IV, then aged eight, on the throne of Naples under a regency headed by a Tuscan, Bernardo Tanucci. He was a classical scholar and set up a very important archaeological institution, the Royal Herculaneum Academy, which initiated the publication of the eight volumes of *Le Antichità di Ercolano esposte* (1757–92). This book had a huge influence on educated taste throughout Europe.

Not long after the arrival of Sir William Hamilton the regent ordered excavations to focus on Pompeii. Ferdinand IV, despite his own boorish character and devotion only to hunting, was to allow Tanucci great leeway, and he didn't interfere in his enthusiasm for archaeology and architecture. The young king continued his father's building programme including the enormous palace at Caserta. He ordered his Farnese collections to be brought to Naples from Rome and placed the great Farnese Hercules at the top of the vast staircase in Caserta. He was making a point – especially to Rome and the papacy – that his kingdom was a centre of culture and could trace its descent from the classical civilizations that were currently being excavated at Pompeii and Herculaneum. At the University of Naples the study of antiquity based on the two sites flourished.

Hamilton was the right man in the right place at the right time, and he seems initially to have devised a way of life in the sunny climes that closely resembled the life of a Roman official posted to Pompeii in imperial times. His friends called him 'Pliny the Elder', noting his propensity to write to nephew Charles Greville in London as though he were Pliny the Younger. He discovered a way of combining *otium* and *negotium*, private leisure and public duty. He dealt with the boredom of his diplomatic and court duties by spending time alone with his collections of vases and bronzes and absorbing knowledge from observing nature. Sir Harold Acton in his brief memoir of Hamilton puts it well: 'Hamilton was qualified to extract every drop of honey from the huge hive of Naples. Vesuvius beckoned to him with its plume of smoke.... Besides the thrill of Vesuvius there were the

The Farnese Hercules, one of the greatest sculptures of the male form from the ancient world, is now in Naples but was originally from the Baths of Caracalla in Rome. It is a giant marble copy by Glykon of Athens of a bronze statue made by Lysippus in the fourth century BC. Ferdinand IV of Naples moved Hercules from Rome to stand at the top of his giant new staircase in his palace at Caserta, outside Naples.

excavations at Herculaneum and Pompeii to whet Hamilton's acquisitive appetite. Hunting for antiques, investigating the caprices of Vesuvius, entertaining the constant flow of Grand Tourists, acting as cicerone to visiting royalty. . . . his most strenuous unofficial duty was to join the young King's hunting and fishing expeditions in every kind of weather.'[8]

This somewhat languorous life is something of an illusion. Hamilton was too intelligent to be preoccupied with the corrupt politics of this modest kingdom, and so his scientific and antiquarian interests were paramount and his contribution to knowledge significant. His Villa Angelica was conveniently sited on the road between Pompeii and Herculaneum. He could watch both the firework performances of the volcano and keep a beady eye on the finds emerging from Pompeii. In one letter to his nephew written soon after his arrival in Naples he is thrilled by a recent important find as one of the city's tutelary gods materialized from the dust:

> . . . a Venus of white marble coming out of a bath and wringing her wet hair. What I thought most remarkable was that all her tit-bits such as bubbies, mons veneris etc., are double gilt and the gold very well preserved, the rest of the marble in its natural state.[9]

There was at the time a lot of secrecy surrounding the excavations and Hamilton, like others, was concerned about accusations of malpractice and deceit. He is the perfect eyewitness, and despite the delicacy of his official position he was prepared to intervene privately and effectively as an antiquarian. Winckelmann had already published an *Open Letter on the Discoveries of Herculaneum* in 1762 and Hamilton had a copy of it in French in his library. A letter that Hamilton wrote to Lord Palmerston, dated 19 August 1766, made clear his concerns:

> The arts here are at the lowest ebb, and the little progress made in the searches at Herculaneum and Pompeii proceeds solely from vanity. I ventured to tell the Marquis Tanucci, who has the direction of these antiquities, my sentiments upon their manner of proceeding and have had the satisfaction of seeing that in some things they have been attended to.
>
> Could one think it possible that, after the principal gate into Pompeii has been discovered at least five years that instead of entering there and going on clearing the streets they have been dipping here and there in search of antiquities and by that means destroyed many curious monuments and clogged up the others with rubbish. Now they are going to begin at the gate.
>
> The Temple of Isis is certainly extremely curious, it is now entirely cleared, the very bones of the victims were upon the altars, and the paintings and stuccos as fresh as they had been just executed. They will have a relation to the Egyptian cults. By the inscription over the gate of the temple, which is perfectly preserved, this temple was rebuilt at the sole expense of N. Pupidius, the ancient one having been thrown down by an

A Pompeian marble statue of Venus in the museum in Naples, very similar to the one that thrilled Sir William Hamilton. Here, she has two child assistants.

earthquake, so that it must have been executed some time between the year 63, when the great earthquake happened and the year 79 when Pompeii and Herculaneum were destroyed by the fatal effects of Mount Vesuvius. Glorious discoveries might still be made, if they would pursue the excavation with vigour.

Hamilton was to go on expressing his concerns. He worried, as we do today, about the excavations being left open and unprotected, especially the Temple of Isis. The paintings were being cut out of the walls of the Temple and being arranged with all the others in the Royal Museum at Portici. Hamilton's private interventions with Tanucci, now the prime minister, had some effect. In an earlier letter, dated 12 November 1765, he wrote:

> The Marquis Tanucci . . . has lately shown his good taste by ordering that for the future the workmen employed in the search for Pompeii should not remove any inscriptions or paintings from the walls, nor fill up after they have searched, so that travellers will soon have the opportunity of walking the streets and seeing the houses of the ancient city (which is infinitely more considerable than Herculaneum) as commodiously as Naples itself.

Hamilton worried too about the publication of researches about these important sites. The royal antiquary and the Royal Herculaneum Academy had been established by Ferdinand's predecessor King Charles III. The antiquities were gradually to be published between 1757 and 1792 in eight beautiful folio volumes as *Le Antichità di Ercolano*. It was to have an enormous influence upon art and design in the eighteenth century. However, it was not at first made widely available. Indeed it was only distributed by presentation from the king. Hamilton was not happy and he wrote again to Tanucci:

> I ventured to say that His Sicilian Majesty would do more service to the arts by allowing the books of Herculaneum to be sold than by giving the few copies in the manner they are given, and as the public are so eager to possess this work, it would no doubt bring in a great sum into the country, which would be a fund to go on with vigour in the searches at Herculaneum, Stabia and Pompeii, which searches are almost at a stand for want of money, and a false pride will not suffer them to think of selling these books. If my scheme took place how much the arts would profit by it, but nothing is more difficult than pride and ignorance.

This rather practical Scottish approach was what was needed at Pompeii and Hamilton did more than anyone to bring the problems there to the attention of a wider world. In 1775 he sent an account of the most recent digging at Pompeii to the Society of Antiquaries in London. The Society subsequently published it with engraved illustrations by Pietro Fabris, the same artist who illustrated Hamilton's books on volcanoes. The originals survive, and belong to the Society of Antiquaries. They have a great charm as well as accurate annotations about the then excavated site Pompeii and some of the interiors of the houses. Fabris, despite his name, was English and he left a delightful record of life in the Palazzo Sessa, showing how full of activity it was. But it is his remarkable views of the

Engraved title page of the first edition of the first vase collection of Sir William Hamilton by Baron Pierre d'Hancarville. This is the third volume, dated 1767 but not printed before 1776. D'Hancarville turned out to be a fake Baron and a swindler who ran off with the plates of Hamilton's book when he was fleeing his creditors. He was, however, a brilliant connoisseur and book designer

pyrotechnics of Vesuvius that bring home the sense of exquisite danger those visitors to Pompeii enjoyed.

A one-eyed local guide would accompany Hamilton on his trips to Vesuvius – he christened him the Cyclops of Vesuvius. They would often spend the night on the mountain, peering into the mouth of the volcano and watching the smoke rising, 'tinged like clouds with the setting sun'. In his extraordinary two volumes full of illustrations of the volcano by Fabris, *Campi Phlegraei: Observations on the Volcanos of the Two Sicilies*, his enthusiasm and excitement are palpable. In his letters to the Royal Society he almost gets carried away: 'It is impossible to describe the beautiful appearance of the girandoles of red hot stones, far surpassing the most astonishing fireworks.'

In one view dated 11 May 1771 Hamilton can be seen showing off to the king and queen in rather a proprietorial way the current of red hot lava pouring forth. Fabris was one of the few artists to record the first moments of the discovery of the Temple of Isis. The gestures of the bewigged gentlemen show suitable amazement and their accompanying dogs are all equally excited.

A large part of the excitement for Hamilton was the prospect of acquisition. He was the first Englishman to acquire archaeological treasure on the spot. He collected some 750 so-called 'Etruscan' vases, 300 examples of ancient glassware, 175 terracottas, 627 bronzes, 150 ivory objects, 150 gems and gold and jewellery and more than 6,000 coins. He was to sell this collection in 1772 to the British Museum for some £8,400. It was Hamilton who laid the foundations of the Department of Classical Antiquities.

A French connoisseur who called himself the Baron d'Hancarville (born in Nancy in 1719 as Pierre François Hughes) catalogued Hamilton's vase collection. The engraved dedication page pays homage to Hamilton's childhood friend King George III. This one page is a cynosure of all Hamilton felt about his life in Naples and his enthusiasm for excavation and collecting. The engraver depicts an Arcadian spot where the passer-by discovers a leaning stone plaque which is, by chance, inscribed with a dedication in Latin to His Britannic Majesty King George III with greetings from William Hamilton, Envoy Extraordinary from Great Britain to the Kingdom of Naples. There is an Etruscan border around the

Pietro Fabris was the artist who recorded eruptions for Sir William Hamilton's book on volcanoes. These two pen and ink and watercolour drawings were sent to the Society of Antiquaries in London as part of a report on the excavations at Pompeii. They are signed and dated 1774.

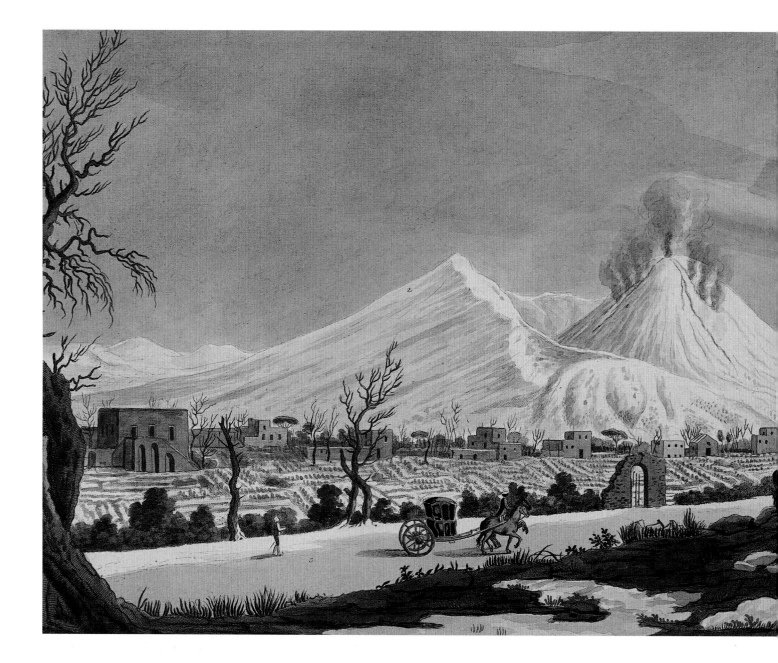

A page from Sir William Hamilton's *Campi Phlegraei*, an account of the volcanic region around Pozzuoli and further afield, including Vesuvius, Etna, Sicily and her islands. His artist, 'Mr Peter Fabris', made beautiful hand coloured etchings to be submitted to the Royal Society in London as evidence of Hamilton's wish that volcanic activity 'will now be considered in a creative rather than a destructive light'.

plaque and the rocky foreground probably represents the hills of the Apennines where Eturia is located. Plants grow from a fallen entablature in the Tuscan taste while laurels appear to show nature's blessing for the British King. A fasces in the Roman style, bound in laurel, leans against the stone, symbolizing the power of the sovereign. It is the Greek vase in the foreground that draws the eye and raises all the questions that the Grand Tourist would have been asking. How Greek were the Etruscans? The true origin of the Greek-style vases discovered in southern Italy was to be the subject of long archaeological debate. This title page sums up not only Hamilton the antiquary and aesthete but also, by the placing of this difficult object in an Italian setting, the essence of the enthusiasm and curiosity of the Grand Tourists.

The catalogue cost Hamilton some £6,000 to produce. He intended it to be a sourcebook for modern artists and craftsmen. Having sold this collection,

My motive when I first began to collect this sort of Antiquity, was from the superior degree of merit I perceived in them with respect for the Fine Arts, and the profit I thought Modern Artists might reap from the study of them.

SIR WILLIAM HAMILTON

Hamilton went on to form another, just as comprehensive, running to more than a thousand vases and several ceramics.

The mood around Pompeii, the Court and Hamilton changed in 1793 when France declared war on England and Hamilton signed a treaty with Naples. Naturally enough Queen Maria Carolina's hatred of France became almost pathological after the murder of her sister Queen Marie Antoinette, and she found some relaxation in the company of Emma Hamilton, who had married the much older Hamilton in 1791. It was the arrival in Naples of Captain Horatio Nelson seeking reinforcements that altered things all round. Nelson initially made a deep impression on William Hamilton – he had more pressing things on his mind than the beauty of Emma at that point. Nelson was to correspond with Hamilton for the next five years. It was not until Nelson's triumphant return to Naples after his great victory in Aboukir Bay that the injured hero won the heart of Emma Hamilton. Hamilton seemed to accept it – he had intense admiration for Nelson and was prepared to play second fiddle in the marriage. But his diplomatic avoidance of the situation did not help his public image as his wife flaunted her conquest. In 1800, after Nelson had escorted the entire royal family from Naples to Palermo, Hamilton was suddenly recalled to London, after thirty-seven years in Naples.

Sir Harold Acton mourns the fact that Hamilton's reputation became overshadowed by Emma's behaviour and for his complacency as the husband of Admiral Lord Nelson's mistress. Hamilton's initial infatuation with the beautiful Emma, and indeed his fascination with her performances bringing his beloved sculptures to life, is well explained by Horace Walpole's view: 'Sir William has actually married his gallery of statues.'

Hamilton's last three years were sad. His wife continued her affair with Nelson and accompanied him on his triumphal tours, Hamilton following them as the least famous member of the strange trio. He died in 1803, missing the warmth of Italy and the excitement of archaeology. He died in Emma's arms with Nelson holding his hand.

Hamilton was an absolutely key figure in the advocacy and support of the excavations of Pompeii. He was the intellectual base for so many Grand Tourists and his friendships and influence are impossible to quantify. The physical evidence of his passion for collecting and his eclectic tastes is to be seen at the British Museum. Some thought he trafficked too much in works of art but he had good motives. His zeal for art and for life depended very much on where he was. He had begged to be sent to Naples and after thirty-seven years there and sixty-eight ascents of Vesuvius he had not exhausted his enthusiasm. He conveys it in his writing and collecting. His life between Vesuvius and Pompeii was indeed, as Goethe said on visiting him, 'a lovely existence'.

THE LEGACY OF POMPEIAN STYLE

ROME MAY HAVE ITS IMPERIAL PALACES, its Coliseum and its great temples, but it was Pompeii that excited the world with the first extensive exposure of everyday Roman life, frozen in time. From the eighteenth century it was possible to imagine exactly how life proceeded in a Roman home. An extraordinary amount of detail has accumulated as the digging has advanced and research continues right up to the present day. On any visit we can see the way the houses were used and decorated. The quality of the decoration first surprised the world and then became a subject of intense research and imitation by architects and designers.

DEFINING
THE STYLE

There has been endless confusion among architects and historians about what exactly constitutes 'the Pompeian style'. From the very beginning of the collecting, drawing and measuring of Pompeii, its art has been termed 'Etruscan' or 'classical' as well as 'Pompeian'. In the latter half of the eighteenth century the style of rooms with elements of their design derived from excavated rooms soon became known as 'Pompeian-cum-Etruscan'. Much of the confusion arose from a widespread tendency during the eighteenth century for collectors and dealers to make the mistake of referring to any Greek pottery that had been found in Italy as Etruscan.

Today so many rooms have been uncovered that historians have been able to classify and interpret different styles of decoration in Pompeian rooms (see pages 122–7). There are two further ways to appreciate the Pompeian style: one is by examining rooms throughout Europe that copied and reinterpreted the antique style from the 1780s to the 1880s. The other is to go to the Metropolitan Museum of Art in New York where you can examine a whole room decorated in the Second Style from the Villa of Publius Fannius Synistor from Boscoreale near Pompeii, which was acquired by the museum in the early twentieth century.

PREVIOUS PAGES The library/dining room of Sir John Soane's house in London. The striking Pompeian red room is full of inspirational ideas that Soane gained during his tour of Pompeii and Italy.

RIGHT The entrance to the sanctuary in the Villa of Publius Fannius in Boscoreale (now in the Metropolitan Museum, New York) shows the perspective treatment that defines the Second Style of Pompeian wall painting. At the centre, two Ionic columns frame an illusionistic decorated doorway and masks and candelabra add to the impression of an entire furnished room.

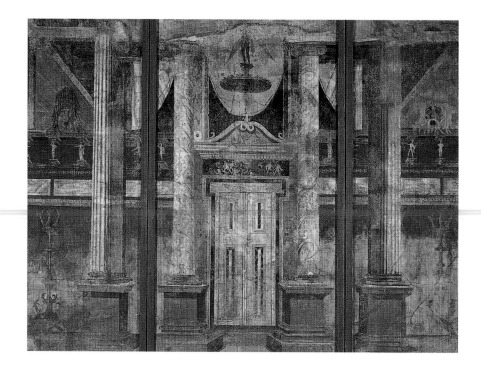

The Boscoreale bedroom dates from 40–30 BC and now lives on Fifth Avenue. The villa was discovered outside Pompeii in 1900 at a time when it was not unusual for frescoes to be removed and then mounted in wood and divided up among the local authorities in Italy and dealers. The museum bought fresco panels from the Paris dealers Canessa. Other panels from the villa can be seen in museums across Europe. The Metropolitan Museum of Art modestly describe their room as 'the most significant well preserved Roman chamber with fresco painting in the Western Hemisphere'.

It is a stunning room and the advantage of seeing it in New York is that it is very well displayed and lit. Although the floor and ceiling are not part of the original room you get a real sense of the modest scale of a Roman cubiculum and the way these extravagant murals extended the space. Near the entrance on both sides are vertical scenes separated by red columns decorated with gilded flowers. The whole decorative scheme is full of buildings – a remarkable architectural fantasy rich in iconography that has yet to be satisfactorily interpreted. There is a progression from elaborate cityscape to a secret garden, suggesting something of the relationship between man and nature as envisioned by our forebears just before the birth of Christ.

Our art-historical vision is clearer now, but exploring the way imitation and exploitation of the Pompeian style developed continues to be fascinating. As information about the discoveries at Pompeii and Herculaneum spread – through letters and publications and the reactions of artists accompanying Grand Tourists – it must have been a revelation. We have to remember that tourists did not return with rolls of film and instant photographs. Only slowly did artists' impressions and scholars' views appear in print. Pompeii soon became a very important primary source of information about the world of ancient interiors and Roman life. The almost perfect preservation of the frescoed walls allowed them to be copied and published, so that the key motifs – gods, athletes, nymphs, candelabra, trellises, architectural elements and views and plants and vines and grotesque patterns – gradually became part of the decorator's vocabulary. Both the delicacy of the details and the strength of the colours were observed and recorded.

Architects in the eighteenth century slowly absorbed the publications that regularly appeared devoted to ancient Greek buildings. They were gradually being made aware of the rare and beautiful qualities of the interiors of Roman houses, many of which preserved in their designs the roots and spirit of Greek art. Southern Italy was, after all, Magna Graecia, the home of many Greek colonies.

Idealized Roman garden designs based on Pompeian wall paintings were adopted by landscape gardeners like Humphry Repton (1752–1818) and by French designers who appreciated the intricacy and formality of the trellises, urns and fountains.

PLATE 26.

Engraved by Chas Heath.

In 1807, William Wilkins, who was to design the National Gallery in London, published his *Antiquities of Magna Graecia*. In this book he acknowledged the assistance of Sir William Gell (1777–1836), a fellow of Emmanuel College, Cambridge, who with the architect John P. Gandy was to publish the standard work on the excavations, *Pompeiana* (1817–19).[1] This book was highly influential. It was published in French in 1827 and followed up in 1832 with a two-volume update penned by Gell alone: *Pompeiana: The Topography, Edifices and Ornaments of Pompeii. The Result of the Excavation since 1819*. Gell was to live in Italy and he developed something of a passion for Roman art and designed Pompeian rooms for himself in Rome. A little later W. Zahn published an almost parallel sourcebook in Berlin in 1828, which was a more elaborate example of chromolithography and was extremely accurate in its details.[2] This book was especially admired by Owen Jones, that doyen of the decorative pattern book, who perceptively singled out the special quality of some of the decoration at Pompeii: 'the freehand sketchy technique which has never been accomplished in any restoration of the style'.[3]

The equivalent publication in France was called *Les Ruines de Pompeii* by François Mazois (1783–1826).[4] Four volumes were published between 1809 and 1838, although a much longer series was planned. Mazois was an architect who had trained under Claude Nicolas Ledoux and Charles Percier. He was appointed by Joachim Murat, instated as king of Naples by Napoleon, to oversee works on the improvements then being carried out in Naples. This gave him the opportunity to devote himself to Pompeii and its interior decoration in a series of beautiful volumes, sadly, unfinished when he died.

ABOVE A reconstruction of the façade of
the Temple of Jupiter in the Forum with a
cross section on each side of parts of the
Forum itself. From *Les Ruines de Pompeii*
by François Mazois.

OPPOSITE Mazois' superb series
of volumes also included brilliant
extrapolations in strong colours
from original Pompeian frescoes.

Here I am, settled in Pompeii once more, where in spite of the heat, my
riches continue to increase, that is, my collection of finds continues to
grow. . . . I get up very early; at 9 o'clock the fierce heat of the sun forces
me to take a break, so I return to my small room, where I finalise the
sketches I have made during the morning. At midday my cook solemnly
presents me with a vast plate of macaroni. After I have eaten that, an
hour's sleep restores my good humour and enthusiasm, so I set to work
again, in my cramped lodgings until five o'clock, and then out in the windy
open air until sunset. All in all that means a total of fourteen hours work a
day. So you can see I am working hard.[5]

His drawings, and he made some 450 of them, were a major influence on French
architects and designers in the nineteenth century. British architects who
travelled in southern Italy were full of praise for what the Napoleonic French
period had achieved. One of them, George Basevi (1794–1845), a pupil of Sir
John Soane who was to design the Fitzwilliam Museum in Cambridge, wrote in
a letter in 1816: 'What a deal of good the French did in that respect. Had they
but held Italy for two or three years more the antiquarians would have no need to
dispute on any of the remains here.'[6] Because of the French clearances
undertaken during the Napoleonic period access to the sites was vastly improved
after 1815. The architect Thomas Leverton Donaldson was to publish his
Pompeii in 1827, closely following J. Goldicutt's *Specimens of Ancient Decorations
from Pompeii* (1825) in which the author wrote how much he admired the
Romans' 'arrangements of colour'.

All four styles of Pompeian decoration are distinguished by the use of strong
colour, and it was that new palette that began to inspire interiors in Europe in the
nineteenth century. Mario Praz, a master historian of interior decoration, once
pointed out that although Greek vases show domestic scenes, and paintings on
the walls of houses in Pompeii show people reclining or sitting, it is quite

Ch. Percier et Fontaine.

Charles Percier (1764–1838) and Pierre Fontaine (1762–1835) were the two French architects who created the empire style under Napoleon. Much of their naturalistic pattern-making can be traced to Pompeian frescoes. Beautifully drawn examples such as this, from their book *Receuils de Décorations Interieurs* (1812), were intended to be easy to copy.

impossible to reconstruct interiors accurately from any figurative evidence of the classical world. He was right. There are no contemporary paintings of Greek interiors – the preoccupation was with the human form. When architects wanted to revive the spirit of Pompeian rooms, they could only capture the mood of the decoration and turn it into a style.

The taste for classical antiquity was strongly influenced by the stream of publications covering the excavations all over Europe. In the eighteenth century this taste was accompanied by an interest in all things English and acted as a tempering influence on the extravagances of the Rococo style on the continent. Gradually the style of Louis XVI that had managed to combine a certain element of the Baroque with neoclassicism gave way to a more archaeological, even pedantic, approach.

As the nineteenth century arrived we see from crucial sourcebooks of interior design there is a real move towards archaeological reconstructions. Charles Percier (1764–1838) and Pierre Leonard Fontaine (1762–1853) were the style leaders in France and their book *Receuil de decorations interieurs* (1812) was almost a Bible. In the preface we read: 'One tries in vain to find forms better than those we have inherited from Antiquity.'

The book began with Pompeian decorations, although they like many others called them Etruscan. Initially their palette of colours was closer to the pale shades of Wedgwood ceramic ware. The first three projects they show in their watercolours are versions of Pompeian rooms, complete with the tripod table that Piranesi had drawn based on a bronze version excavated at Pompeii. As neoclassicism became the imperial and accepted style throughout Europe it was as important to have an Etruscan (either Greek or Pompeian) room as it had been to have a Chinese room in the eighteenth century. Percier and Fontaine were employed by Napoleon to alter the royal palaces that had been plundered by the Revolutionaries. France was now to be seen as the successor to imperial Rome. Pompeii provided the sources for some of the more domestic interiors, especially rooms at the empress Josephine's palace at Malmaison. The rooms are decorated with strong colours and have ceiling paintings based on those in Pompeii and Herculaneum. The Royal Palace at Potsdam soon followed suit with a very fine example of the Etruscan style room in 1840.

It is accepted that the Painted Room at Spencer House in London to the designs of James 'Athenian' Stuart (1713–88) is the first fully integrated room in Europe and the forerunner of the many Etruscan and Pompeian rooms that followed in its wake. Stuart visited Pompeii in 1748 with Gavin Hamilton, Matthew Brettingham and Nicholas Revett, and began this room in 1759. The sources for the room are closer to the Renaissance designs of Raphael, the influences of the Baroque and the Rococo and so, although clearly a forerunner, the painted room is in fact much more of a hybrid. The gallery the architect Joseph Bonomi (1739–1808) built at Packington Hall in Warwickshire was finished in 1782, although the painting of the room (by J. F. Rigaud) took another twenty years to complete. Bonomi was born in Rome, where he had met the Adam brothers, for whom he worked initially in England. He had been taught draughtsmanship by Clerisseau. His interiors are more robustly antique in style than the Adam brothers' work and at Packington he produced, for his patron the Earl of Aylesford, a great Grand Tourist, the most complete Pompeian scheme in England. The room fills the whole south front of the house and is tripartite, divided by Sienna marble coloured scagliola columns. The colour scheme of very strong black panels with red borders dominates the small figurative paintings. A later room at Hinxton Hall in Cambridgeshire was completed in 1831; although now beautifully restored by the Wellcome Trust, little is known about its designer or origins.

Robert Adam had steeped himself in antiquity during his Grand Tour and had been friendly in Rome with Clerisseau and Piranesi, both of whom were strong aesthetic influences on him. Between 1760 and 1780 he was the most fashionable architect in England. His sophisticated palette of motifs was largely inspired by Roman interiors such as those surviving in Pompeii. He frequently incorporated copies of antique statuary into his schemes.

There is debate about how authentically Pompeian his two 'Etruscan' rooms are. The Etruscan dressing room at Osterley Park is clearly inspired in its colours by the vases of Sir William Hamilton published by d'Hancarville and possibly by the copies by Wedgwood. Horace Walpole was not impressed with the Osterley room, describing it as 'being painted all over like Wedgwood's ware with black and yellow grotesques. . . . It is like going out of a palace into a potter's field.'

In 1777 Adam drew designs for another Etruscan room for the Countess of Home's house in Portman Square in London. This house has recently been restored and the colours are distinctly Pompeian: red, terracotta, black and white. Adam here plays freely with the motifs, using sphinxes, husks and birds drawn from Pompeii and Herculaneum.

It is thought that the technique used for these rooms was to paint the decoration on paper, which was then laid on to canvas. Adam designed some eight rooms in this style but only these two have survived, which suggests either that the decorations were not designed to last or that the style simply went out of fashion.

Sir Watkin Williams Wynn (1749–89) was known as the Maecenas of Wales. He commissioned Robert Adam to design and furnish his house at 20 St James's Square, London. The decoration of the Eating Room has the leitmotif of a ram's head. This is seen on these Roman-style tureens and on much of the silver gilt service designed for dining in splendour.

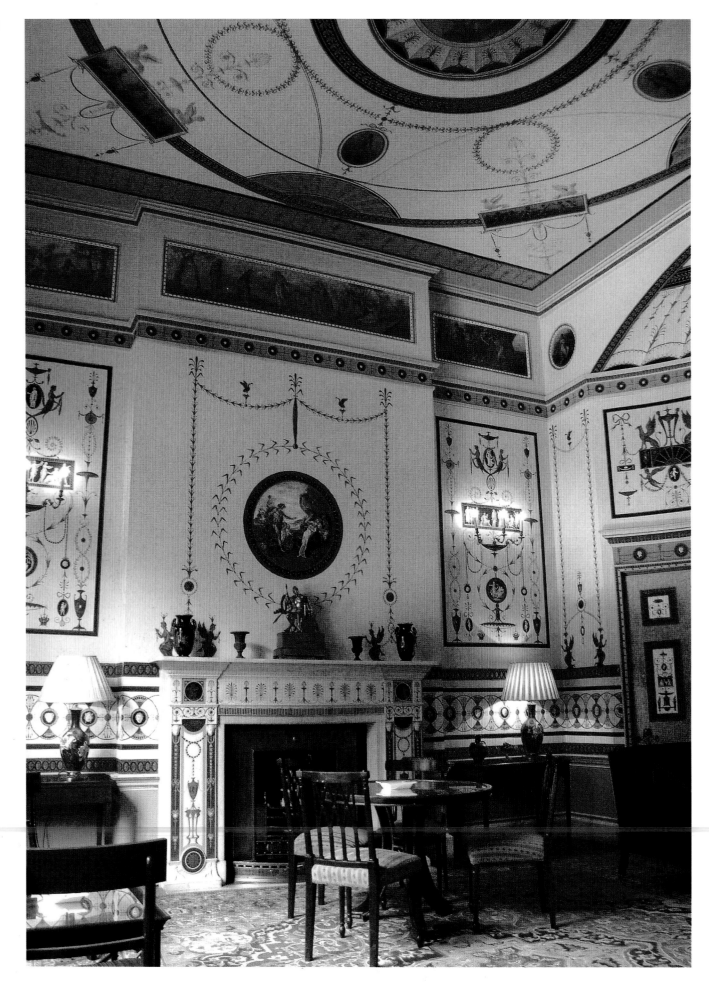

At Syon House, near London, Adam completely remodelled the interiors of a sixteenth- and seventeenth-century house for the Duke of Northumberland. It is his masterpiece, combining Greek, Roman, Pompeian, Hellenistic and Palladian styles. The richly coloured anteroom with its *verde àntico* columns topped by gilded statues is a remarkable synthesis of all the Roman ideas that he gathered on his Grand Tour. In this case, archaeology is an influence, not a matter of imitation.

Understanding and interpreting the past was something that another architect, who had been much influenced by his visits to Italy, put into practice in his designs. Sir John Soane (1753–1837) had been in Pompeii in 1779 and his Grand Tour experience ensured that he not only mastered the conventions of classical architecture but also soon began to develop a highly individual style. He absorbed a great deal of the atmosphere of Pompeii: his shallow domed rooms with their top light and low level of relief decoration and his enthusiasm for Pompeian red all owe a lot to his Tour. Following the example of his mentor George Dance (1741–1825) Soane worked to achieve a synthesis of Greek, Roman and Italian styles and succeeded in creating something completely original. He was influenced by the fusion of Gothic and Pompeian styles that Dance achieved in his Council Chamber for London's Guildhall in 1777. Soane sought to achieve what he called 'the poetry of architecture' and he succeeded. All the seeds of his struggles to reach that state of perfection can still be seen in his house in

It is impossible to name the infinite number of things contained in that collection, and it is a great satisfaction to find that they are going to publish them by degrees, though no doubt it is a much higher pleasure to examine them on the spot than in any book.

JAMES ADAM,
ON VISITING THE MUSEUM
AT NAPLES, 1761

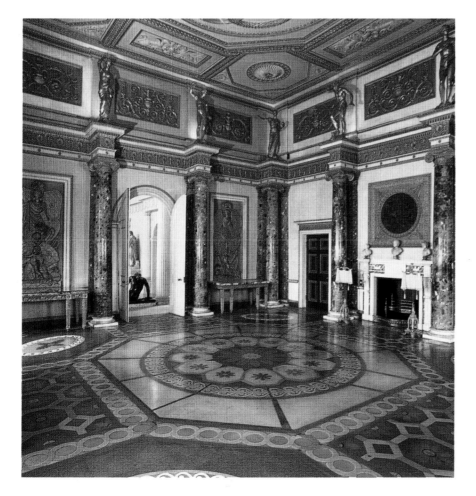

OPPOSITE One of the most interesting rooms in Robert Adam's house for the Countess of Home in London's Portman Square is the 1770s Etruscan Room. Adam here interprets the term very freely and much of the decoration is drawn from Pompeii and Herculaneum and carried out in strong colours – Pompeian red or terracotta with grey, black and white. The room has recently been beautifully restored by Royston Jones for the distinctive private club Home House.

LEFT Robert Adam's Grand Tour experiences inspired the richness of his architectural palette and at Syon House near London his ante-room incorporates real Roman marble columns and follows closely the inspiration of Piranesi's vision of imperial Rome. The strong colouring shows how he could have been inspired by the colours of Pompeii.

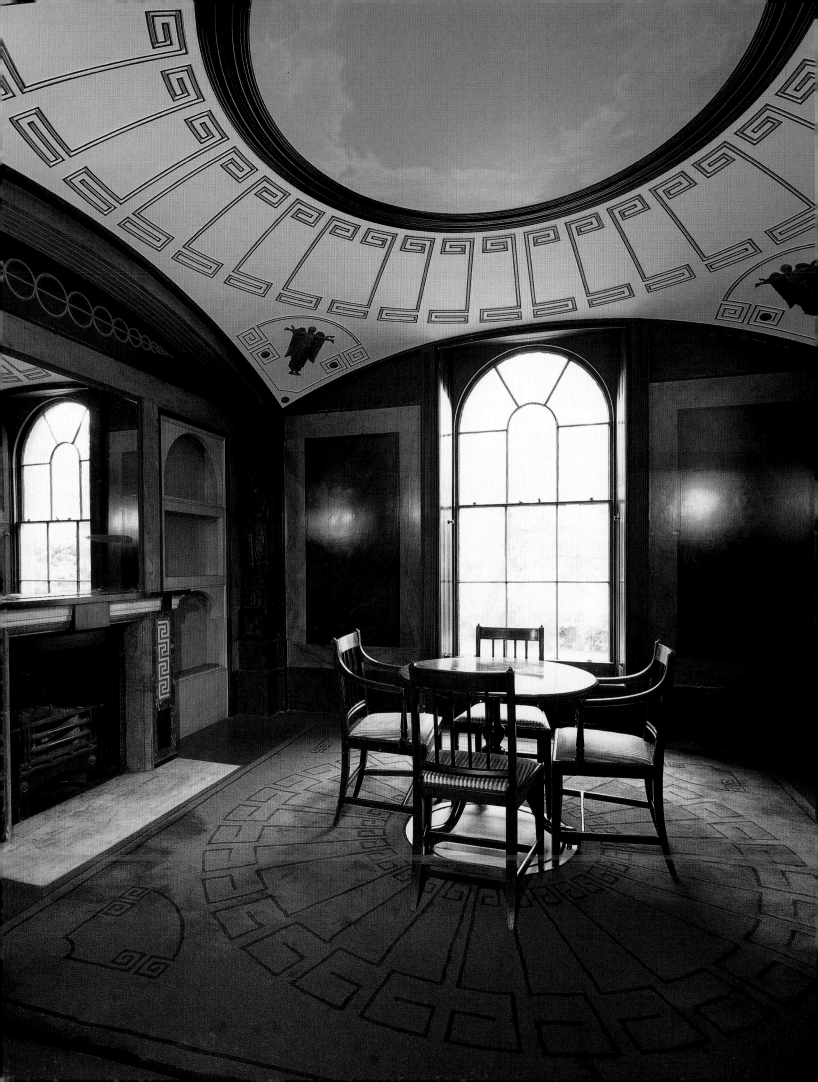

London's Lincoln's Inn Fields (now Sir John Soane's Museum) – which has been described as one of the best products of the Grand Tour. His collections put flesh on all the architectural ideas he absorbed in Italy. Soane had a particular skill for acquiring the large, pre-existing collections of other architects. He was able to buy all the drawings of Robert Adam, for example, and works by the man who influenced him and so many others, Clerisseau. The original works by Piranesi in the collection are all key works in the distribution of the ideas of Antiquity.

The architecture of his own houses, both in London and in the country at Pitshanger Manor in Ealing, demonstrate how skilled he was at reinterpreting the classical canon. The library and breakfast room at Pitshanger Manor are a linked pair of rooms with canopied ceilings and walls full of niches and mirrors that reflect light. There is a sensation that you might be sitting under some pergola in Pompeii. But it is the London house/museum that is like a labyrinth of Soane's recollections of architecture, painting and sculpture. Every object from Egypt, Greece or Rome is resonant with memory. Once you have been to Pompeii, the house in Lincoln's Inn Fields provides an extraordinary sense of being inside the mind of an architect who understood the essence of the classical world and made effective use of all he learned from the excavations of the past.

While Soane was interested in creating a living interpretation of the past, he was also obsessed by death. One of the things he had most admired on his visit to Pompeii were the streets of tombs around the city. Soane drew many of them and would have agreed with Petronius, who wrote in his *Satyrica*: 'It is a big mistake to have nice houses just for when you're alive and not worry about the one we have to live in for much longer.' The early death of Soane's wife caused him great grief, and he spent a lot of time designing the family tomb which was to be built in the graveyard of St Pancras church. It is a far cry from the shady cypresses of the Via delle Tombe at Pompeii, but Soane has synthesized the dignified elements of pre-Christian burial chambers with his aedicular design over a huge block of inscribed Carrara marble. Even in death Soane lies in the classical world.

Soane would have appreciated the continuity of Pompeian ideas if he had lived to see the installation of the Pompeian Room at Ickworth in Suffolk, designed for the third Marquess of Bristol by the architect F. C. Penrose and the decorator J. D. Crace in 1879. In 1777–9, Soane had travelled in Italy with the Marquess's great-grandfather the Earl Bishop of Derry, when the Earl had acquired some fragments of the Roman wall paintings from the Villa Negroni on the Esquiline Hills. These paintings and the series of engravings based on them were the influence for this remarkable room. Ickworth was intended to be the great repository of the Earl Bishop's loot from his many Grand Tours. Although the vast rotunda was built among the cabbage fields of Suffolk, the collections were impounded in France during the Napoleonic troubles and the dream of a great museum was never fully accomplished. Today the National Trust looks after Ickworth and has made great strides in showing the house as the inspiration of a great collector and traveller.

One other remarkable architect who brought the world a complete vision

ABOVE The ceiling of the new Picture Room in Sir John Soane's Museum in London was recently painted by the mural painter Alan Dodd following original but unexecuted designs by Lord Leighton. It has all the qualities of the classical originals.

OPPOSITE Sir John Soane's own country house, Pitzhanger Manor in Ealing, pares down Roman decoration to a minimal level in the breakfast room. It was inspired by a visit Soane paid to the Villa Negroni in Rome.

and reinterpretation of the past is Charles Cameron (1745–1812). As all his work is in Russia he represents the far-flung spread of neoclassical ideals. He had trained himself in Rome by working on a book which he published in 1772 as *The Baths of the Romans explained and illustrated, with the Restorations of Palladio corrected and improved*. Cameron, like Adam, had formed part of the group in Rome with Clerisseau, Hubert Robert, Piranesi and Winckelmann. In his volume on the architecture and decoration of Roman baths, Cameron included the major baths of Pompeii. When this book was seen by empress Catherine the Great she immediately employed Cameron to design her 'house in the antique manner' instead of Clerisseau, who had prepared elaborate drawings of a Roman house. Cameron was to build substantially for Catherine at Tsarskoe Selo and Pavlosk in the environs of St Petersburg. He built the Cold Baths, the Agate Pavilion, the colonnaded Cameron Gallery and the empress's private apartments. It is the latter which are probably the most lavish examples of the Pompeian style expressed in precious materials – agate, amber, lapis lazuli, malachite and glass. In the long Russian winters it must have taken a leap of the imagination to believe that the enlightenment of the sunny Mediterranean had arrived in Baltic Russia. It is less difficult to understand why such an imperial style appealed to a German empress determined to inspire her adopted country to new ways of thought and governance.

The spread of the Pompeian style from Naples to Russia also extended to Potsdam and to Karl Friedrich Schinkel (1781–1841), the greatest German architect of the nineteenth century working entirely in Prussia. In 1824 Prince Karl, already renowned as a collector of antiquities, had purchased the estate of Kein-Gleinicke with its schloss about three miles from Potsdam on the far side of the Havel river. Schinkel was commissioned to redesign the house with Ludwig Persius to carry out the changes. It became a palatial villa with pergolas, a casino and a hunting lodge. In the interior the prince's collection was displayed in a series of rooms designed by Schinkel including a Pompeian one. In the garden is one of Schinkel's famous raised stone seats under a painted wooden canopy based on the structure on the grave of Mamia, the priestess of Venus, at Pompeii.

Another German prince was to build a small garden pavilion in the Pompeian style for his English wife. This was Prince Albert, Victoria's Prince Consort, in the garden of Buckingham Palace. The pavilion, completed in 1846, is a small garden temple with a lavish Pompeian interior.

All over Europe ideas from Pompeii spread and were enjoyed. It was even possible to eat and drink from ceramic ware produced by Wedgwood closely based on designs from Pompeii and Herculaneum. Ferdinand IV of Naples gave George III a magnificent service of 282 pieces called the Etruscan Service, made in Naples at the Royal Porcelain Factory, which is today at Windsor Castle. The decorative ideas inspired by the richness of the discoveries at Pompeii continue to be an influence. In 1999, a distinguished art historian in London, Ann Dumas, commissioned a Pompeian dining room from the artist Alan Dodd for her London home in Dorset Square.

Out of the dust and smoke of the eruption has come a world of beauty and elegance that continues to delight. Pompeii lives.

OPPOSITE *Schinkel in Naples* by Franz Ludwig Catel (1778–1856), depicting him on his second Italian journey in 1824. He is clearly thinking about Pompeii and the Pompeian room he is designing for Prince Karl of Prussia. Through the open window Capri can be seen across the Bay of Naples. In the corner stand a Greek vase and a bronze bowl from an excavation.

BELOW Two of the 'First Day Vases' made by Josiah Wedgwood to mark the opening of his Etruria manufactory on 13 June 1769. The vases were painted with the figure subject of Hippothion, Antiochus and Clumenos, taken from Sir William Hamilton's *Antiquities Volume I*.

NOTES

CHAPTER 1: THE CITY VANISHES

1. Pliny the Younger *Letters* in *Pliny Vol. 5* trans. Betty Radice, The Loeb Classical Library (London, W. Heinemann, 1969) 6.20
2. Martial *Spectacles, Book 4* in *Epigrams Vol. I* trans. D. R. Shackleton Bailey, The Loeb Classical Library (Cambridge, Harvard University Press, 1993) 4.44
3. Dio Cassius *Fragments of Books 12–35* in *Roman History Vol. II* trans. Earnest Cary, The Loeb Classical Library (Cambridge, Harvard University Press, 1914) LXVI.23.3–5
4. Suetonius *De Vita Caesarum: Divus Titus* in *Suetonius Vol. II* trans. J. C. Rolfe, The Loeb Classical Library (London, William Heinemann, and New York, The MacMillan Co., 1914) 8.3–4
5. Richardson, L. *Pompeii: An Architecural History* (Baltimore, The Johns Hopkins University Press, 1988) 25–26
6. Guzzo, Pietro Giovanni and Ambrosio, Antonio *Pompeii* (Milan, Electa, 1998) 13
7. Richardson, 5
8. Livy *The History of Rome* in *Livy Vol. IX* trans. Evan T. Sage, The Loeb Classical Library (London, W. Heinemann, 1936–88)
9. Richardson, 14–15
10. Tacitus *The Annals Book XIV* in *Tacitus Vol. V* trans. John Jackson, The Loeb Classical Library (Cambridge, Harvard University Press, 1988) XIV.17
11. Seneca *Naturales Quaestiones, Book VI* in *Seneca Vol. VII* trans. T. H. Corcoran, The Loeb Classical Library (Cambridge: Harvard University Press, 1972) VI.1.1–2

CHAPTER 2: REDISCOVERY AND EXCAVATION

1. De Carolis, Ernesto *Pompeii – Life in a Roman Town* (Milan, Elemond Electa, 1999), 23
2. De Carolis, 23
3. Parslow, Christopher Charles *Rediscovering Antiquity: Karl Weber and the Excavation of Herculaneum, Pompeii and Stabiae* (Cambridge, Cambridge University Press, 1995) 45
4. Deiss, Joseph Jay *Herculaneum: Italy's Buried Treasure* (Los Angeles, The J. Paul Getty Museum, 1989) 28
5. Nappo, Salvatore *Pompeii: A Guide to the Ancient City* (New York, Barnes and Noble, 1998) 16
6. Parslow, 112
7. De Carolis, 23
8. Guzzo, Pietro Giovanni *Discovering Pompeii* (Milan, Electa, 1998) 7
9. Grant, *Cities of Vesuvius: Pompeii and Herculaneum* (London, Pheonix Press, 2001) 136
10. Guzzo, 39
11. Fothergill, B. *Sir William Hamilton Envoy Extraordinary* (Chicago, Harcourt Brace, 1969) 61–2
12. Guzzo, 9
13. Nappo, 16–17
14. Grant, Michael *Eros in Pompeii: The Erotic Art Collection of the Museum of Naples* (New York: Stewart, Tabori and Chang, 1997) 169
15. De Carolis 27

CHAPTER 3: VOICES FROM A LOST WORLD

1. Richardson, 89
2. Richardson, 89
3. Grant *Cities of Vesuvius: Pompeii and Herculaneum* 127
4. Etienne, Robert *Pompeii: The Day a City Died* (New York, Thames and Hudson, 1992) 60
5. Grant, 133
6. Grant, 130
7. Richardson, 147
8. Starr, Chester *The Roman Empire: 27 BC–AD 476 A Study in Survival* (New York, Oxford University Press, 1983) 31
9. Grant, 49
10. Etienne, 130
11. Nappo, 164
12. Kebric, Robert *Roman People* (Mountain View, Mayfield, 2001) 169
13. *Corpus Inscriptionum Latinarum* IV 3.4 # 9839
14. Grant, 125
15. Pliny *Natural History Vol. II Books 3–7* trans. H. Rackham, The Loeb Classical Library (Cambridge, Harvard University Press, 1942) 3.40, 3.60
16. Grant *Eros in Pompeii* 58
17. Guzzo *Discovering Pompeii* 24
18. Zanker, Paul *Pompeii: Public and Private Life* (Cambridge, Harvard University Press, 1998) 93
19. Richardson, 197
20. Zanker, 44
21. Etienne, 111
22. Zanker, 116
23. Seneca *Vol. IV Epistles 1–65* trans. R. M. Gummere, The Loeb Classical Library (Cambridge, Harvard University Press, 1917) 56.1–2
24. Grant, 119
25. *Appendix Vergiliana Copa 1–8* trans. H. R. Fairclough, The Loeb Classical Libary (Cambridge, Harvard University Press, 2001)
26. Nappo, 74
27. *Appendix Vergiliana Copa 35–51*

CHAPTER 4: THE POMPEIAN HOUSE

1. Kebric, 168
2. Richardson, 384
3. Jones, Mark Wilson *The Principles of Roman Architecture* (New Haven, Yale University Press, 2000), 38
4. Vitruvius *De architectura: The Ten Books on Architecture* trans. Morris Hicky Morgan (New York, Dover Publications, 1960) Book VI, 3.1
5. Grant, 69
6. Richardson, 388
7. Wallace-Hadrill, Andrew *Houses and Society in Pompeii and Herculaneum* (Princeton, Princeton University Press, 1994) 83
8. Clarke, John R. 'The "View Through" and the "View Out" in the Ancient Roman House' in *Texas Classics in Action*, Summer 1996
9. Clarke, 4

10. Ciarallo, Annamaria *The Gardens of Pompeii* (Los Angeles, The J. Paul Getty Museum, 2001) 42

11. Grant, 77

12. Zanker, 145

13. Zanker, 136

14. Nappo, 152

CHAPTER 5: LIFE AND ART

1. Vitruvius, Book VII.5.1

2. Pliny *Natural History Vol. IX Books 33–35* trans. H. Rackham, The Loeb Classical Library (Cambridge, Harvard University Press, 1952) 35.117

3. Goethe, J. W. *Italian Journey* (1788) trans. W. H. Auden and E. Mayer (London, Penguin, 1970)

4. Stendhal *Rome, Naples et Florence* (Paris, 1817)

5. Clarke, John R. *Looking at Lovemaking* (Berkeley, University of California Press, 1998)

6. Petronius, *Satyricon* trans. M. Heseltine, W.H.D. Rouse, The Loeb Classical Library (Cambridge, Harvard University Press, 1913) 41

7. Shelley, Percy Bysshe *Essays, Letters from Abroad, Translations and Fragments* ed. Mary Shelley, Letter XVI

8. Jashemski, W. F. *The Gardens of Pompeii, Herculanaeum and the Villas Destroyed by Vesuvius* (New York, Melissa Media, 1979)

9. Garnsey, P. *Food and Society in Classical Antiquity* (Cambridge, Cambridge University Press, 1999)

CHAPTER 6: THE GRAND TOUR

1. Ayres, P. *Classical Culture and the Idea of Rome in Eighteenth Century England* (Cambridge, Cambridge University Press, 1997)

2. Stendhal *Promenades en Rome* (Paris, 1929)

3. Jones, T. 'Memoirs' (*Journal of the Walpole Society* 32, 1951)

4. Goethe, 195

5. Haskell, F. Preface to *The Grand Tour: The Lure of Italy in the Eighteenth Century* ed. A. Wilton and I. Bignamini (London, The Tate Gallery, 1996)

6. Hamblyn R 'Private cabinets and popular geology: the British audiences for volcanoes in the eighteenth century' in *Transports: Travel, Pleasure and Imaginative Geography 1600–1830* ed. Chard, Chloe and Langdon, Helen (London, Yale University Press, 1996)

7. Soane, J. *Memoirs of the professional Life of and Architect.* (London, 1835)

8. Acton, H. *Three Extraordinary Ambassadors* (London, Thames and Hudson, 1983) 43

9. Perkins, J. W. and Claridge, A. *Pompeii AD 79* exhibition catalogue (Sydney, 1980) item 208

CHAPTER 7: THE LEGACY OF POMPEIAN STYLE

1 Gell, Sir William and Gandy, John P. *Pompeiana: The Topography, Edifices, and Ornaments of Pompeii* (London, 1817–19)

2. Zahn, W. *Die schonsten Ornamente und merdwurdigsten Gemalde aus Pompeji, Herkulanum und Stabiae* (Berlin, 1828–59)

3. Jones, Owen *The Grammar of Ornament* (London, 1856)

4. Mazois, F. *Les Ruines de Pompeii – Dessins et Mesures* (Paris, 1809–38)

5. Mazois, F. 'Letter to Mlle Duval' quoted in Etienne, Robert *Pompeii: The Day a City Died* (New York, Thames and Hudson, 1992)

6. Basevi, George *Home Letters from Italy and Greece* ed. Bolton, A. T. (London, Soane Museum)

7. Peck, A. and Parker, J. *Period Rooms in the Metropolitan Museum of Art* (New York, Harry N. Abrams, 1996)

FURTHER READING

Berry, Joanne (ed.) *Archaeological Superintendency of Pompeii. Unpeeling Pompeii* (Milan, Electa, 1998)

Ciarallo, Annamaria and De Carolis, Ernesto (eds.) *Archaeological Superintendency of Pompeii. Around the Walls of Pompeii* (Milan, Electa, 1998)

Cohen, Ada 'The Alexander Mosaic: Stories of Victory and Defeat' *Cambridge Studies in Classical Art and Iconography* (Cambridge, Cambridge University Press, 1997)

D'Ambrosio, Antonio *Women and Beauty in Pompeii.* (Los Angeles, The J. Paul Getty Museum, 2001)

De Caro, Stefano *Houses and Monuments of Pompeii: The Work of Fausto and Felice Niccolini* (Los Angeles, The J. Paul Getty Museum, 2002)

De Carolis, Ernesto *Gods and Heroes in Pompeii* (Los Angeles, The J. Paul Getty Museum, 2001)

De Franciscis, A. *Pompeii: Monuments Past and Present* (Rome, Vision, 1995)

Diess, Joseph Jay *The Town of Hercules; A Buried Treasure Trove* (Los Angeles, The J. Paul Getty Museum, 1995)

Guzzo, Pier Giovanni, et al. *Pompeii* ed. Silvia Cassani, trans. Mark Weir (Naples, Electa, 1998)

Irlando, Antonio *Pompeii: Everyday Life in the Town Buried by Mount Vesuvius 2000 Years Ago* (Pompeii, Guide Touristche Fortuna Augusta, 1998)

Knopf Guide to Naples and Pompeii (New York, Knopf, 1996)

Lawrence, Ray *Roman Pompeii: Space and Society* (New York, Routledge, 1996)

Ling, Roger, Kenneth S. Painter, Paul Arthur *The Insula of the Menander at Pompeii: The Silver Treasure* (Oxford, Oxford University Press, 2002)

Lytton, Edward Bulwer *The Last Days of Pompeii* (Kila, Kessinger Publishing Company, 1998)

Parslow, Christopher *Pompeii: History, Archaeology, Reception* (Cambridge, Cambridge University Press, 2003)

Pompeii: A Practical and Complete Guide of the Archaeological Zone (Florence, Bonechi, 2000)

Varone, Antonio *Eroticism in Pompeii* (Los Angeles, The J. Paul Getty Museum, 2001)

GLOSSARY

aedicule: a shrine, from the Latin *aediculum* meaning 'small house'. It is usually made up of two columns supporting an entablature or a pediment placed against a wall.

alae: plural of the Latin *ala* meaning 'wing'. In Roman houses the alae were small open rooms accessible from the atrium.

amphitheatre: an oval-shaped stadium used primarily as a venue for gladiatorial games and spectacles.

apodyterium: the undressing chamber of a bathhouse complex, also used as the waiting room for slaves and attendants.

atrium: the central hall of a Roman house.

Basilica: a public building which served as the court of law and an exchange, or place of meeting for merchants and men of business.

Boscoreale: a town located to the north of Pompeii on the slopes of Vesuvius. The town is particularly known for its proliferation of villas with fine frescoes.

caldarium: the room in the Roman bathhouse containing the hot bath.

Civitas: Latin for 'city', the name given to the excavation site before it was identified as Pompeii.

Comitium: a multi-purpose roofless building used for trials and public meetings. Also believed to have been used for casting votes during elections.

compluvium: a central opening in the roof of the atrium that let in light, air and rainwater, which was collected in the impluvium.

cryptoporticus: a subterranean covered portico.

culina: the kitchen of the Roman house.

Curia: the building where the magistrates of the decurionum met and carried out the governance of Pompeii.

decurions: magistrates, members of the municipal council.

duovir: one of two *duoviri iure dicundo* or chief magistrates, responsible for justice and government.

Etruscan: the most advanced civilization in Italy before the Roman era.

Eumachia: the high priestess of the imperial cult, after whom the Eumachia building is named.

exedra: a room or alcove open on one side, often located off the peristyle in a Roman house.

fauces: the entrance passage leading from the street into the interior of a house or building (Latin: 'jaws').

Forum: the public square of a Roman city which acted both as a marketplace and as the centre of judicial and public business.

frigidarium: the room in a Roman bathhouse for cooling off and swimming.

Herculaneum: a town located to the northwest of Pompeii on the Bay of Naples. Herculaneum shared Pompeii's fate as it was covered in volcanic mud in AD 79. It is here that archaeological discoveries began the enthusiasm for further excavation at Pompeii.

hortus: a service yard around which were arranged the kitchen garden, stables and offices, usually found to the back or side of a Roman house.

impluvium: centrally located basin in the atrium of a Roman house for the collection of rainwater entering through the compluvium above.

insula: a city block.

laconicum: a second hot room within the Roman bathhouse complex equipped with a brazier to create dry heat, producing a sauna-like environment.

lapilli: rounded tephra (magma, accessory or accidental material) ejected from a volcano during an eruption.

lararium: a family or household shrine.

lares: Roman guardian spirits of houses and fields.

lava tenera: volcanic stone.

Macellum: the central market of the Pompeian Forum.

Magna Graecia: the Greek colonies of southern Italy.

mofeta: Spanish word meaning 'skunk'. A term used by early excavators of Pompeii to describe the noxious and lethal carbon monoxide trapped within the pyroclastic debris left by the eruption.

Palaestra: from the Greek meaning 'wrestling school'. A building with a large open courtyard dedicated to competitive athletic activities and training.

peristyle: an internal courtyard flanked on at least one side by a colonnade or row of piers looking out over an ornamental garden.

regio: an urban district or region.

scaenae frons: the architectural backdrop which formed the rear of the theatre behind the stage.

Stabiae: an ancient port city to the south of Pompeii. Pliny the Elder died at Stabiae due to the fallout from the eruption of Vesuvius.

tablinum: the main reception room of the atrium in a Roman house, usually elaborately decorated.

Tabularium: a civic building next to the Comitium in the Forum, used for storing official records.

tepidarium: the warm room of a Roman bathhouse equipped with a warm pool and used for the application of oils and massage.

thermae: a Roman bathhouse.

triclinium: a dining room, the word refers to the three couches placed in the room.

vestibulum: an entrance hallway or room immediately following the fauces and doorway leading into the atrium.

villa: a suburban country residence, often connected to a vineyard or a farm.

CHRONOLOGY

1360 BC Eruption of Vesuvius destroys Bronze Age settlements.

1000 BC Area re-occupied by various tribes.

Seventh century BC First Oscan settlements founded in the vicinity of the future Pompeii.

Sixth century BC Etruscan influence and growth of the town.

525–474 BC Etruscans and Greeks battle for domination over Campania.

474 BC The Greeks defeat the Etruscans at Cumae taking control of the region.

423 BC Samnites conquer Capua, then Cumae, and later the whole Campanian region.

343–290 BC Rome is victorious over the Samnites and assumes control of the Campania region.

264–241 BC The First Punic War; the Bay of Naples becomes a centre of ship building for the Roman Navy.

218–202 BC The Second Punic War; Hannibal invades Italy, Pompeii allies with Rome.

91–88 BC The Social War; Pompeii joins the revolt of the Italic towns against Rome; Sulla besieges Pompeii.

87 BC The Social War formally ends with Roman citizenship awarded to all Campanian cities. Pompeii is made a Roman colony under the name Colonia Cornelia Veneria Pompeianorum.

49 BC Julius Caesar pardons the combatants of the Social War leading to the renaissance of Pompeii's old families.

27 BC Augustus Caesar becomes the first Roman emperor.

AD 59 Rioting between the inhabitants of Pompeii and Nuceria.

AD 62 Earthquake hits Pompeii causing severe damage.

AD 79 24 August, Eruption of Vesuvius. Pompeii is destroyed.

Late sixteenth century Domenico Fontana, architect to the Neapolitan Court, discovers pieces of marble and frescoes in the vicinity of Pompeii.

1689 More pieces of marble found. Architect Francesco Pichetti claims to have found the villa of Gaius Pompeius Magnus. Scholar Francesco Bianchini declares Pichetti has actually found Pompeii.

1693 Early archaeologist Giuseppe Macrini confirms Bianchini's hypothesis after viewing more unearthed frescoes.

1699 Macrini publishes his findings in his book *De Vesuvio*.

1709 Pompeii's neighbour Herculaneum is discovered.

1734 Charles III assumes the Throne of Naples and orders further excavations at Herculaneum.

1738 Herculaneum is positively identified.

1748 Roque Joachim de Alcubierre on the authority of Charles III begins excavations at the Civitas Hill; Pompeii is discovered.

1750 Karl Weber joins the excavation team and begins the first serious documentation of the findings.

1755 The Praedia of Julia Felix is unearthed in Pompeii.

1763 Pompeii is positively identified.

1764 Francesco La Vega replaces Weber as Alcubierre's assistant; the Temple of Isis is discovered.

1780 Death of Alcubierre.

1789 Revolution in France.

1798–99 Naples joins the Second Coalition against France and is defeated. King Ferdinand IV flees to Sicily. Parthenopean Republic established in Naples.

1806 Naples falls again to Napoleon. Joseph, Napoleon's brother, becomes King of Naples. He encourages further excavations and employs Michele Arditi to lead the excavations.

1808 Joachim Murat and Napoleon's sister Caroline, succeed Joseph as King and Queen of Naples. Work at Pompeii continues under royal supervision.

1809–11 François Mazois records and draws the first series of engravings of Pompeii, published in *Les Ruines de Pompei*.

1812 Excavation of the Forum begins under Antonio Bonucci.

1814 Ferdinand IV returns to Naples following the defeat of Napoleon as Ferdinand I, King of Two Sicilies. The Bourbon restoration marks a period of decline at the excavations.

1830 Discovery of the House of the Faun.

1860 Naples united with the Kingdom of Italy forcibly by Giuseppe Garibaldi who during his brief tenure as dictator of Naples and Sicily appoints French author Alexandre Dumas director of the excavations at Pompeii.

1863 Giuseppe Fiorelli becomes director of the excavations.

1875 Michele Ruggerio succeeds Fiorelli as director.

1893 Ruggerio succeeded by Giulio De Petra; the House of the Silver Wedding is discovered.

1901 Ettore Pais named director of the Museum of Naples and excavations at Pompeii following disgrace of De Petra.

1904 Antonio Sogliano named director. Many of Pompeii's gardens are revived during his tenure.

1906 De Petra returns as director.

1910 Vittorio Spinazzola begins term as director.

1923 Spiazzola removed for political reasons. Amedeo Maiuri succeeds as director.

1929–30 The Villa of the Mysteries is discovered.

1943 Pompeii suffers damage from Allied bombing.

1963 Maiuri retires; all major excavations are halted in favour of conservation efforts.

1994 Pier Giovanni Guzzo becomes director of Pompeii.

1996 Pompeii first added to the World Monuments Watch List of the 100 Most Endangered Sites.

1997 Pompeii listed as a Unesco World Heritage Site along with the archaeological areas of Herculaneum and Torre Annunziata.

INDEX

AUTHORS' ACKNOWLEDGMENTS

The authors would like first of all to pay tribute to the memory of the late Frances Lincoln, who had the idea for this book, and to her remarkable husband John Nicoll, who continued to work to ensure that it became a reality.

At every stage the staff of Frances Lincoln have been creative and helpful, especially our infinitely patient and excellent editor Michael Brunström. The photographer Chris Caldicott coped brilliantly with some on-site difficulties at Pompeii and the picture editor Sue Gladstone backed up his contemporary photographs with inspired choices from the richness of the archives. Anne Wilson has been a wonderful designer.

All the staff of the World Monuments Fund in Britain have supported us – Naomi Gordon, Will Black and Dorothy Connell and, in New York, Bonnie Burnham, John Stubbs and Angela Schuster, plus Marilyn Perry who helped with the original idea.

John Julius Norwich was going to write this book but generously passed on the task to us. Many people helped, especially our agent Andrew Best, Alan Dodd, John Harris and our friends at 'Private View of Italy'. Kevin MacLelland and Chuck London provided good-natured support and technical skills on the computer which made it possible to complete the book in London and Los Angeles. We were honoured that Professor Andrew Wallace-Hadrill, the Director of the British School in Rome, agreed to write the Introduction.

We would like to dedicate this book to Grand Tourists past, present and future.

PHOTOGRAPHIC ACKNOWLEDGMENTS

NMAN= The National Archaeological Museum of Naples
a=above, b=below, l=left, r=right

All photographs © Chris Caldicott except for those listed below. For permission to reproduce these images and for supplying photographs, the Publishers would like to thank the following:

AKG, London: 25 (Musée des Augustins, Toulouse), 31 (Postmuseum, Berlin), 42, 46a, 151 (Städelsches Kunstinstitut, Frankfurt), 175 (Landesmuseum, Oldenburg), 182 (SMPK Nationalgalerie, Berlin)
AKG, London/Erich Lessing: 16 (NMAN), 21 (NMAN), 57 (NMAN), 68 (NMAN), 74l (NMAN), 75 (NMAN), 78 (NMAN), 121 (NMAN), 131 (NMAN), 140 (NMAN), 149 (The Louvre, Paris)
The Art Archive/Dagli Orti: 41 (Bibliothèque des Arts Décoratifs, Paris), 124 (House of the Silver Wedding, Pompeii)
Bridgeman Art Library: 10–11 (Musée du Petit Palais, Paris), 19 (NMAN), 28–9 (Musée d'Orsay, Paris), 69 (NMAN), 76 (NMAN), 85 (NMAN), 92–3 (NMAN), 143 (Musée d'Orsay, Paris), 144 (Museo e Gallerie Nazionali di Capodimonte, Naples), 145 (NMAN), 161 (Private Collection)
Alan Dodd: 181
By courtesy of Home House, London: 178 (photo David Lambert)
National Trust Photographic Library/John Hammond: 152–3
By courtesy of His Grace the Duke of Northumberland: 179 (Syon Park)
Pitshanger Manor Gallery & House: 180 (Geremy Butler Photography)
Private Collections: 34, 40, 46b, 100a, 141, 150, 156, 157, 158, 162, 164, 165, 170, 171, 172, 173, 174, 176, 177
© Roger Ressmeyer/CORBIS: 54–5
SCALA: 15, 26 7 (Museo Statale Russo, Leningrad), 80 (NMAN), 95 (House of the Silver Wedding, Pompeii), 106 (House of Menander, Pompeii), 123 (House of Sallust, Pompeii), 126 (House of Marcus Lucretius Fronto, Pompeii), 137 (House of the Gilded Cupids), 146–7 (The Hermitage, Leningrad), 163
By courtesy of the Trustees of Sir John Soane's Museum: 36, 159, 166–7, 168–9 (Photo: Martin Charles)
Sotheby's Picture Library: 155
By courtesy of the Wedgwood Museum Trust Limited, Barlaston, Staffordshire: 183

PUBLISHERS' ACKNOWLEDGMENTS

Editor Michael Brunström
Picture editor Sue Gladstone
Designer Anne Wilson
Index Margot Levy
Production Kim Oliver

Plasterwork from the ceiling of the Stabian Baths at Pompeii.